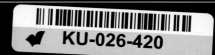
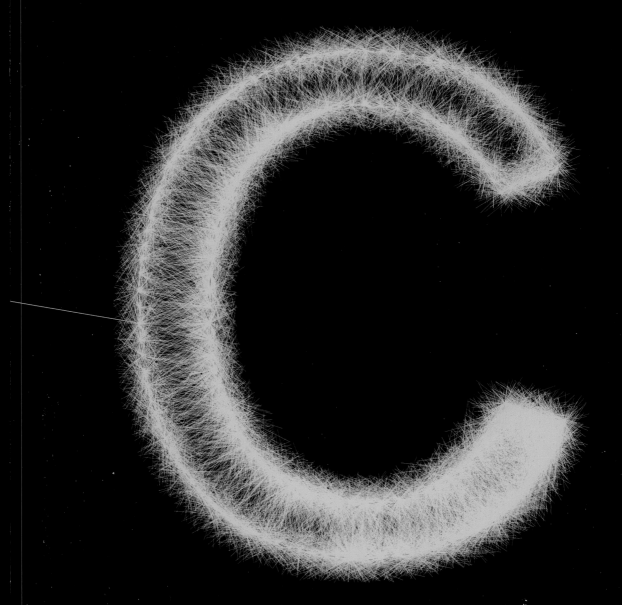

Library of Congress
Cataloging-in-Publication Data

Reas, Casey.
Form+code in design, art, and architecture /
Casey Reas, Chandler
McWilliams, and Jeroen Barendse.
176 p. : ill. (some col.) ; 22 cm. — (Design briefs)
Includes bibliographical references
and index.
ISBN 978-1-56898-937-2 (alk. paper)

1. Computer software--Development.
2. Computer-aided design. 3. Art and
technology.
I. McWilliams, Chandler. II. Barendse,
Jeroen. III. Title. IV.
Title: Form and code in design, art,
and architecture.

QA76.76.D47R42 2010
005.1—dc22

2010008505

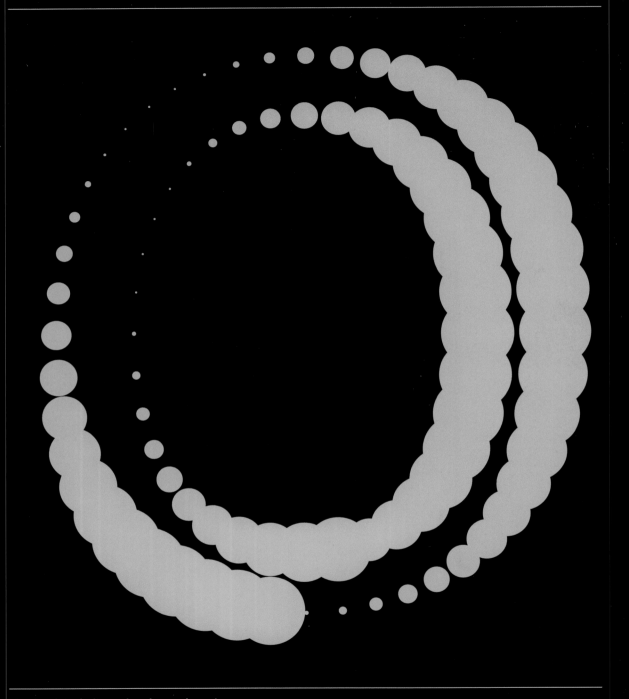

This book is dedicated to the students in
the Department of Design Media Arts at the
University of California, Los Angeles.

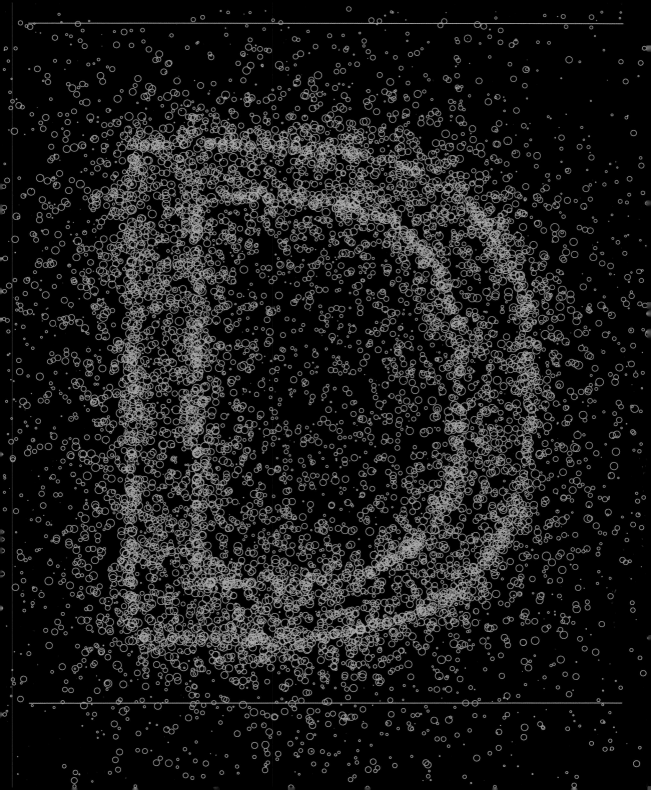

HOW HAS SOFTWARE AFFECTED THE VISUAL ARTS?

WHAT IS THE POTEN-TIAL FOR SOFTWARE WITHIN THE VISUAL ARTS?

AS A DESIGNER OR ARTIST, WHY WOULD I WANT OR NEED TO WRITE SOFTWARE?

Software influences all aspects of contemporary design and visual culture. Many established artists, such as Gilbert and George, Jeff Koons, and Takashi Murakami, have totally integrated software into their processes. Numerous prominent architects and designers use software extensively and commission custom programs to realize their ideas. The creators of innovative video games and Hollywood animated films also write software to enhance their work.

While these exciting developments are taking place at the highest levels of the creative professions, integrating them into design education is a challenge. Even the most motivated student will find the technical boundaries difficult to overcome. As a comprehensive first introduction to software development within the arts, this book seeks to encourage the enthusiasm that the field requires. It will not, however, teach you to program computers. To satisfy that urge, see Processing: A Programming Handbook for Visual Designers and Artists by Casey Reas and Ben Fry.*

* Casey Reas and Ben Fry, Processing: A Programming Handbook for Visual Designers and Artists (Cambridge, MA: MIT Press, 2007).

In Form+Code in Design, Art, and Architecture we define form as visual and spatial structures; code is defined primarily as computer programs, but we extend the definition to include instructions beyond computer code. The book is organized into seven chapters: What is Code?, Form and Computers, Repeat, Transform, Parameterize, Visualize, and Simulate. The first two chapters set the foundation by defining terms and introducing basic concepts. The themed chapters that follow are deeply linked to code. Each begins with an essay to define the territory, continues with images and captions to clarify and explain each theme, and concludes with two illustrated examples of programs. The corresponding source code is available in multiple programming languages and can be downloaded for free from the book's website: http://formandcode.com.

We're tremendously excited about the potential for creating form with code. We hope this book will inspire readers to think further about the relationships between these topics.

INTRODUCTION

The diverse typographic explorations on the title pages of the following chapters began with the same typeface used for this page—Neutral by Kai Bernau. Using Neutral's geometry as a foundation, we developed all of the typefaces by tweaking and writing code using Python, PostScript, and Processing. The title-page typography demonstrates the nature of codification: the embedding of information within a system.

Codes typically serve three main purposes. They are used for communication, clarification, or obfuscation.

In Morse code, a word is transformed into short and long pulses so that it can be communicated over a telegraph. The word my is encoded by the sender into "-- -.--"; the resulting sound is then decoded back into my by the receiver.

Genetic information is encoded in sequences of deoxyribonucleic acid (DNA), such as "AAAGTCTGAC," with A standing for adenine, G for guanine, T for thymine, and C for cytosine. The genetic code is a set of rules that use these sequences to build proteins.

The California Health and Safety Code is a set of written laws that codify the rules set forth by the State Legislature. For example, section 12504 states, "Flammable liquid means any liquid whose flashpoint is 100 degrees Fahrenheit, or less."

Ever since the origins of writing, codes have been used to protect messages from unwanted eyes. For example, a code can be as simple as replacing each letter of the English alphabet with a number: A is 1, B is 2, C is 3, etc; with this code, the word secret becomes "19, 5, 3, 18, 5, 20."

WHAT IS CODE?

The grid on this page began as a simple and evenly spaced pattern. The outline of Neutral was converted to points, and a system was defined in code to map these points on the grid. The point systems are slightly offset from their initial positions to reveal the information.

--.. -. . - .. -.-. / -.-. --- -.. . .-.-.- / - .-. .-.. - / -.-. --- -.. . .-.-.- / -... ..-
.. .-.. -.. .. -. --. / -.-. --- -.. . .-.-.- / -... .- -. . / -.-. --- -.. . .-.-.- / -- --- .-.
/ -.-. --- -.. . .-.-.- / -.. .- / -.-. --- -.. . .-.-.- / .- .-.-. / -.-. --- -.. . .-.-
.- /-. -.. .- / -.-. --- -.. / .- .-. . - -.. / .-
--- .-. / -.-. --- -.. . .-.-.- .- -. .-.-.- .-.-.- / .-.-. -.. . .-.-. --- -- --- .-.-.- --
.- -. -.. / --- -.. .-.-. .- .- ... -.-. .- - .. --- -.- .-.-.- / .. -. / -- --- .-. / -.-. --- -..
. .--.-- / .- / --- -.. . .-. -.. / / - .- .-. . .--. . .-. -.-. / .. .-. - --- / ...
.... --- .-. - / .- .- . -.. / .-.. --- -. -. . --. / .-.. .-. .- -.-.--. / - --- / .. - /
-.-. .-. -. . / -... . / -.-. --- -- -- .. -. .-. .. .-.-.- - . -.. / --- .-. . .-. / .- / . .-.. .-.. -..
.-. .- .-. -.-.-. / ..-. --- -.. . .-. / .- . . .-. .-. .-.. .-.-.- / -.-- . / .-- --- -. . -..
/ -- -.-- / / . -. -.-. . --- -.. -. . / .-- --- -.-- / - / - / .. .-. - --- /
-....- -....- / -....- .-.-.- -.... .--.-- - -... -....- -.... --..-- / .-- -. .-. / - -. / -..
. .-.. . --- -.. .. -.. / -.-. .- .- -. .-.-.- .-.- / .-- - / -- --.-- / -- -..-. / -.-.
.- - . .-- ... / .. -. .-. --- -.. . -. .-.-. / .- -. / -.-- . -.-. .- . .-. / -.-. / .. - .-. --- .-.
-.-. .-.- / -.-. .-.-.- . .-.-.- --- --. -.-. .-. .- / -. . - .-. --- -. .-.-. .- .-.-.- .-.-.- .-.-.- .-.-.- .-.-.- -.-
-.-. .-.-. / - .-.-. . / --. . . / --.-. .- -. .- -. .-.-.- / -.-. --- -.. . / .. .-.- / .- / .-.-. .- - / --- -.. . / -.-.
.. .-. .-. .-.. / - .-.-.- . / .. .- .-.- - / .. .-.. . .- / - .-.-.- /- .- . / - / --- / -.
.--.-.- .-. / - .-.-.- . / .. .-.. . -.-. / - .-.-.- . / - .-.-.- . / .-- .-.-. --- /
.. .-.-.. -.. / .-.-. --- -.. . -. .-.-. / -.-. .- .- -. .- .-. -. .-. / .- .-. - / .- -.. .- --- /
.-. .-. -.. / .-.-. --- -.. . -. .-.-. / -.-. .- .- -. .- .-. -. .-. / .-. --- -.. .- . -. .. / . -.-. .- - -- .-. .- .--
. .--.-- / - .-.-. . / -.-. .- -. .- .-. .-. .- --- .-. .-. .- -. . .-.-.- . .-. / .-.- -. . -. . / .-.-.-
. .-. .- .. .-.-. . -. .-. / -.-. .- / .- .-. / .- .-.-. .- -.-. --- -.. --- .-.- -. .- / --- --. . /
.-- - -.-. .. -. .. - .-.-.- -.. / .-.-. .-.- . -. -.-. --- / - .- . . . / .. .-.. .- .-.. . / .- .-.-. / .----
----- ----- / -... .. --. .-. .-. / ..-. .- -. .-. .-. . -. - --..-- / -.-. --- -.. /
.- .- .-.. ... --- / -- -... .-. -.. .. .-. .- -. .-. .. / --- -. -. -. --- .-. .. / -. .-.
/ - .-... . / --- .-.-.. .. -. / --- --- .-. .- / .- .-. .-. .. .- - -. .-. .-. .-.-.- / - .-.. . . .-.. -.-- / .-.. ...
.- ..-. . / -... -. .- / .- .-.-.. / .-. -.-. --- - . .-.-.- - / --- -. . .- . --.-- .. / .. -.-. -.-.
.-. / .-- .. - -.... /- .. -- -.. .-.-. .-. / .- / -.-. .-.-. .-. .-. -.. -.-. .. -. .-. / .. .- .-. .- . -- --
-... .. --..-- / .- .-.-. / .-.-. --- --- -.. .- / / .-. .-.-. .-. . - / -... . -.-. --- . . .-.. / .---- ---.
/ / ...-- / .---- ---.. / / ..--- ----- .-.-.-

Morse code, 1840s
In Morse code, every
character is encoded as
a rhythmic sequence of
dots and dashes.

THE ALGORITHM

There are many types of code. Within the context of this book, we're interested primarily in codes that represent a series of instructions. This type of code—often called an algorithm, procedure, or program—defines a specific process with enough detail to allow the instructions to be followed. While the word algorithm may be unfamiliar to you, its meaning is not. It's just a precise way of explaining how to do something. It is commonly used within the context of computer instructions. While most people wouldn't refer to a pattern for knitting a scarf as an algorithm, it's the same idea.

```
Row 1: (RS) *K2, P2* across
Rows 2, 3, & 4: Repeat Row 1
Row 5: (RS) *K2, P2, C8F* Repeat to last
    4 sts, K2, P2
Row 6: Repeat Row 1
Repeat rows 1-6 for desired length,
    ending with row 4
Bind off in K2, P2 pattern
```

Likewise, directions to get from one place to another, instructions for assembling kit-of-parts furniture, and many other types of guidelines are also algorithms.

```
Hiking Directions to Point Break

From the North:
- Follow the trail from the Nature
  Center
- Turn right at the Water Tower,
  walk until you see the Old Oak Tree
- Follow directions from the Old Oak
  Tree

From the South:
- From the Picnic Grove, follow the
  Botany Trail
- Turn right on the South Meadow Trail
- Turn right on the Meadow Ranch Trail,
  walk until you see the Old Oak Tree
- Follow directions from the Old Oak
  Tree

From the Old Oak Tree:
- Follow the path under the tree
- Turn right onto the Long Hill Trail
- Follow the trail until you reach
  Point Break
```

Algorithms can be defined as having four qualities. These qualities can be easily understood when defined in relation to travel directions.

There are many ways to write an algorithm. In other words, there are always multiple ways to get from point A to point B. Different people will create different sets of directions, but they all get the reader to their intended destination.

An algorithm requires assumptions. Hiking directions assume that you know how to hike, from knowing to wear the right shoes, to understanding how to follow a winding trail, to assuming that you know to bring plenty of water. Without this knowledge, the hiker may end up lost and dehydrated with blistered feet.

An algorithm includes decisions. Directions often include instructions from different starting locations. The person reading the directions will need to choose a starting position.

A complex algorithm should be broken down into modular pieces. Directions are often divided into small units to make them easy to follow. There may be separate directions for coming from the North or South, but at a certain point the directions converge and both groups follow the same instructions.

WHAT IS CODE?

PostScript

```
gsave
            % move to the center of the page
            306 396 translate
            % repeat from 0 to 360 in increments of 12
            0 12 360 {
                    pop
                    % draw line from (20,0) to (200,0)
                    20 0 moveto 200 0 lineto
                    % rotate 12 degrees
                    12 rotate
            } for
            stroke
grestore
```

Processing

```
void setup() {
   size(800, 600);
   stroke(255, 204);
   smooth();
   background(0);
}

void draw() {
   float thickness = dist(mouseX, mouseY, pmouseX, pmouseY);
   strokeWeight(thickness);
   line(mouseX, mouseY, pmouseX, pmouseY);
}
```

PostScript, 1982
The PostScript language specializes in defining pages for print output. Although PostScript files can be written in a text editor, they are typically created with a graphical user interface (GUI), which makes it easier to create and edit files but removes the more powerful features.

Processing
Processing is a programming language and environment with a focus on coding form, motion, and interaction. It simplifies and extends the Java language. This Processing program draws a line at the position of the mouse; the line thickness is calculated by the speed of the mouse.

CODE AND COMPUTERS

In computer programming, code (also called source code) is used to control the operations of a computer. It is an algorithm written in a programming language. There are thousands of programming languages, and new ones are developed every year.

Although the words and punctuation used in programming languages look different from written English words, the codes they use are intended to be read and understood by people. Specifically, computer-programming languages are designed for the way people are taught to read and write from a young age, with the precision necessary for instructing a computer. Human languages are verbose, ambiguous, and contain large vocabularies. Code is terse, has strict syntactical rules, and small vocabularies. Constructing an essay and a computer program are, however, both forms of writing, as explained in Processing: A Programming Handbook for Visual Designers and Artists:

> Writing in a human language allows the author to utilize the ambiguity of words and to have great flexibility in constructing phrases. These techniques allow multiple interpretations of a single text and give each author a unique voice. Each computer program also reveals the style of its author, but there is far less room for ambiguity."[1]

[1] Casey Reas and Ben Fry, Processing: A Programming Handbook for Visual Designers and Artists (Cambridge, MA: MIT Press, 2007), 17.

In fact, there can only be one interpretation of every piece of code. Unlike people, computers are not able to guess or interpret a meaning if it's not stated exactly. There are rules of grammar in every language, but if I misspell a wurd or two, you will still understand, but the computer won't. Fortunately (or maybe unfortunately), people are highly adaptable, and for many individuals it's easy to learn how to structure code.

Before a piece of code can be run on a computer, it must be converted from a human-readable format to a computer-executable format; these are sometimes called machine code, binaries, or executables.

This conversion transforms the code into software. It can now run (or execute) on a computer. Machine-based code is usually represented as a series of 1s and 0s:

```
0001 0001 0000 1001 0000 0001 0000
1110 0000 1001 1100 1101 0000 0101
0000 0000 1100 1001 0100 1000 0110
0101 0110 1100 0110 1100 0110 1111
0010 0001 0010 0100
```

While this series of 1s and 0s looks different from source code, it's a literal translation of the human-readable code. This translation is required for the computer to be able to follow the instructions. We think you'll agree that understanding what these sequences of 1s and 0s mean is more difficult than reading the source code. This format instructs the computer's operations at the lowest level. Each bit (1 or 0) is grouped into bytes (a sequence of eight bits) that define how the computer makes calculations and moves data into and out of the processor.

WHAT IS CODE?

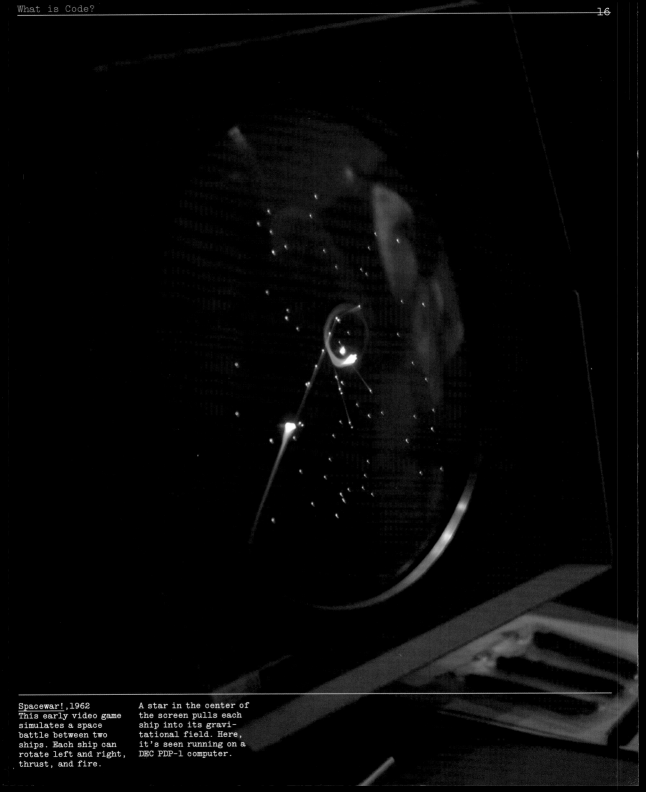

Spacewar!, 1962
This early video game
simulates a space
battle between two
ships. Each ship can
rotate left and right,
thrust, and fire.

A star in the center of
the screen pulls each
ship into its gravi-
tational field. Here,
it's seen running on a
DEC PDP-1 computer.

THINKING IN CODE

Software is a tool for the mind. While the industrial revolution produced tools to augment the body, such as the steam engine and the automobile, the information revolution is producing tools to extend the intellect. The software resources and techniques at our disposal allow us to access and process enormous quantities of information. For example, the science of genomics (the study of the genome) and the collaborative scholarship of Wikipedia were not possible without the aid of software. But using software is not only about increasing our ability to work with large volumes of information; it also encourages new and different ways of thinking.

The term procedural literacy has been used to define this potential. Michael Mateas, an associate professor in the computer science program at the University of California, Santa Cruz, describes procedural literacy as "the ability to read and write processes, to engage procedural representation and aesthetics."[2] One component of procedural literacy is the idea that programming is not strictly a technical task; it's an act of communication and a symbolic way of representing the world. A procedural representation is not static. It's a system of rules that define a space of possible forms or actions. Video game designer Ian Bogost defines this elegantly in his book Persuasive Games: The Expressive Power of Videogames:

To write procedurally, one authors code that enforces rules to generate some kind of representation, rather than authoring the representation itself. Procedural systems generate behaviors based on rule-based models; they are machines capable of producing many outcomes, each conforming to the same overall guidelines.[3]

A video game like Spacewar! is a good example of a procedural representation. Playing the game requires understanding the spatial and kinetic relationships between two opposing spaceships. Each player controls a ship by rotating left and right and by thrusting the rocket with the goal of shooting down the other ship. To write the game, a procedurally literate individual had to break the behaviors into modules with enough detail so that they could be programmed. The primary complexity involved in creating the game is not technical; it's about choreographing all of the components into a coherent and enjoyable experience. Procedural literacy is a general way of thinking that cuts across all programming languages and even applies to thinking outside the domain of writing source code.

Each programming language is a different kind of material to work and think with. Just as a carpenter knows the unique properties of various woods, including oak, balsa, and pine, a person knowledgeable about software knows the unique aspects of different programming languages. A carpenter building a table will select the wood based on factors such as cost, durability, and aesthetics. A programmer selects a programming language based on the estimated budget, operating system, and aesthetics.[4] The syntax (or grammar) of each programming language structures what is possible within that language. Different programming languages encourage programmers to think about their work through the affordances (or action possibilities) and constraints of that language.

The way that a programming language encourages a certain mode of thinking can be demonstrated by comparing two very different languages: BASIC and LOGO. In each of these programming environments, drawing a triangle requires a different approach and understanding of space. BASIC relies on an established coordinate system and requires the knowledge of coordinates; lines are drawn by connecting one coordinate

WHAT IS CODE?

[2] Michael Mateas, "Procedural Literacy: Educating the New Media Practitioner," Beyond Fun, ed. Drew Davidson (Pittsburgh, PA: ETC Press, 2008), 67.

[3] Ian Bogost, Persuasive Games: The Expressive Power of Videogames (Cambridge, MA: MIT Press, 2007), 4.

[4] There are many reasons why one programming language may be preferred over another. For example, some languages allow code to be written faster, but this is usually at the expense of how fast the code is capable of running. Some languages are more obscure than others, therefore reducing the chances that another programmer knows of the language.

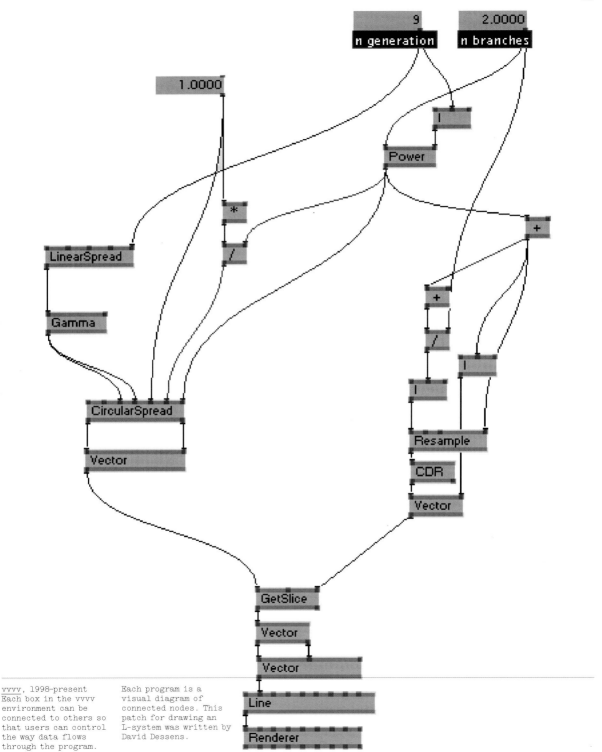

vvvv, 1998–present
Each box in the vvvv
environment can be
connected to others so
that users can control
the way data flows
through the program.

Each program is a
visual diagram of
connected nodes. This
patch for drawing an
L-system was written by
David Dessens.

[5] The BASIC language was designed in 1964 to teach non-technical university students how to program. Variations of it were used to teach many children and hobbyists how to program in the early era of personal computing.

[6] In LOGO, first developed in 1967, drawings are made by moving a triangular turtle around on screen. Early versions of the language moved a robotic turtle around the room.

to another.[5] In contrast, LOGO is a language developed for young children who have not yet studied geometry; it allows the user to code a shape with only an understanding of angles and the difference between left and right. In this program, the child draws lines by directing the path of a turtle on screen. The child imagines that he or she is the turtle and moves forward, turns to the right, moves forward, turns to the right again, and then moves forward to complete the triangle.[6] Although both languages allow the same shapes to be drawn, BASIC promotes objectivity, while LOGO fosters exploration. Additionally, LOGO encourages the programmer to run the code mentally, which is a useful skill for developing procedural literacy.

Visual programming languages (also called graphical programming languages) provide an alternative way of thinking with code. Writing a program with a visual programming language is similar to making a diagram instead of writing a text. Three of the most popular visual programming languages within the arts—Max, Pure Data, and vvvv—were influenced by the way sounds are constructed using patch cables attached to analog synthesizers. Virtual cables, represented as lines on screen, are used to connect programming modules together to define the software. Visual programming languages make it easy to generate and filter images and sounds, but they are often too cumbersome for writing long, complicated programs. For example, the Max program is written in the text programming language C++, not a visual programming language.

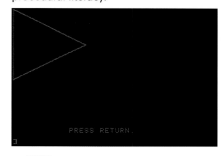

BASIC
```
10 HGR : HCOLOR = 3
20 HPLOT 0, 0 TO 100, 50 TO 0, 100 TO 0, 0
30 END
```

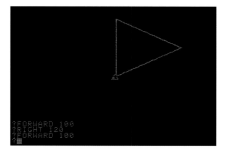

LOGO
```
FORWARD 100
RIGHT 120
FORWARD 100
RIGHT 120
FORWARD 100
```

WHAT IS CODE?

PROPOSAL FOR WALL DRAWING, INFORMATION SHOW

Within four adjacent squares,

each 4' by 4',

four draftsmen will be employed

at $4.00/hour

for four hours a day

and for four days to draw straight lines

4 inches long

using four different colored pencils;

9H black, red, yellow and blue.

Each draftsmen will use the same color throughout

the four day period,

working on a different square each day.

Proposal for a Wall Drawing, Information Show, by Sol LeWitt, 1970 The instructions for LeWitt's drawings are executed by a skilled draftsperson who interprets the instructions during the drawing process.

CODE AND THE ARTS

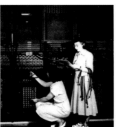

Beginning in the 1940s, code was developed to assist with work in the fields of science and engineering. Seymour Papert, a pioneer in researching computers and creativity, explains the situation at the time:

> The world was at war. Complex calculations had to be done under time pressures not normally felt by mathematicians: numerical calculations related to the design and use of weapons; logical manipulations to break ever more complex codes before information became old news....It's unlikely that they gave even a passing thought to making computers user-friendly to people with softer styles than theirs.[7]

The decisions made about computers and programming languages since that time have, along with other factors, hindered the synthesis of software and the arts. It's an unfortunate fact that many languages used within the arts were not originally designed for those areas. The software desires of designers, architects, and artists are often different from those of scientists, mathematicians, and engineers. The technical skill required to create visual form with the most dominant languages, such as C++ and Java, often takes years to acquire.

An alternative way of considering code is revealed through the work of artists who in the 1950s and 1960s began to experiment with software and themes related to software, such as dematerialization and system aesthetics. These explorations were first presented to the general public in the exhibition Cybernetic Serendipity, held at the Institute of Contemporary Arts in London in 1968; as well as in the shows Software—Information Technology: Its New Meaning for Art, held at the Jewish Museum in New York in 1970; and Information, held at the Museum of Modern Art (MoMA) in 1970. The curator of the Software exhibit, Jack Burnham, described the works on view as "art that is transactional in that they deal with underlying structures of communication and energy exchange."[8] Among the works on view, Hans Haacke's ambitious Visitor's Profile sought to reveal the elite social status of the museum's patrons as a form of critique of the art world. Using a computer interface, it tabulated personal information solicited from visitors. Les Levine exhibited Systems Burn-off X Residual Software, a collection of photographs discussed within the context of software. Levine claimed that images are hardware, and that information about the images is software. He wrote the provocative statement, "All activities which have no connection with object or material mass are the result of software."[9] Similar to Levine's piece, many of the works featured in the Information exhibition at MoMA were characterized as "conceptual art."

At the same time, artists and musicians—including Mel Bochner, John Cage, Allan Kaprow, Sol LeWitt, Yoko Ono, and La Monte Young—created a different type of conceptual and process-based art by writing instructions and creating diagrams as a form of art. For example, instead of physically making the drawings, LeWitt encoded his ideas as instructions that were used to produce drawings. He wrote a series of rules to define the task of a draftsperson, but the rules are open for interpretation; therefore many different results are possible. Ono's artworks, such as Cloud Piece, are instructions for life; each short text asks the reader to perform actions like laughing, drawing, sitting, or flying. Like programmers, these creators all wrote instructions for actions. Through their use of English as the programming language, they introduced ambiguity, interpretation, and even contradiction.

Simultaneous with these conceptually focused explorations, engineers were creating programming systems for the creation of visual images. In 1963 at Bell Laboratories, Kenneth C. Knowlton wrote BEFLIX, a specialized program for constructing animation, which he used

[7] Seymour Papert, The Children's Machine: Rethinking School in the Age of the Computer (New York: Basic Books, 1994), 157.

[8] Jack Burnham, Software—Information Technology: Its New Meaning for Art (New York: The Jewish Museum, 1970), 10.

[9] The New Media Reader (Cambridge, MA: MIT Press, 2003), 255.

```
CLOUD PIECE
Imagine the
clouds dripping.
Dig a hole in
your garden to
put them in.

1963 Spring
```

WHAT IS CODE?

Electronic Numerical Integrator And Computer (ENIAC), 1943–46
The first digital computers were very different from modern computers. ENIAC cost almost $500,000 and weighed over thirty tons. This U.S. Army photo shows two of the computer's programmers.

Cloud Piece, by Yoko Ono, 1963
Ono's artwork is the instructions. The reader imagines or performs the actions.

BASIC

```
10  DEFINT A-Z' DRAW100SQ
20  CLS
30  MOVE$="!AX"
40  DRW$="!AY"
50  OPEN "COM1:1200,0,7,1" AS #1
60  PRINT #1, "!AE";
70  FOR ROW=0 TO 90 STEP 10
80   FOR CLM=0 TO 90 STEP 10
90       GOSUB 310
100      PRINT #1, MOVE$+STR$(ROW)+STR$(CLM)
110      GOSUB 310
120      PRINT #1, DRW$+STR$(ROW+10)+STR$(CLM)
130      GOSUB 310
140      PRINT #1, DRW$+STR$(ROW+10)+STR$(CLM+10)
150      GOSUB 310
160      PRINT #1, DRW$+STR$(ROW)+STR$(CLM+10)
170      GOSUB 310
180      PRINT #1, DRW$+STR$(ROW)+STR$(CLM)+";"
190  NEXT CLM
200  NEXT ROW
210  PRINT
220  GOTO 70
230  '
240  '
250  '
260  '
270  'XON/XOFF subroutine
```

Hypertalk

```
on mouseUp
  put "100,100" into pos
  repeat with x = 1 to the number of card buttons
    set the location of card button x to pos
    add 15 to item 1 of pos
  end repeat
end mouseUp
```

BASIC, 1964
This program draws a
grid of 100 squares.
It demonstrates how
the BASIC language can
be used to control a

mechanical drawing arm
known as a plotter.

HyperTalk, 1987
The HyperTalk language
was written to be easy
for beginners. It is
more similar to English
than most other pro-
gramming languages.

to create early computer films in collaboration with artists Stan VanDerBeek and Lillian F. Schwartz. The computer-generated film, Permutations, was created in 1966 by John Whitney Sr. using GRAF, a programming library developed by Dr. Jack Citron of IBM. Both BEFLIX and GRAF were built on top of the language Fortran. From these and other early explorations, the development of programming languages written expressly for the arts has continued to gain momentum, building toward the current frenzy of activity.

In the 1980s, the proliferation of the personal computer allowed programming to reach a wider audience, which in turn led to the development of HyperTalk, a programming language for Apple's unique HyperCard application (an early hypermedia system). The related Lingo language was developed for the first release of Adobe Director in 1988 (formerly Macromedia Director, and before that MacroMind Director). Lingo was the first programming language used by many designers and artists in the era leading up to the development of the World Wide Web in the early 1990s. The early days of the web fostered intense graphic programming exploration, primarily channeled through the ActionScript language. The rise of programming literacy within the arts and architecture communities has led to the current proliferation of programming options; many are featured within this book.

The influence of code is not limited to the screen and projected image. It is also felt in physical space. Code is used to control elements of products, architecture, and installations. It is used to create files that are output as prints and made physical through computer-controlled machines that cut and assemble materials, including wood, metal, and plastic. Code is rapidly moving outside the boundaries of the screen and is starting to control more aspects of the physical world. There are examples of this in the Producing Form section of "Form and Computers" (p. 37), as well as throughout this book.

WHAT IS CODE?

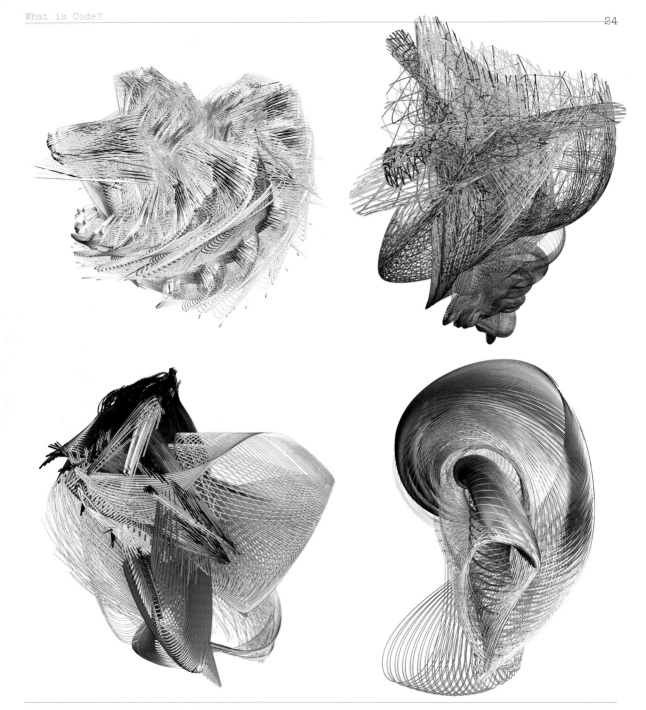

Strand Tower,
by Testa & Weiser,
Architects, 2006
Strand Tower precursors
were generated using a
purpose-built software (Weaver) and coded
through an iterative
templating process.
Specific fiber behav-
iors or traits such
as fraying, bundling, knitting, and bias
patterning are coded
into the design. Fiber
agency and affiliation
is more informal and
multidimensional than conventional woven
patterns.

WHY CODE?

The use of software in the arts can be separated into two categories: production and conception. In the first category, the computer is used to produce a preconceived form; in the second, the computer participates in the development of the form. Within the context of this book, we're primarily interested in the latter. (It is important to note that this distinction does not imply a value judgment but does impact the types of forms that are created.)

Using the computer to reduce the amount of time needed to create a complex, repetitive composition was often the motivation for the early adoption of software and its integration into the creative process. This was especially important in the field of animation, where subtle changes had to be repeated thousands of times to create the illusion of motion; however, this alluring technical benefit has had a profound effect. If initial production takes one-tenth the time that it would take to execute the work by hand, then the artist can create ten versions in the same amount of time. This way, many versions can be created and the best chosen. Efficiency facilitates the creative process by enabling more time for exploration as less time is needed for the final production. Eventually the computer came to be understood as more than just a production tool. People started to see it as, in the words of computer graphics pioneer A. Michael Noll, "an intellectual and active creative partner that, when fully exploited, could be used to produce wholly new art forms and possibly new aesthetic experiences."[10]

Often, to realize a new or unique vision requires that artists and designers exceed the limitations of existing tools. Proprietary software products are general tools designed for the production of specific types of forms. If you are already using software for your work, why constrain yourself to the expectations of a software company or another programmer? To go beyond these limitations, it is necessary to customize existing applications through programming or to write your own software.

Each existing form of media—whether drawing, printing, or television—is capable of assuming new qualities of expression. For example, video games demonstrate many of the distinct characteristics of software. If you've ever succumbed to the pleasures of a great game (we know some of you have; if you haven't, then what are you waiting for?), you already know that the emotions experienced while playing are different than those felt while watching a film or looking at a drawing. Games can be physically engrossing and socially engaging, and they can sustain intense fascination over a period of months.

In reference to the emerging media of his time, theorist Marshall McLuhan wrote, "Today we're beginning to realize that the new media aren't just mechanical gimmicks for creating worlds of illusion, but new languages with new and unique powers of expression."[11] Writing code is one gateway for realizing these new forms. Learning to program and to engage the computer more directly with code opens the possibility of not only creating tools, but also systems, environments, and entirely new modes of expression. It is here that the computer ceases to be a tool and instead becomes a medium. We hope the following chapters will provide evidence for you to draw your own conclusions about the potential of software in the visual arts.

[10] Jasia Reichardt, Cybernetics, Art, and Ideas (New York: New York Graphic Society, 1971), 143.

[11] Edmund Snow Carpenter and Marshall McLuhan, Explorations in Communication: An Anthology (Boston, MA: Beacon Press, 1960), 2.

Computers

form have a

history nea

old as the c

puter itself

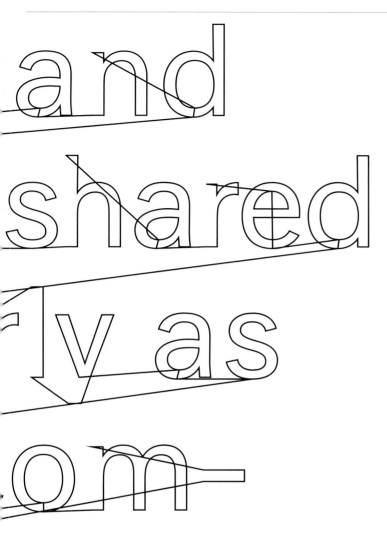

Even before the advent of the modern personal computer in the late 1970s, "computing machines" were used by designers in the aerospace and automotive industries to perform complex calculations, and by scientists to develop intricate simulations of the physical world. The advantages initially offered by computers came in the form of efficiency and precision. Exploring new possibilities was not a priority; more importantly, they were used to perform calculations in a fraction of the time. The efficiency offered by the computer extended to the production of technical blueprints and allowed complex geometric drawings to be created far more quickly than with conventional techniques. Today, computers are still used as accurate drafting machines, but new ways of using them have opened new territories.

FORM AND COMPUTERS

These letters convey the way computers interpret and display typography as a series of points, lines, and curves. For example, Adobe's PostScript language renders typography with three commands: moveTo, lineTo, and curveTo. To create this typeface, the moveTo command was removed, rendering the letters as a continuous line.

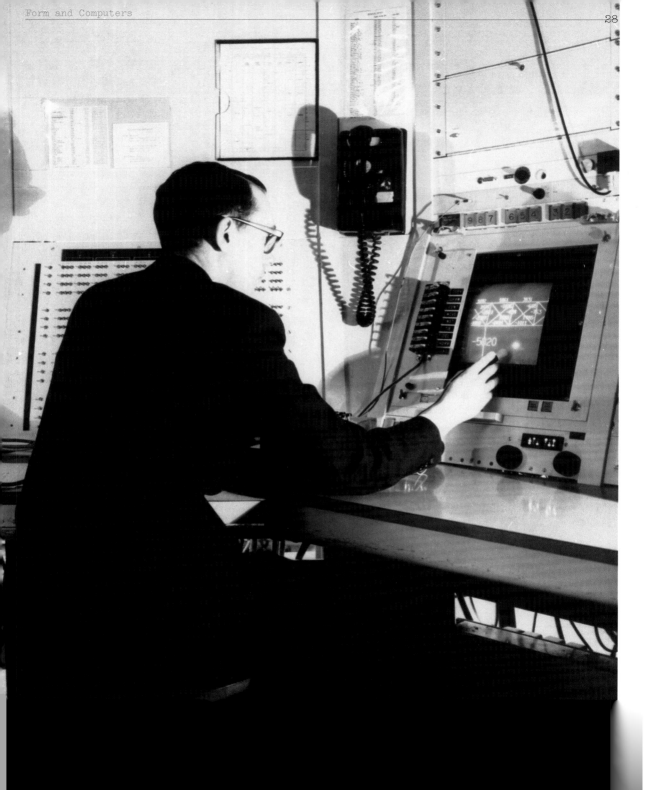

DRAWING WITH COMPUTERS

[1] Jasia Reichardt, Cybernetic Serendipity: The Computer and the Arts (New York: Praeger, 1969), 67.

[2] William John Mitchell and Malcolm McCullough, Digital Design Media: A Handbook for Architects and Design Professionals (New York: John Wiley & Sons Inc., 1991), 129.

[3] Christopher Woodward and Jaki Howes, Computing in Architectural Practice (London: Spon Press, 1998), 92.

In 1963, Ivan Sutherland pioneered the graphical user interface (GUI) with his Sketchpad; this initiated a paradigm shift in how people interacted with computers. Sketchpad's interface consisted of a set of switches and dials, a display, and a light pen—a device used to draw directly on the screen. By pressing switches on a control panel while drawing, the user was able to instruct the computer to interpret the movement of the pen in different ways. Each time the pen touched the screen, a new line was added between the last point and the new one. In this way, the user could draw simple polygons. Another switch was for drawing circles, and another for arcs, etc.; this allowed for fairly sophisticated drawing. Sketchpad gave designers a way to directly manipulate objects on screen without having to first write a numerical, code-based representation of those objects. After the objects were made, they could be duplicated, moved, scaled, and rotated to create new compositions.

Sketchpad was much more than a crude analog of paper and pen; it was a fundamentally new way to design. When drawing in Sketchpad, the designer could make use of constraints in order to form new relationships between elements and to force them to behave in specific ways, for example: snapping the end points of line segments to other end points or lines, keeping lines parallel, or forcing them to have the same length. The user could also create more sophisticated constraints, for example: a constraint could be designed to simulate the load-bearing properties of a bridge.

With the first computer-aided design (CAD) systems, Sutherland's innovations left the lab and entered industry. The software used within the fields of engineering and architecture lacked many of his innovations and served as little more than an analog for pen and paper. They allowed designers to draw using mathematical lines and curves rather than T-squares, drawing boards, and pencils. These "high-powered drafting machines" were hailed for their efficiency, speed, and productivity.[1] Drawings that would have taken days could now be done in hours.

Even in this capacity, drawings made on the computer were considered a poor substitute for hand-drawn sketches and diagrams. Some people felt that the drawings produced by CAD machines were cold and overly technical, preferring the "slightly wobbly line work and imprecise endings of hand-drawn lines."[2] There were other obstacles to integrating CAD systems into industry. Some felt that they presented a new temptation—to never stop editing a drawing or set of plans; others believed that there were too many assumptions in the software that restricted the design possibilities.[3] As a result of these and other problems, computers were considered insufficient for the conceptual stage of design and were often used only at the end of the creative process. The advantages focused primarily on saving the designer's time and increasing productivity.

Within the design industry, however, the field that has been most profoundly transformed by the use of computers is graphic design. The proliferation of the personal computer—and, later on, the laser printer—laid the foundation for desktop publishing. Apple's LaserWriter could reproduce typography and images at much higher resolutions than previous home and small-business printing technologies. Perhaps more importantly, the LaserWriter included PostScript, which made it possible to use a wide array of fonts in the design, because they were now treated as software as opposed to physical metal type or transferrable lettering. This opened the door for designers to create and distribute their own typefaces and to have more control over the final typesetting. These technologies enabled vibrant activity and widespread innovation within the field of visual design in the 1980s and 1990s, ranging from the fonts of

FORM AND COMPUTERS

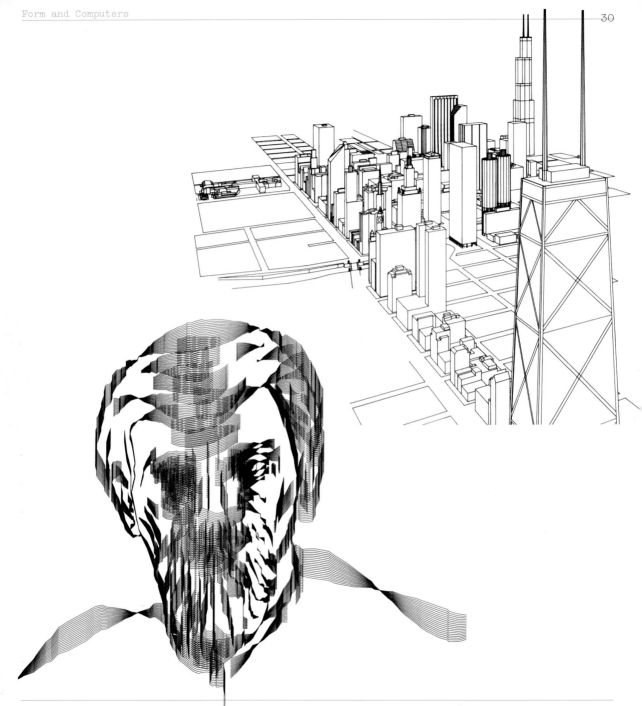

Sine Curve Man,
by Charles A. Csuri,
1967
The geometry for this
plotter drawing was
created by distorting
an image of a face
using the values of a
sine wave. Like much of
Csuri's work, code was
manipulated to create
an abstraction of the
human form.

Chicago,
by Skidmore, Owings &
Merrill (SOM), 1980
With the rise in com-
puting power and the
increasing sophistica-
tion of CAD software,
it became possible to
model entire cities.
SOM created a wireframe
model of downtown
Chicago to give viewers
a feel for the city's
form and massing of
buildings.

Emigre and FUSE, to the radical work of April Greiman, David Carson, and many others.

With PostScript solidifying its place as the de facto standard, Adobe introduced Illustrator as its new visual development tool. With Illustrator, anyone could draw and lay out text and graphics without having to know the intricacies of the PostScript language. Eventually Illustrator, along with Adobe's Photoshop and InDesign applications, became nearly ubiquitous among graphic designers. Interestingly, all three of these applications have introduced scripting languages in recent years that allow users to extend the tools by writing code.

Following the birth of the Internet and other networking technologies, the computer increasingly became a tool for collaboration. Global computer networks called into question the need for centralized offices, in favor of an organization consisting of individuals spread around the globe. This has had a massive impact on the open-source software movement, where large and sophisticated applications are often built by a loose collection of individuals united by a shared interest. These new ways of working also had an impact on the way forms were created. In a distributed environment, different individuals work simultaneously on different parts of the same piece, seeing the whole only after the parts are stitched back together.

Having begun to represent objects and, with the aid of Sketchpad, relationships and behaviors, the real potential for the role of computers in design started to assert itself. If computers could be used to model what we know, then perhaps we could also use them to simulate what we don't know. French architect and philosopher Bernard Cache summed up the history of CAD systems by saying they "have certainly increased the productivity of the idea, but fundamentally they offer no advances over the work done by hand. Now, we can envisage second-generation systems in which objects are no longer designed but calculated."[4]

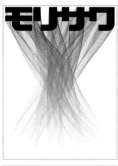

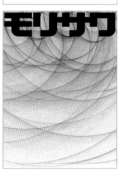

[4] Bernard Cache, Earth Moves: The Furnishing of Territories (Writing Architecture) (Cambridge, MA: MIT Press, 1995), 88.

FORM AND COMPUTERS

Morisawa Posters, by John Maeda, 1996 Rather than rely on existing software tools, Maeda wrote his own code to manipulate typographic form. This allowed him to explore a unique graphic language for the ten posters he created for Morisawa. Each poster performs an algorithm to transform the logo of the company.

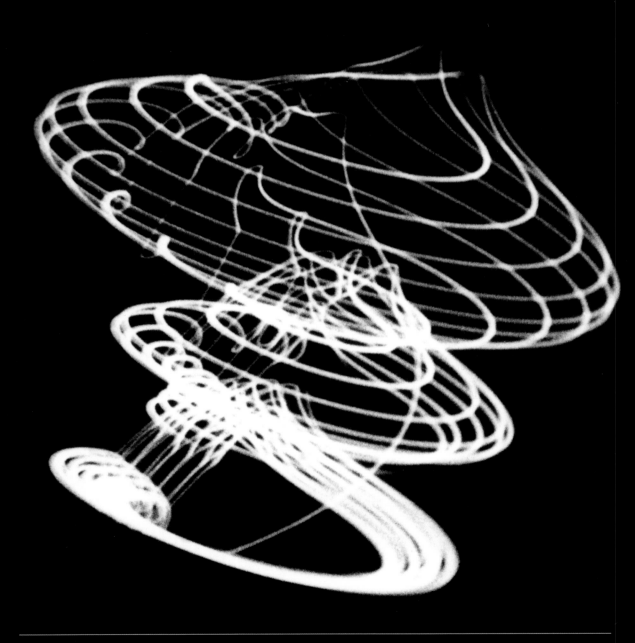

Electronic Abstraction 6,
by Ben F. Laposky, 1952
Laposky used an oscillo-
scope—a technical device
for viewing changes in
voltage—to produce his
abstract images.

Starting in the early
1950s, he refined a
process of modulating
electronic waveforms
to produce stunning and
diverse images.

CONTROLLING FORM

Understanding the ways that code is used in the production and creation of form requires a general knowledge of how form is manipulated by the computer. Outside the computer, form itself is physical and intuitive—it is the curve of a line on a page, the texture of paint, or the slope of a hillside. To manipulate form in the world, we don't need to understand the mathematics behind how things are put together, and we can specify where things are in relative terms, like "over there" or "next to me." If a piece of clay is close enough to touch, then it can be directly molded and shaped. In contrast, computers rely on the ability to specify everything in numerical terms.

COORDINATES

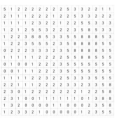

The computer needs to know the position of every mark it draws, either on the screen or with a printer. To do this, we typically use Cartesian coordinates. If you imagine laying a large piece of graph paper over the screen, an x-axis runs from left to right, and a y-axis goes from top to bottom. These axes allow us to specify a precise position on the grid using a pair of numbers, normally the x-value followed by the y-value. For example, a point at (5, 10) is 5 lines from the left edge of the screen, and 10 lines down from the top.

SHAPE

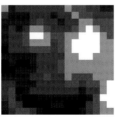

Placing a piece of graph paper on the screen is more than just a metaphor. The screen is, in fact, composed of a grid of points called pixels. One way to draw a form on-screen is to lay the grid of pixels over an image of the form and measure the color value at each pixel in the grid. This method of representing an image makes what is called a raster image.

A raster image, which is sometimes referred to as a bitmap, is a complete description of what is shown on-screen at a given resolution. Resolution refers to how many points make up an image for a given physical size. If an image has a resolution of 800 × 600 pixels, there is a total of 480,000 pixels in the image, therefore requiring 480,000 numbers, with each one representing the color of one pixel. Resolution can be thought of as an image composed of tiles. There are two ways to make a tiled image look better: make the tiles smaller or move farther away from the image. On a computer, the two are related. Since the screen has a set size, lowering the resolution is like increasing the size of the tiles; alternately, you can keep the screen resolution constant and make the image smaller on-screen.

As explained earlier, an image's form, color, and shape must be converted to numbers in order for it to be useable on a computer. As a result, these qualities often lose the continuity that we have become accustomed to in the world. Every image on the computer has a resolution, or a width-by-height measurement, in pixels, but how many pixels are enough? The ever-increasing number of megapixels available in digital cameras and the popularity of high-definition television (HDTV) suggest that there are never enough.

A megapixel is one million pixels. It refers to the total number of pixels in an image. In other words, the width of the image in pixels is multiplied by the height of the image in pixels so that an image measuring 2,048 by 1,536 is said to have 3.1 megapixels (2,048 × 1,536 = 3,145,728). Our eyes see a continuous analog stream of colors. The best we can do to represent that digitally is to increase the resolution to fool the eye into thinking that the image is continuous. But the fact remains that this is just a simulation, and it requires a lot of processing and memory to store enough information for the illusion to hold.

Raster graphics are an ideal way to store and manipulate photographic imagery, but they suffer from the confines of the resolution at which they are created. If we scale a bitmap image up to make it larger, the blocks of color must also be enlarged. This makes raster graphics a less than ideal way

Coordinates
Most computer graphics use a square grid with a horizontal x-axis and a vertical y-axis. An additional x-axis is used to draw 3-D forms.

Raster
A raster is a grid of pixels. The color of each pixel is controlled to create an image.

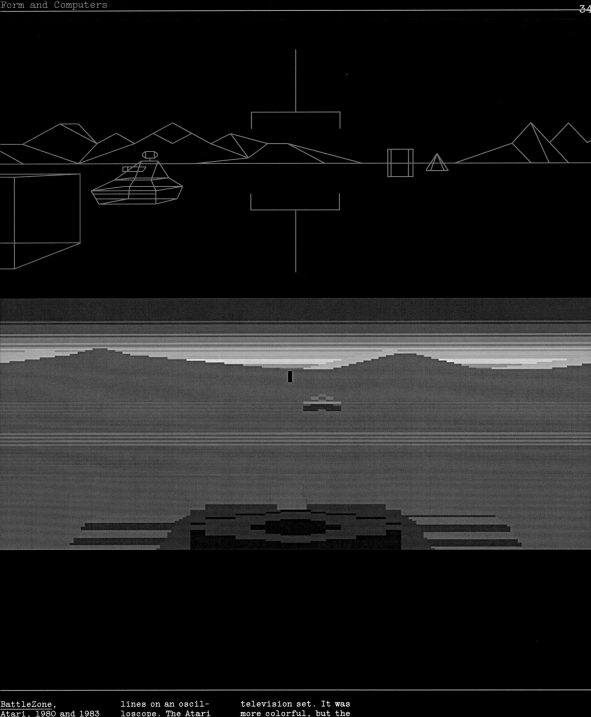

BattleZone,
Atari, 1980 and 1983

lines on an oscil-
loscope. The Atari

television set. It was
more colorful, but the

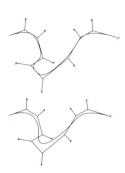

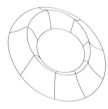

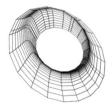

to store drafting or drawing information that often needs to be moved, scale, rotated, and reworked. For this, there are vector graphics.

Vectors graphics use the same Cartesian grid as bitmaps, but instead of storing the value for every pixel in the image, they store a list of equations that define the image. This is ideal for drafting and precision drawing, where any shape available to geometry—lines, circles, rectangles, and curves—can be combined to create a composition. Because the forms are described using geometric equations, they can be scaled and transformed easily and without losing detail. The scalable nature of vector graphics makes them an essential element in the production of printed matter. A printer may have a resolution many times greater than that of a monitor, and without vector graphics it would be very difficult to create smooth lines and crisp type. Furthermore, fabrication technologies, such as laser cutting and computer numerical controlled (CNC) milling rely on the detail and precision offered by vectors.

Objects in three-dimensional modeling software, such as Rhinoceros and Autodesk Maya, are commonly represented using vectors. In addition to the two-dimensional curves, points, and lines we are familiar with, these applications allow designers to create a number of different objects, such as meshes, NURBS (Non-Uniform Rational B-Splines), and subdivision surfaces.

COLOR

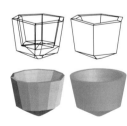

Unlike paint, color on-screen is additive, meaning that the more colors you add together, the closer you get to white. Additive color systems use the primary colors red, green, and blue to create the colors we see on-screen. The common 24-bit color depth allows each base color to be assigned a value from 0 to 255, giving a total of 16,777,216 possible colors—that's more than can be distinguished by the naked eye. For example, pure yellow has a red value of 255, a green value of 255, and a blue value of 0.

Light brown has a red value of 140, a green value of 98, and a blue value of 0. Changing this blue value to 255 produces an electric purple.

REALISM

Like the history of European painting until the end of the nineteenth century, the history of computer graphics has prioritized a realistic depiction of the natural world. The bridge between the crude wireframe engineering models produced in the 1960s and the naturalistic form, lighting, and textures of today's rendering tools has spanned over thirty years of focused research. (This transition can be traced, in part, using the dates of the work included in this book.) One of the first effects mastered was the illusion of a third dimension rendered on a flat screen. After that came the hidden-surface algorithm for hiding the lines at the back of a model and making it appear solid rather than composed of wire. Similar to how shading in a pencil drawing helps produce depth and continuity, shading algorithms were developed to create the appearance of smooth surfaces from the hard edges of flat polygon models. Over time, new and better techniques were developed to accurately depict textures and, more importantly, light reflecting off surfaces. Beyond these algorithms, a mathematical model of a camera is at the core of most rendered software images. The parameters of these models imitate those of real lenses, such as focal length, field of view, and aperture. When the image is rendered, the calculated lens optics determines how near or distant the objects appear and distorts the geometry to create perspective. The development of ever-more-realistic rendering techniques continues, but in recent years there's been a renewed interest in non-photorealistic rendering. These techniques make geometric models look as if they were painted or built from clay.

FORM AND COMPUTERS

Splines
A spline is a type of curve, with a shape defined by the position of control vertices. Splines have a dimensionality that affects

how close the curve fits to each vertex.

Advanced Geometry
Surfaces can be mathematically defined in a number of different ways. A triangle mesh is a set of connected triangles; NURBS are

smooth surfaces created with splines; and subdivision surfaces use recursion to make a fine mesh to represent curvature.

Toward realism
The history of algorithms in computer graphics follows a path toward realism, from coarse outlines to smooth, solid surfaces.

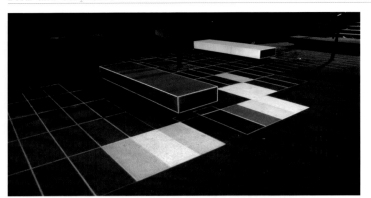

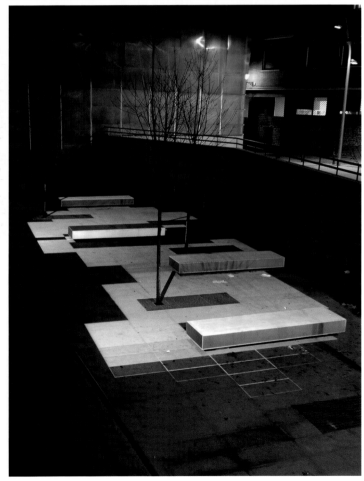

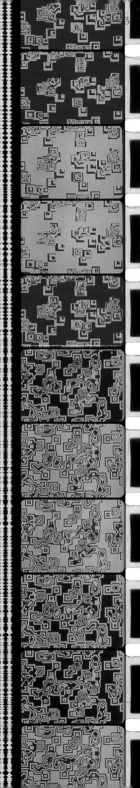

Entramado,
by Pablo Valbuena, 2008
Valbuena combines
virtual 3-D models
with precisely placed
projectors to augment
physical space with
a closely choreographed
sequence of light,
which appears to follow
and modify the space
itself.

Pixillation,
by Lillian Schwartz,
1970
Schwartz worked with
Ken Knowlton at Bell
Labs to produce the
computer-generated
sequences of this
abstract film.

PRODUCING FORM

An important aspect of the relationship between form and code is how the abstract, immaterial, and imperceptible world of code comes into contact with our senses. Understanding how color is represented is a part of this relationship, but there are other processes by which the numerical representation of form can be transformed into something that we can perceive, such as light, pigment, or material structure.

LIGHT

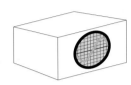

Long before the ubiquity of full-color displays, the oscilloscope served as the primary device for real-time visual output from the computer. Despite its low-quality monochrome image, systems like Sketchpad and early video games made excellent use of this device.

The full-color cathode ray tube (CRT) in the form of the television was targeted as the primary display device for early home video game systems, such as ColecoVision and the Atari 2600. The CRT consists of an electron gun and fluorescent screen enclosed in a vacuum tube. The gun fires electrons at the screen in a left-to-right, top-to-bottom pattern. When the electrons strike the screen, the fluorescent material glows. As a result of this process, the images on CRT screens have a very distinctive appearance.

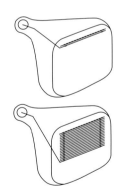

The invention of the framebuffer was crucial to the widespread use of the full-color CRT, and to computer graphics as a whole, opening the door for digital painting programs, photo manipulation, and texturing. First developed at Xerox Palo Alto Research Center (now called PARC Inc.) in 1972, the framebuffer stored the entire contents of the screen in memory. Prior to this, only vector graphics could be drawn on-screen, because it was impossible to manage the amount of memory necessary to work with rasterized images.

Increasingly, the most common computer displays in use today are liquid crystal displays (LCD). LCDs have numerous advantages over the CRT. They use less power and are smaller, which makes them ideal for mobile computing. They can also update their image faster to provide a more vivid experience. Because LCDs can be made in a range of sizes, from the handheld to a large television, they can be used to create both intimate and public experiences. In addition, they can be modified to make touch screens and to provide physical feedback.

Modern digital projectors allow content to be seen by a large group of people at once. Beyond this basic use, projectors offer a way to immerse the viewer in imagery, augment a physical space, or create nonstandard display shapes such as circles. The front-projection setup, where the image is projected onto the front side of a screen, is the most common. A rear-projection setup, with the image projected onto the back of a semitransparent screen, is a good way to allow viewers to approach the image without worrying about casting shadows or otherwise interfering with the image.

Appearing in everything from key chains to coffee makers to animated billboards; light-emitting diodes (LEDs) are a staple of contemporary everyday life. An LED is an electronic component that creates light when a current is applied to it. Compared to traditional means of generating light, LEDs are far more energy efficient and last longer. In the context of form making, they are interesting for their highly variable appearance and small size. It is possible to create displays of nearly any size or shape by piecing a large number of LEDs together. In this way, each LED can act as a pixel in a raster display. These custom displays are then controlled using hardware and software that make them behave like traditional screens.

<div style="writing-mode: vertical">FORM AND COMPUTERS</div>

Oscilloscope
Oscilloscopes use voltages to control the movement of an electron beam. The movement from left to right is sometimes fixed to a clock,

while the movement up and down is controlled by an electrical signal. This setup makes it easy to visualize regular signals like sine waves.

Cathode ray tube (CRT)
Electrons are fired through a vacuum tube at a phosphorescent screen, causing it to glow on impact. In raster displays, the

beam moves from left to right, top to bottom.

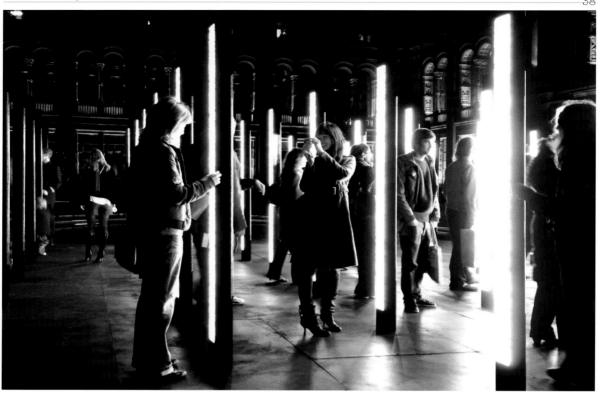

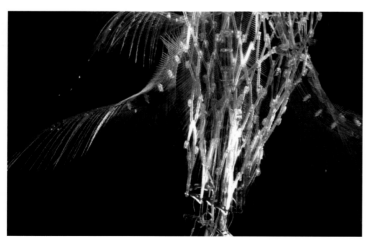

Volume,
by United Visual
Artists, 2006
This light and sound
sculpture is composed
of a series of custom-

designed LED columns
that respond to the
motion of viewers.

Hylozoic Grove,
by Philip Beesley, 2008
Beesley used a laser
cutter to create two
different types of form
for this sculpture.

The structure and
mechanisms were cut
from rigid plastics;
while light, flexible
plastics were used to

create the delicate
featherlike elements.

PRINTING

In the early days of computer graphics, images were printed on paper using a plotter in order to make the details, which appeared vague on the extremely limited displays, appear clear. A plotter is a machine that moves a pen over a drawing surface. The pen is given commands to control the direction and speed of movement, making it possible to vary the quality of the lines. By changing the material of the drawing surface or swapping the pen for a pencil, brush, or other drawing instrument, many interesting results have been created.

In the mid-1980s, the first laser printers designed for home use began to appear. Laser printers use a combination of electric charge and focused light to fuse toner to paper. This technique allows them to print 300 dots per inch (dpi), which is considerably higher than the 72 dpi available with the common dot matrix printer.

Though laser printers excel at printing on paper, the invention of the inkjet printer expanded the range of possible mediums and inks available. The basic spray-nozzle design of the inkjet is so flexible that it is now possible to print on diverse types of paper, plastic, and fabric. Even entire circuit boards can be "printed" using conductive ink.

FABRICATION

Fabrication is a catchall term used to describe a host of new technologies that are capable of producing physical objects out of digital representations. In a far more drastic way than printers and screens, various fabrication techniques are used for vastly different purposes and require new ways of thinking about code, space, and structure. The most common and straightforward fabrication tool is the laser cutter, which is mechanically similar to a plotter, except that a laser, rather than a pen, is positioned on an arm that can move in two dimensions. The computer moves the laser along the x- and y-axis of the bed to cut the material. Often, laser cutters have restrictions on the size, thickness, and type of material that can be cut. In addition to movement in two directions, the power of the laser cutter can be adjusted to etch metal and create intricate burn patterns on wood. Though laser cutters are limited to working in two dimensions, many architects, designers, and sculptors have found inventive ways to cut sections (similar to topographic maps) that are then reassembled to create intricate 3-D objects.

CNC milling, Selective Laser Sintering (SLS), stereolithography, and 3-D printing are just a few of the ways to create fully three-dimensional objects; that is, objects whose representations on the computer screen include information for x, y, and z axes, which are used to control the output device. A CNC-milling machine is similar to a plotter or laser cutter, but with the added flexibility of a continuous up-and-down motion. For example, a router bit is moved over a block of material, and as the bit moves, it cuts away a small amount of material, leaving behind a sculpted surface. In a three-axis machine, the router bit can only move directly up-and-down, making it difficult to sculpt objects from all sides. Some machines mount the block of material on a lathe, which rotates the surface facing the bit in order to provide additional flexibility.

CNC milling is a subtractive process; that is, material is cut away from a larger block in order to create the object. In contrast, SLS, 3-D printing, and stereolithography are additive processes that build up the final object by adding or fusing material together. Additive techniques have the distinct advantage of being able to create hollow spaces, undercuts, and overhangs, which are difficult to do using a three-axis CNC machine.

In a 3-D printer, a model is created by layering and fusing successive cross sections of material. Layers of powdered material, such as plaster, resin, or even cornstarch or sugars, are deposited and then selectively fused together by

FORM AND COMPUTERS

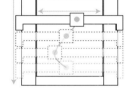

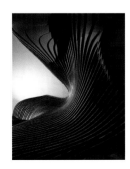

Plotter
Plotters work by moving a drawing implement, typically a pen or brush, over a surface to control its horizontal and vertical positions with two motors. A similar mechanism is used in laser cutters and CNC-milling machines.

Cirrus 2008, by Zaha Hadid Architects, 2008 This sculptural seat, built by Associated Fabrication, is made of milled sheets of Formica and medium density fiberboard.

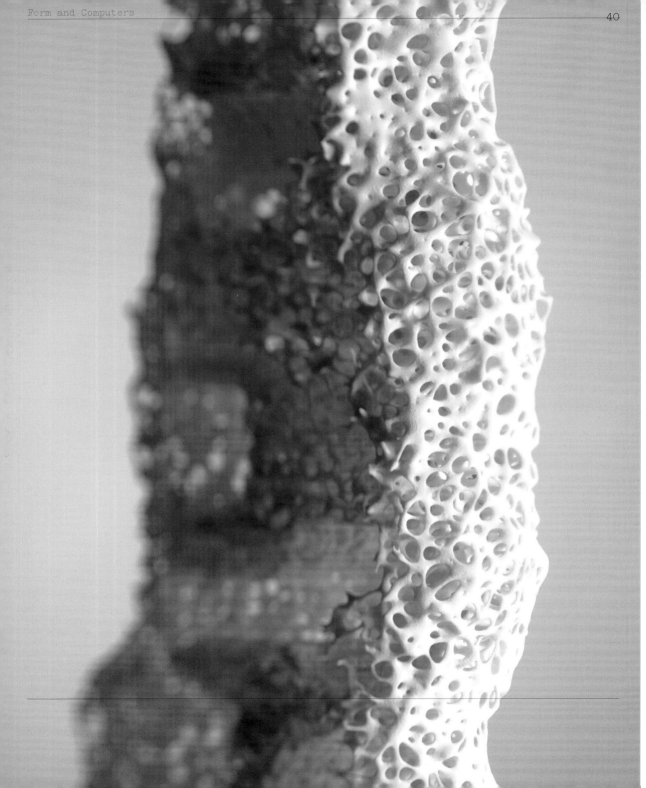

"printing" an adhesive from an ink-jet-like printer head. After the model is complete, it is excavated from the excess powder, which is then recycled for the next model. Stereolithography and SLS both employ variations of this additive technique. In stereolithography, thin layers of a photopolymer resin are deposited and then cured with an ultraviolet laser to harden the areas where it is focused. Once all of the layers are complete, the remaining liquid is drained and the model undergoes additional curing in ultraviolet light. SLS combines ideas from both 3-D printing and stereolithography. Thin layers of powder are deposited and then fused together using a laser to build the model layer by layer. A distinct advantage of SLS is the wide variety of materials that can be used, including nylon, ceramics, plastic, and metals, making it possible to quickly create prototypes of working machine parts.

Ecorché structurel, by R&Sie(n)+D, 2008 R&Sie(n)+D imagine possible future worlds and ways of living. This SLS 3-D-printed model is described by its creators as, "The cells were no longer enclosures to protect from the outside...[but]'habitable networks, woven space,' an exfoliation of constantly reconfigured habitable organisms."

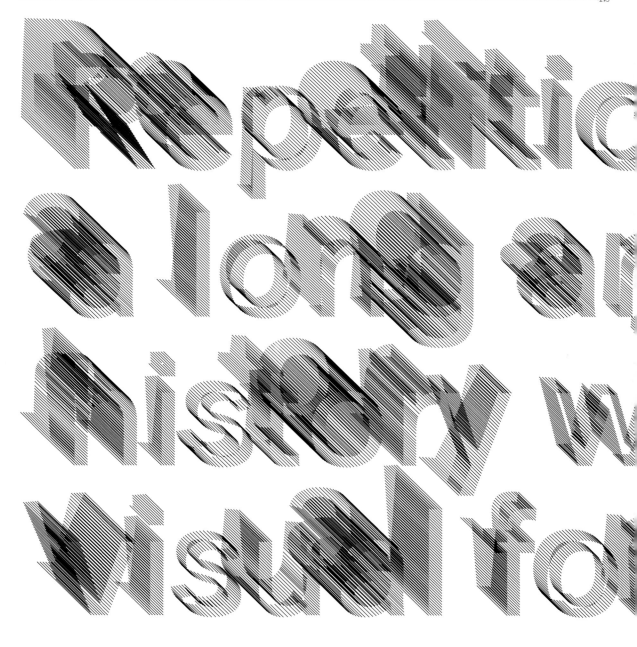

Repetition petition
a long as
history w
visual fou

Printing technologies are an obvious example. Woodblock reproductions, etchings, and lithographs have all transformed image distribution. As a precursor to computers, the Jacquard loom (invented in 1801) used punch cards to store weaving instructions. These cards guided the machine to weave the same pattern repeatedly. Jacquard's punch cards inspired early computing devices, such as Charles Babbage's Analytical Engine. Today, digital computers are exceptional machines for creating repetition; their state can change over two billion times per second—2 GHz—to perform accurate, reliable calculations.

REPEAT

These letters are composed of a series of lines drawn backward in space, from interpolated points drawn along the outline of each character. The depth of each line was set by an oscillating sine wave. Although this depth increases or decreases only slightly from one point to the next, the order in which the points were originally drawn produces a unique optical effect, while accentuating the anatomy of the original letters.

Here to There,
by Emily Gobeille and
Theodore Watson, 2008
This series of large-
format posters combines
natural and algorithmic
forms that balance hand
illustration with gen-
erated pattern. A suite
of software tools serve
as building blocks for
telling visual stories.
Programmed elements
are mixed with hand-
illustrated forms to
create engaging hybrid
worlds.

Repetition is deeply embedded into the language of computing and therefore intrinsic to the way people are taught to program. For example, a common early program for learning the BASIC language would fill the screen by reproducing the same text over and over:

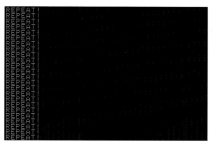

```
10 PRINT "REPEAT!"
20 GOTO 10
```

A slight modification opened new paths for exploration:

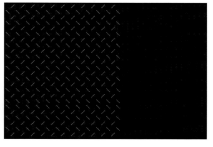

```
10 PRINT "\ \ \ \ \ \ \ \ \ \ \ \ \ \ \"
20 PRINT " / / / / / / / / / / / / / /"
30 GOTO 10
```

Twenty years ago, a simple moving pattern of letters often provided sufficient motivation to encourage further explorations in programming. Users were attracted to the minimal input of a two-line program and its corresponding output of symbols moving continuously down screen. Programs like these were usually written by hobbyists as well as by children that were first learning how to use computers. Today, most computer users never learn how to program and therefore never feel the thrill of directly controlling a computer. Regardless, repetition is still an inherent part of code, and it continues to be a source of motivation to learn and explore this space of limitless variation.

REPEAT

ASDFG,
jodi.org, 1997
ASDFG is a frenetic
cacophony of flash-
ing, scanning, and
reloading text in a
web browser. It is
structured as a set of
folders embedded in
folders, zooming in on
the naming limits of
the server's operating
system. The result is
seen in the navigation
toolbar, not long
enough to display the
full lengths of the
paths. Looking at the
growing browser his-
tory, ASDFG unfolds
an ASCII path of
titles that reflect
the on-screen
randomness.

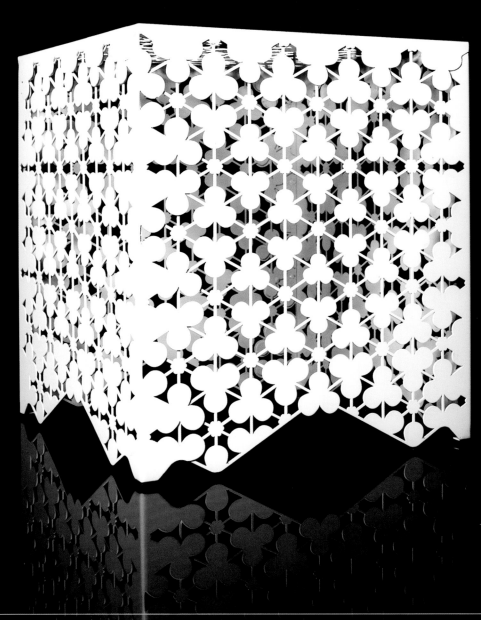

Arktura Ricami Stool,
by Elena Manferdini,
2008
The intricate laser-
cut pattern in this
metal stool makes it
appear delicate in
contrast to its actual
strength. The machine
that cut the metal
used software to con-
trol the position and
strength of a laser,
based on Manferdini's
original digital
pattern.

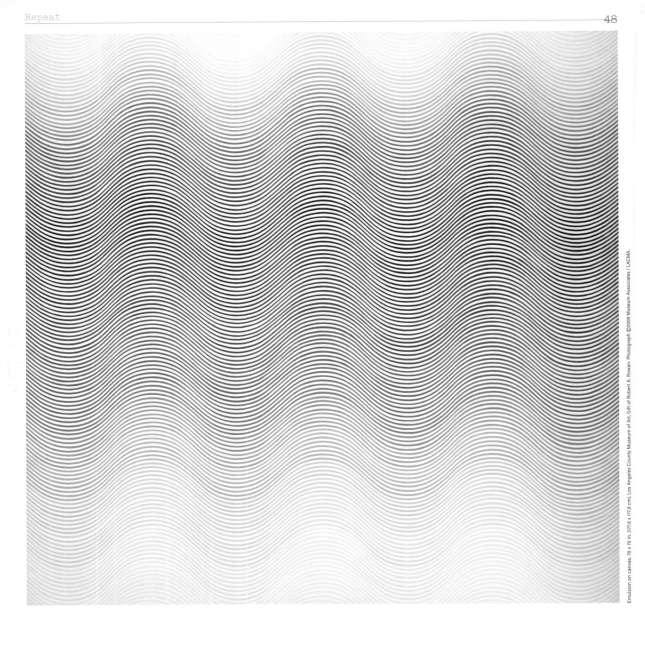

Emulsion on canvas, 70 x 70 in. (177.8 x 177.8 cm), Los Angeles County Museum of Art, Gift of Robert A. Rowan, Photograph ©2009 Museum Associates / LACMA.

Polarity,
by Bridget Riley, 1964
Riley's paintings use
repetition and contrast
to produce subtle, dis-
orienting effects on
the viewer.

QUALITIES OF REPETITION

Repetition can have a powerful effect on the human body and psyche. One of the most extreme examples is the way a rapidly flashing light can trigger a seizure. A more universal example is how the beat of a good song will inspire people to dance along. In a similar way, dynamic visual patterns can appear, in subtle ways, to vibrate physically.

Within the visual realm, repetition encourages our eyes to dance. Controlling repetition is a way to choreograph human eye movement. There are many examples of artworks that modulate repetition to create strong sensations of depth and motion. Optical art (often shortened to "op art") is a term used since the early 1960s to describe artworks that induce retinal phenomena, including vibration, flashing, swelling, and warping. Pioneers within this movement include Yaacov Agam, Richard Anuszkiewicz, Bridget Riley, Jesús Rafael Soto, and Victor Vasarely. Though their works were created without the aid of computers, many of them relied on the use of algorithms. For example, Vasarely made preliminary drawings called programmations, in which he explored variations with a modular color system of six hues, each with twelve variations. Instead of using a computer to implement his programs, Vasarely employed assistants that painstakingly followed his instructions to construct the works.

During the same period that witnessed the rise of op art, Andy Warhol used repetition in a completely different way. Instead of inducing physical affects within the human eye, he worked with repetitive images in mass media, creating portraits of iconic celebrities such as Marilyn Monroe, Jacqueline Kennedy, and Elvis Presley by silk-screening a single image many times within the same painting. Through repetition, the image lost its relation to its subject and became a product rather than a portrait.

Beyond visual repetition, setting rhythms in time can have strong, palpable effects. Repetition has always been an important part of music. From classical to contemporary jazz, the repetition of musical phrases within a larger composition is integral. Martin Wattenberg's The Shape of Song software visualizes repetition in music; it's fascinating to see the difference in complexity between Madonna's "Like A Prayer" and Frédéric Chopin's Mazurka in F#.

Repetition can also be an important component within time-based works such as video, animation, and live software. In this capacity, repetition becomes a form of rhythm. The thresholds of rhythm were explored by artist Tony Conrad in the experimental film The Flicker from 1965. This work was made using only plain black and white frames; the film's structure is formed by the number of black frames shown before flipping to white, and vice versa. Conrad pushed the limits of perception by alternating between clear and colored frames—up to twenty-four frames per second (the speed at which film is pulled through a projector). The contemporary performance work Modell 5, by Granular-Synthesis (Kurt Hentschläger & Ulf Langheinrich), builds on this technique by combining image and audio elements into a striking sensorial assault. Without manipulating individual video frames, they transform the repeated image of the performer's face into a writhing posthuman machine by re-sequencing the frames alongside the audio slices that correspond to each image. These works, and many others by contemporary audio-visual artists, explore perception through subtle and violent acts of repetition.

REPEAT

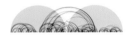

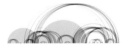

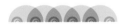

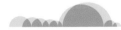

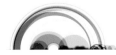

Shape of Song, by Martin Wattenberg, 2002 This visualization depicts musical passages as arches. Each arch connects identical passages within the composition to expose the patterns that unfold in time as a single image. From top to bottom, these compositions shown are: one of the Goldberg Variations by Johann Sebastian Bach, Frédéric Chopin's Mazurka in F#, the folk song "Clementine," Philip Glass's "Candyman II," and Madonna's "Like A Prayer."

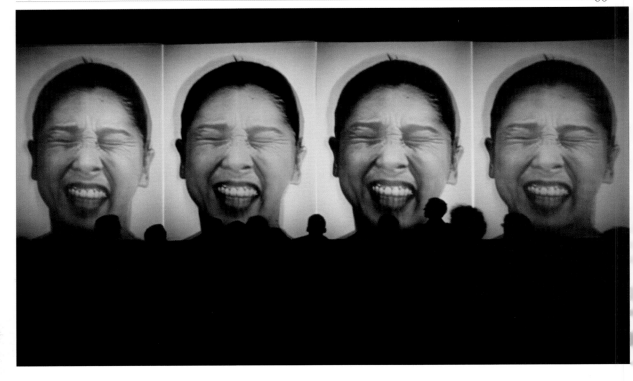

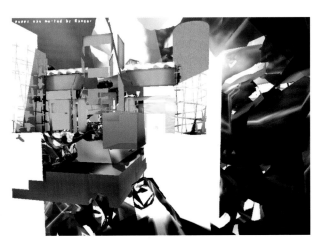

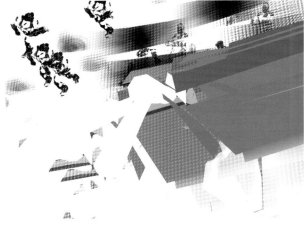

Modell 5,
by Granular-Synthesis,
1994
Short clips and indi-
vidual audio and video
frames are recombined to
create an intense
performance. Four
projected images of a
face are sequenced to
produce a hybrid
machine-human choreo-
graphy and choir.
Editing the video and
sound in parallel
creates audiovisual
synchronicity. The
sound of the original
video recording is part
of each edited frame.

QQQ,
by Tom Betts, 2002
Betts modified the
computer game Quake
by editing the resource
files and transforming
its arenas into nearly
abstract spaces. By not
refreshing the screen,
the images accumulate
and transform as the
player moves through
the game.

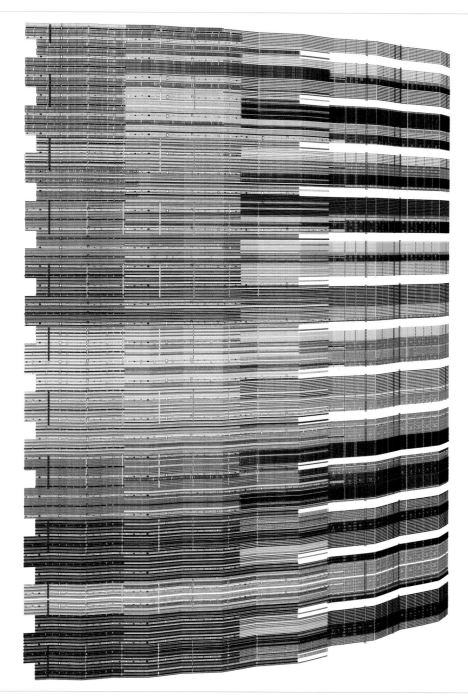

REPEAT

PSC 31,
by Mark Wilson, 2003
These images
explore repeated
geometric forms and
transformations.

They are an extension
of Wilson's programmed
works from the early
1980s.

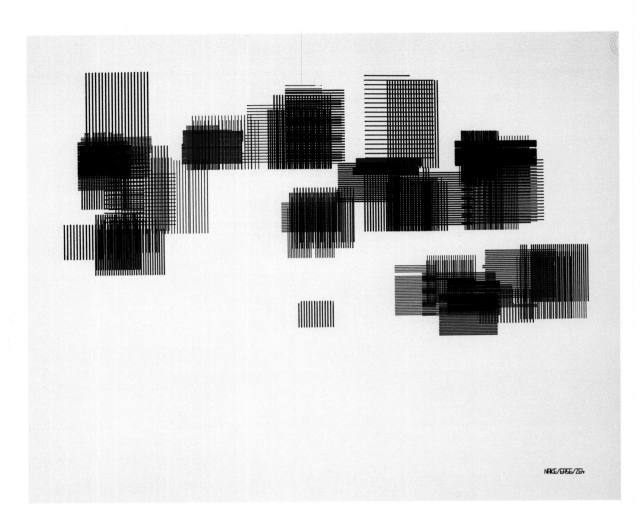

Felder von Rechteck the size, location,
Schraffuren Überlagert, orientation, quantity,
by Frieder Nake, 1965 and pen for each set of
For this image, Nake lines.
used seven random
values to control

THE COMPUTER'S TALENT

1 Ruth Leavitt, Artist and Computer (New York: Harmony Books, 1976), 35.

2 Ibid., 94.

3 Ibid., 95.

Computers are designed to accurately perform the same calculation over and over. People who write programs to control these machines often utilize this inherent talent. In fact, it is more difficult to work against the computer's electronic precision in order to produce idiosyncratic images. Early computer-generated images often featured the ease of repetition made possible through coding.

Frieder Nake's early visual works are excellent examples of programmed repetition. In the mid-1960s at the University of Stuttgart in Germany, Nake was among the first to use a pen plotter to produce drawings from code for aesthetic reasons. At the time, he wrote programs to generate drawing instructions that he then encoded onto a paper tape. The tape was fed into a Zuse Graphomat Z64 plotter to create a physical image using traditional artist papers and inks. Trained as a mathematician, Nake worked with repetition by modulating random values and applying space-division algorithms.

Vera Molnar and Manfred Mohr are two of the first artists to create custom software to realize their aesthetic concepts. In the 1960s, Molnar was making nonfigurative images composed of basic geometric shapes; she would make drawings, perform small changes, and then evaluate the differences. In 1968, she started to use computers to assist with her work. She wrote about this decision in 1975:

> This stepwise procedure has however two important disadvantages if carried out by hand. Above all it is tedious and slow. In order to make the necessary comparisons in developing series of pictures, I must make many similar ones of the same size and with the same technique and precision. Another disadvantage is that I can make only an arbitrary choice of the modifications inside a picture that I wish to make. Since time is limited, I can consider only a few of many possible modifications.[1]

Mohr started to use computers for similar reasons; he was led to software through his early hard-edge drawings, which were clearly influenced by his training as a jazz musician. For him, the motivation to write software came, in part, from his opinion that the computer was a "legitimate amplifier for our intellectual and visual experiences."[2] He outlined the new possibilities of working with software:

— Precision as part of aesthetical expression.
— High speed of execution and therefore multiplicity and comparativity of the works.
— The fact that hundreds of imposed orders and statistical considerations can be easily carried out by a computer instead of by the human mind, which is incapable of retaining them over a period of time.[3]

Both Molnar and Mohr situated their work within the context of art history and contemporary art. For example, Mohr's work has obvious similarities to conceptual artists working with systems and multiples, such as Sol LeWitt. Molnar wrote about the theme of iteration and slight variation within art, citing Claude Monet's series of haystack paintings as an example.

<div style="writing-mode: vertical">REPEAT</div>

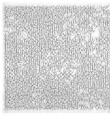

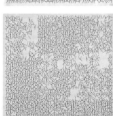

Interruptions, by Vera Molnar, 1968-69 The prints in the Interruptions series are among Molnar's first software-generated images. She started working with computers in 1968 to produce unique ink on paper plotter drawings to realize her visual ideas.

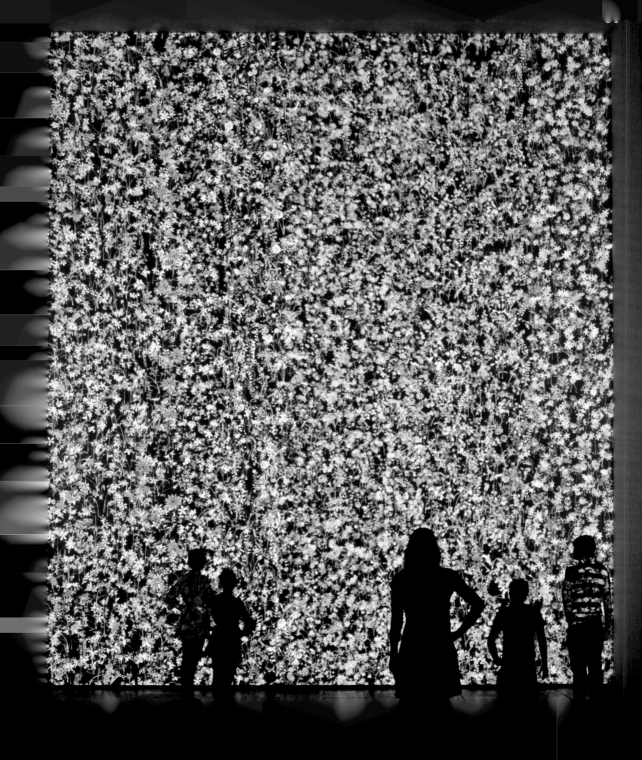

The computers used by these pioneers and their contemporaries were refrigerator-sized machines, which at the time were only available in research and government facilities. Obtaining access to the machines was difficult, and artists had to be very determined. Despite their prohibitive cost, these machines were technically primitive compared to today's computers. The Spartan quality of the early pen-plotter images attests to the visual limitations of these computers and their output devices.

In contrast, the era of raster graphics, enabled by the framebuffer allowed for a different visual quality of repetition. With this technical innovation, the world of programmed graphics transformed from skeletal outlines to worlds of vibrant colors and textures. Computer artist David Em was a pioneer in working with this new type of graphic. Like his predecessors, he worked at research labs to gain access to the high-end computers he needed to produce his work. At the NASA Jet Propulsion Laboratory (JPL) in Pasadena, California, he worked with computer graphics innovator Jim Blinn. Em wrote of the new software: "Blinn's programs, which among other things could display objects with highly textured surfaces, represented a major redefinition of the field of computer imaging."[4] Em used this capacity to work with textures in a simulated 3-D environment in order to produce a series of dense, surreal environments.

This way of working with textures was brought into the home with the Macintosh computer in 1984. The original MacPaint program made it possible to draw with the mouse and to fill these shapes with one-bit textures selected through the patterns palette. The Kid Pix software, released in 1989, built on the ideas introduced in MacPaint but added elements of play and repetition that delighted children (and, of course, many adults too). Graphic icons, ranging from a dinosaur to a strawberry, could be stamped on-screen and easily repeated. This feature

enabled a dynamic collage approach to making images.

The natural talent of the computer to repeat the same calculations has followed a progression from rendering many lines to creating a population of fully realized, autonomous characters. For example, Massive is used to simulate crowd behaviors such as large-scale battles and stadium audiences, as well as for the creation of contemporary effects for films like The Lord of the Rings trilogy. Today's custom software programs have radically changed the quality of imagery that is produced and consumed.

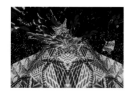

[4] David A. Ross and David Em, The Art of David Em: 100 Computer Paintings (New York: Harry N. Abrams, 1988), 17.

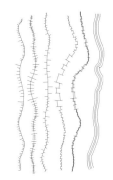

Volkan,
by David Em, 1982
Developed on the most sophisticated computers of the era, Em's images from the late 1970s and early 1980s combine repetitive textures and forms to create fantastical landscapes.

Mobility Agents:
A computational sketchbook,
by John F. Simon Jr,
2005
This software augments drawn lines by adding new ones in relation to the original gestures. It was inspired by Paul Klee's Pedagogical Sketchbook, and it can reinterpret a single line into many different forms

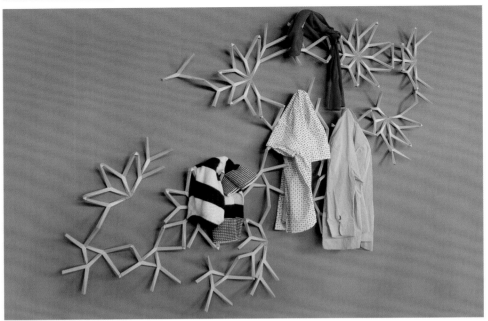
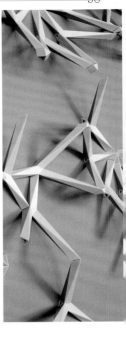

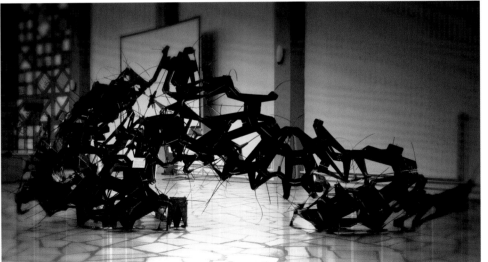
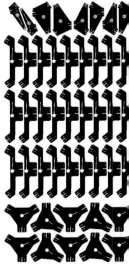

Ivy,
by MOS Architects, 2006
This whimsical system
for hanging coats,
hats, and other objects
uses one standard

Y-shaped form and
four connector types
to provide the owners
with the flexibility
to create their own
structure.

Aperiodic Vertebrae
v2.0, by THEVERYMANY /
Marc Fornes and Skylar
Tibbits, 2008
This architectural
prototype is made of

360 panels composed of
11 different types and
320 unique connections.
It is held together
with zip-tie fasteners.

MODULARITY

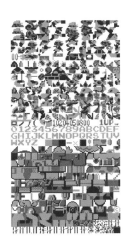

Modularity involves the arrangement of one or more elements to produce a multitude of forms. (It is related to parameters in that the elements are not transformed; they are simply repositioned.) These two themes blend together. Most typefaces are good examples of modular structures. Their range of visual forms is created through a few basic shapes. For example, the lower-case letters p, q, and b are built by arranging the same elliptical and vertical forms in different ways. Some alphabets are more modular than others. The alphabet designed by De Stijl founder Theo van Doesburg in 1919 and the New Alphabet created by Wim Crouwel in 1967 are examples of extremely modular typefaces.

In software, modularity is often used as a strategy for optimization. Because storage space and bandwidth are always limited, a small set of graphics is repeated to generate larger images. This technique is used to produce complex, vibrant images from a small group of forms. For example, when bandwidth was extremely limited in the early days of the web in the mid-1990s, it could take minutes to download graphically intense websites. To decrease the download time, many sites used small repeating images as background textures. Video games have a long history of using a small set of graphics to create large worlds. One of the most famous examples, Super Mario Bros., constructs the game environment using only a small set of 8-by-8 pixel "image tiles" that are stored directly on the game cartridge as raw data. These tiles are combined and recombined to move the characters and create all of their motions. To make this system even more complex, the game machine allows only 64 tiles to be used at a time. Ben Fry's Mario Soup software reconstructs these images as they are stored on the Nintendo cartridge. His companion software, Deconstructulator, shows how the tiles are moved in and out of the machine's memory while the game is being played.

Within the context of physical objects and manufacturing, modularity is used to reduce cost and to make complex building projects feasible. Although some high-profile design and architecture projects are built entirely with custom-manufactured parts, most budgets require working with a set of standard pieces. In fact, most buildings are constructed from standardized, prefabricated elements. The visionary structures of Buckminster Fuller pushed this idea to the extreme in the 1950s. His geodesic dome designs for homes and city-sized structures were built from uniform elements.

The modular coat hook system called Ivy, designed by MOS (an architecture firm led by Michael Meredith and Hilary Sample), is an excellent example of using software to explore a design space of fixed parts. The product comes in a small plastic bag, ready to be assembled into a wall sculpture. It includes sixteen Y-shaped elements and four types of connectors that can be assembled in myriad ways. A software simulation on the MOS website uses a layout algorithm to explore possible configurations of the system.

Beyond the regular repetitions demonstrated here, computational machines (i.e. computers) can produce form with endless variation. This property is discussed in depth in the Parameterize chapter.

REPEAT

Minimum Inventory, Maximum Diversity diagram, by Peter Pearce, 1978 Pearce's book Structure in Nature Is a Strategy

for Design makes a strong case for the technique of using a minimum number of elements to create a range of diverse forms.

Here, four shapes are used as the basis for all of these structures.

Mario Soup, by Ben Fry, 2003 This software shows how all of the graphics used in Nintendo's 1985 Super Mario Bros. game are stored within

two matrices. In this image, one matrix is shown as red and the other as blue. The colors used in the game are applied while the game is running.

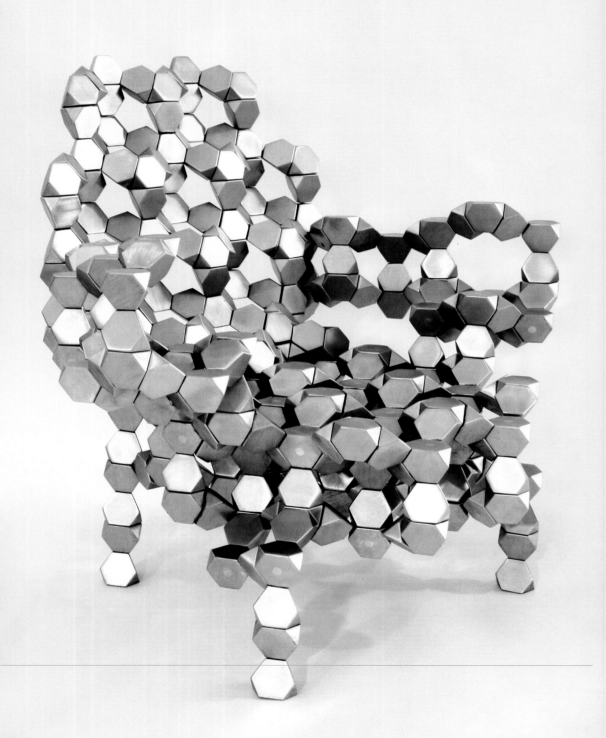

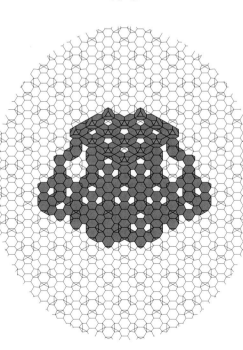

PATTERN

All visual patterns and tessellations at their core are composed of algorithms. Even centuries-old patterns, such as Scottish tartans, follow strict compositional rules that are capable of being encoded into software. Writing code is an exciting way to approach visual patterns. Repetitive patterns are used extensively for applications requiring the illusion of a continuous image, such as textiles and wallpapers. These patterns can be extremely ornate and complex like William Morris' wallpapers, or clean and simple like many of the textile designs by Charles and Ray Eames. New rapid-prototyping machines and computer-controlled fabrication equipment make it possible to explore this area even further.

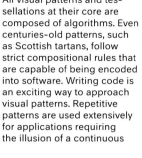

REPEAT

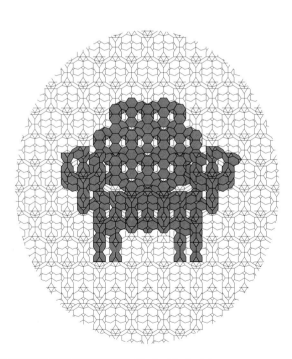

1774 Series Fauteuil, by Aranda\Lasch, 2007 The form of this aluminum chair was "found" within the repeating pattern of an enlarged model of a manganese oxide lattice. The shape of the chair is based on a Louis XV-style armchair.

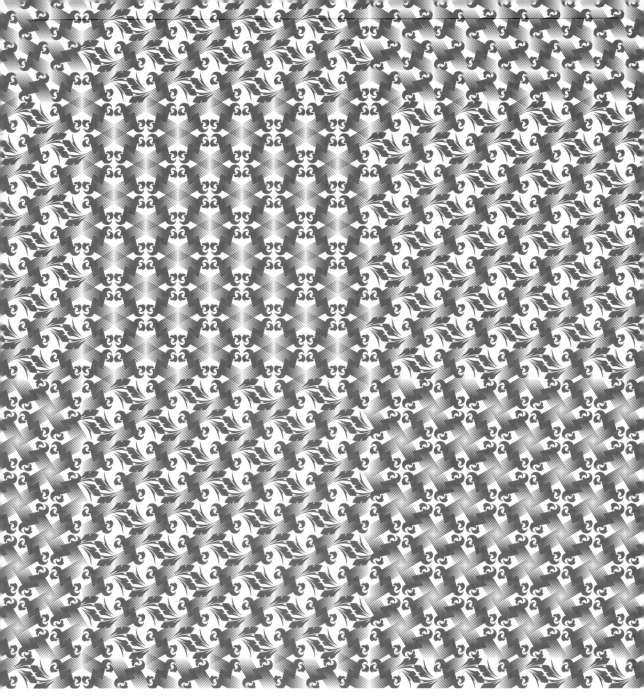

Whirligig,
by Zuzana Licko, 1994
Licko composed the 152
Whirligig characters
as building blocks
for infinite pattern

variations. Because
it is packaged as a
typeface, composing a
Whirligig pattern is
as simple as typing.
The repetition works

on both the micro and
macro scales. To create
each element, a simple
form is repeated and the
elements are combined
to form second-order

patterns, as the
positive and negative
shapes of the elements
connect.

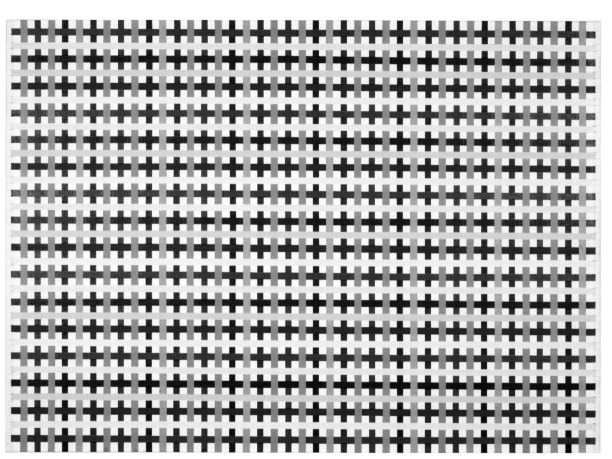

Painting #207 - N,
by Vasa Mihich, 2004
Mihich is a sculptor and
painter, but he started
sketching with computers
in 1998.

He works with fixed algo-
rithms that sometimes
introduce the element
of chance. This painting
was composed with the
following rules:

NINE COLORS WERE DIVIDED INTO THREE VALUE GROUPS:
BLUE/GREEN/RED, VIOLET/ORANGE/TURQUOISE, AND LIGHT ORANGE/LIGHT VIOLET/
LIGHT BLUE. RED WAS FIRST. BLUE WAS SECOND. GREEN WAS THIRD.
VIOLET, ORANGE, AND TURQOISE WERE ARRANGED VERTICALLY.
LIGHT ORANGE, LIGHT VIOLET, AND LIGHT BLUE WERE ARRANGED HORIZONTALLY.

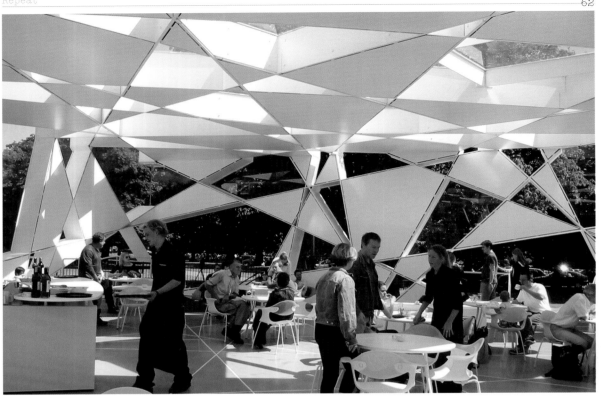

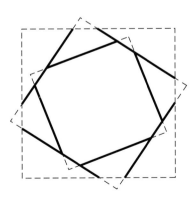 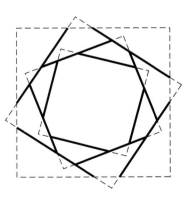 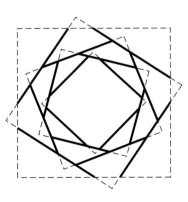

Serpentine Gallery
Pavilion,
by Toyo Ito &
Associates, Architects,
and Arup, 2002

The rhythmic lines of
Ito's pavilion resulted
from a recursive system
of rotated concentric
squares. Arup helped

to create a pattern
of beams that was
structurally sound and
preserved the chaotic
look of the building.

RECURSION

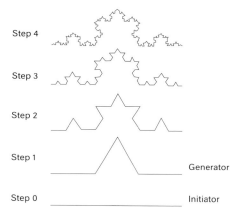

Step 4

Step 3

Step 2

Step 1

Generator

Step 0

Initiator

The technique of recursion is an extremely powerful tool for generating form. Using a broad definition, recursion is a process of repeating objects in a self-similar way. A fern leaf is an example of a recursive form; each leaf is composed of a series of smaller and smaller leaves. A joke about the definition of recursion gets the point across:

Recursion
 See "Recursion"

A more technical definition within the context of code defines it as a function that includes a reference to itself as a part of the function. This is a potent technique, but it can be difficult to control. The definition points out the potential problem: it can cause an infinite loop, unless there is a condition to break out of the cycle.

The Koch Snowflake example clearly shows how the idea of recursion is used to create a complex form from a simple base element. At each level of the recursion, a straight line is replaced by a four-segment triangular bump. This powerful process clearly emulates nature and can be applied to many other situations.

REPEAT

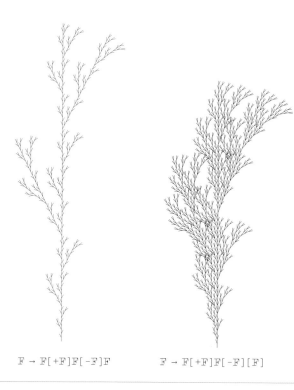

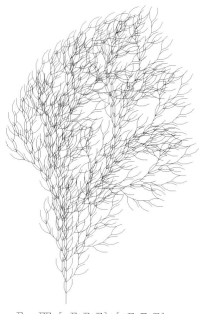

F → F[+F]F[-F]F

F → F[+F]F[-F][F]

F → FF-[-F+F+F]+[+F-F-F]

L-Systems, first introduced by Aristid Lindenmayer, 1968 Lindenmayer systems (L-Systems) are an elegant way to simulate plant forms. A starting pattern is replaced according to a set of rules, and it is then transformed again and again.

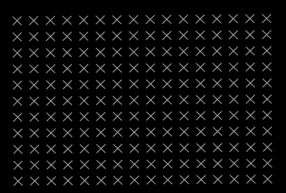

All programming languages can repeat an action, such as drawing the same shape over and over. When one repetition sequence is embedded within another, the effect multiplies. For example, if the action of drawing five lines is repeated ten times, fifty lines are drawn. This simple technique can be used to explore many kinds of patterns.

Each of these images was generated from the same grid of points. Sixteen elements along the x-axis and eleven along the y-axis combine to form 176 coordinates. Changing just one line of code produces the differences between theses images.

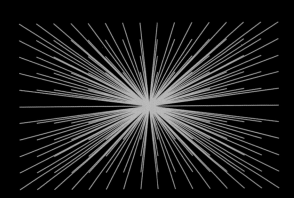

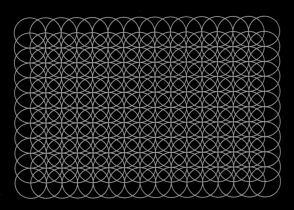

CODE EXAMPLES
RECURSIVE TREE

Within the domain of image making, recursion involves drawing a group of related, self-similar shapes. Treelike forms are a clear example—each branch spawns many smaller branches, which in turn spawn more branches. As a simple example, draw the letter Y on a sheet of paper. Now draw two smaller Ys sprouting from the top of each branch. After repeating this process a few times, the number of Ys drawn at each step has increased from 1 to 2, to 4, 8, 16, 32, 64, and so on.

While this type of tree makes a predictable shape, adding a small amount of randomness to the line lengths and number of branches can yield more organic forms.

These treelike forms were created by drawing one circle at a time. Starting at the base, each circle was slightly rotated and scaled relative to the one before it. At random intervals during the growth, two smaller branches sprout to form new growths. This continues until the circles reach the minimum size set by the user.

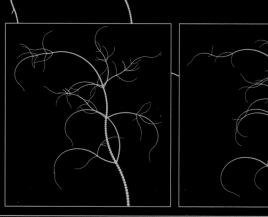

Download the code at http://formandcode.com

When we form so we appro we manipu it, make it di make it ne

This can be as basic as sculpting with clay, mixing paint, or enlarging a photograph; it is the transformation of raw material into a work. But we typically think of transformation as acting on a preexisting object. Trying to define transformation is a daunting task in itself, and the concept can quickly get away from us. Understanding what transformation is within the context of the arts is almost too broad; instead we will focus on how transformation is used and how code can facilitate visual transformations.

TRANSFORM

These letters are distorted by applying the same algorithms that CAPTCHAs (Completely Automated Public Turing test to tell Computers and Humans Apart) use. A CAPTCHA is a type of challenge-response test used in computing to ensure that the response is not generated by a computer. A computer should be unable to solve the CAPTCHA, so any user entering a correct solution is presumed to be human.

(i)

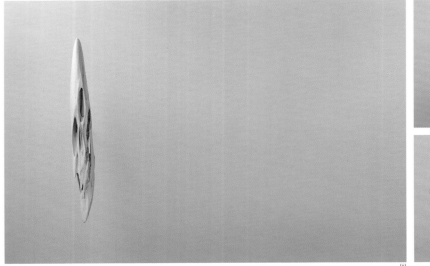

(ii)

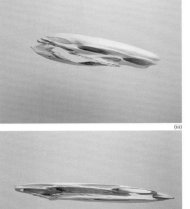

(iii)

(iv)

skull(i), skull(ii),
skull(iii), skull(iv),
by Robert Lazzarini,
2000
This series of 3-D
human skulls was

created using computer
modeling techniques.
First the skull was
scanned and distorted,
then it was fabricated
using resin, bone, and

pigment to create an
unsettling series of
replicas.

Encaustic on canvas. Overall: 30.875 x 45.5 x 5 in. (78.4 x 115.6 x 12.7 cm), Whitney Museum of American Art, New York; 50th Anniversary Gift of the Gilman Foundation, Inc.,
The Lauder Foundation, A. Alfred Taubman, Laura-Lee Whitier Woods, and purchase 80.32. Art © Jasper Johns / Licensed by VAGA, New York, NY.

Transformation refers to the act of manipulating a preexisting form to create something new. It suggests a change in shape, behavior, or context, but more importantly, it indicates a change in the viewer's relationship to the object that has been transformed. Take, for example, a common transformation used in photography: converting a color photo to black and white. This technically simple transformation—it is available in every digital camera, image-editing tool, and copy machine—changes the photograph's appearance. Often, the black-and-white version feels more emotional, timeless, and nostalgic. In some cases, a grayscale conversion even enhances our perception of the image. We see it as more important, and it reminds us of a shoe box full of old photographs in grandmother's attic or the work of countless great photographers of the past.

By making reference to existing symbols and schemes within society, transformation can alter our perception in a way that emphasizes our emotional connections. Jasper Johns' 1958 painting Three Flags achieves this to great effect. The potent symbol of the American flag is repeated on top of itself and then scaled.

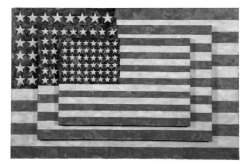

Johns' use of wax encaustic as the medium combined with a subtle use of transformation imbues the work with a sense of ambiguity. Is it critical? Playful? Both? The repetition and stacking could imply motion, perhaps though time, or simply represent a play on geometric perspective.

As if to champion the importance of transformation, Johns famously wrote a prescription for art in his notebook:

```
Take an object.
Do something to it.
Do something else to it.
"      "      "       "      "

Jasper Johns,
Notebook [ND], 1965
```

TRANSFORM

Three Flags,
by Jasper Johns, 1958
Johns uses the repetition and transformation
of a powerful symbol to
create ambiguity in the
mind of the viewer.

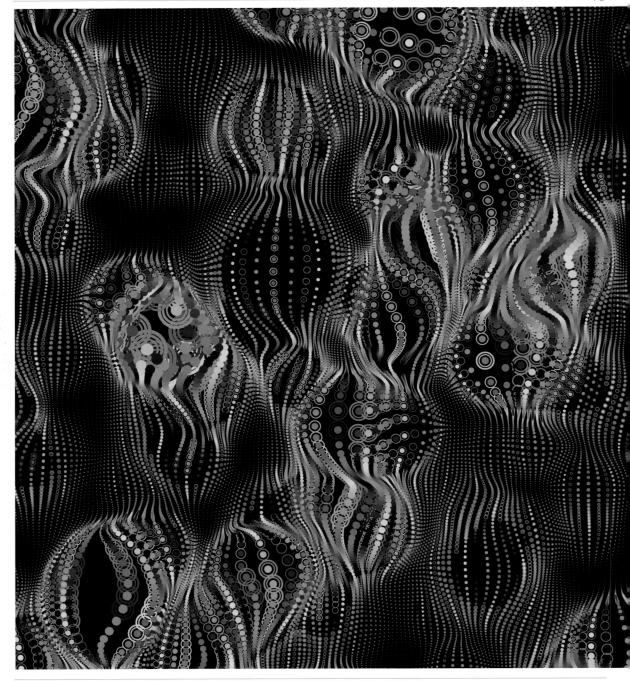

ElectroPlastique,
by Marius Watz, 2009
Inspired by the work of
Victor Vasarely, Watz
used a regular grid that
deforms progressively

over time. Changes
in the grid appear as
ripples of evolving
shapes in bright color.
Eventually, the grid is
ripped apart, leaving

the shapes to float
freely.

GEOMETRIC TRANSFORM

Perhaps the most basic transformation simply involves moving an object. We don't typically think of movement as a type of transformation, but moving elements around is the most fundamental way to make changes to a composition. Another familiar transformation is rotation. An object can be rotated in any number of ways to change its relationship to other objects around it. Flat 2-D items can only be rotated around one axis; for instance, turning a photograph on the wall to change which end faces up. Three-dimensional objects, on the other hand, can be rotated around any number of axes. Another fundamental transformation that has become familiar within everyday life is scaling, but it is difficult to find instances where objects can easily change their size. In the real world, differences of scale are typically seen through a series of multiples or in perspective, as objects appear to shrink as they move further away.

Representing images and objects digitally opens up the possibility for a number of transformations that are not feasible in real life. Objects can be sheared, stretched, reflected, warped, and distorted. In his series of skull sculptures, Robert Lazzarini used techniques of transformation to create a profoundly unsettling installation at the Whitney Museum of American Art. He began with a 3-D scan of a human skull, and applied a series of distortions and projections to the digital model to create an impossible object—one that retained a morbid familiarity (see page 68). Each skull appears to have been transformed using a technique called anamorphosis, a type of visual distortion made popular in the sixteenth century, in which an object is manipulated so that it can only be seen correctly from one vantage point. The most famous example of this technique is Hans Holbein the Younger's 1533 painting The Ambassadors, which features a prominently placed, distorted skull that can only be viewed in full when the painting is viewed from the side. Lazzarini references this disconcerting image; through the use

of digital techniques, he creates a series of skulls that have no true vantage point. He constantly puts the viewer on guard, in search of a perspective that allows the onlooker to make sense of the objects.

The advent of computer animation and special-effects software has had a profound impact on the work of film and video artists, as well as architects and choreographers. Many animation software packages use geometric transformations to create smooth transitions between shapes. These tweens, as they are called (an abbreviation of in-between), take a predefined beginning and end state, and they smoothly animate the morphing of one into the other. Architect Greg Lynn has used the intermediate shapes of the tween, along with other computer-animation techniques, as the basis for an animate architecture "defined by the co-presence of motion and force at the moment of conception."[1] Likewise, dance choreographer Merce Cunningham uses software to find new forms and movements that appear when the program is asked to find transitions between two unlikely positions. Both of these creators highlight an important connection between form and code: that code can be a source of inspiration and it can help create previously unimaginable forms.

[1] Greg Lynn, Animate Form (New York: Princeton Architectural Press, 1999), 11.

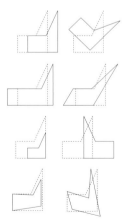

Geometric Transformation
Each 2-D transformation preserves some features of the original while destroying or distorting others.

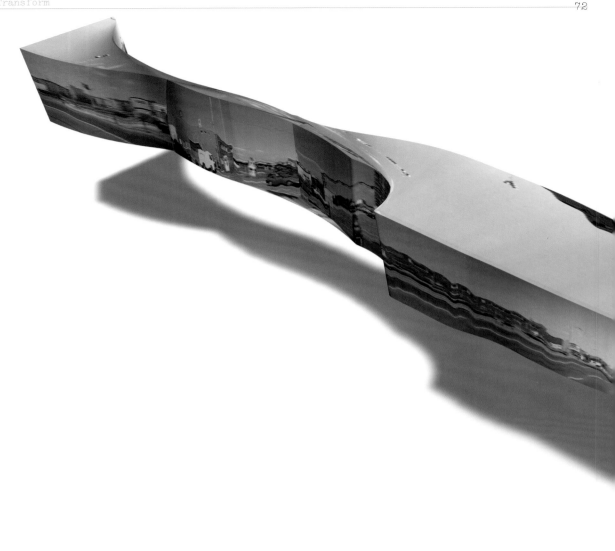

The Invisible Shape of Things Past, by ART+COM, 1995 The idea that a video can be imagined as a physical object is the foundation for this project. Because each frame is flat and 2-D, it can be stacked in space to produce a 3-D object that can then be viewed from any angle. As the camera moves with a pan, tilt, or turn, the frames twist and turn, producing unexpected and fascinating shapes.

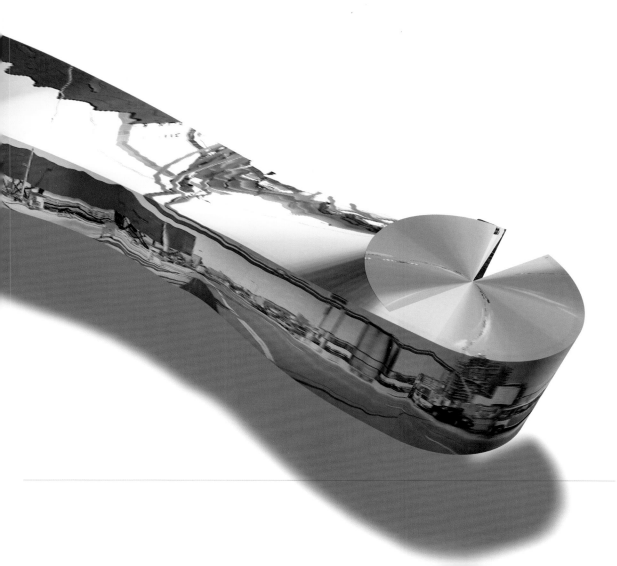

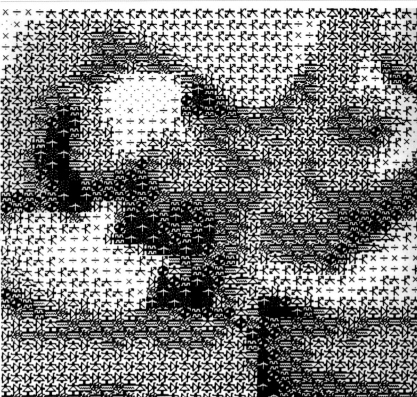

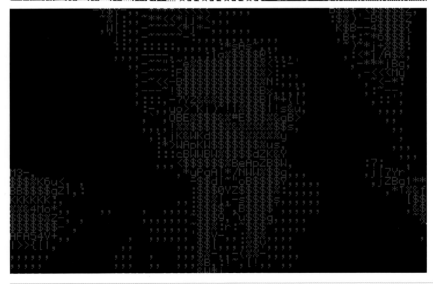

Mural (detail),
by Ken C. Knowlton and
Leon Harmon, 1966
A series of photographs
were transformed into
images composed of
engineering symbols.
Each point was repre-
sented as a grayscale
value, then replaced by
a graphic symbol.

ASCII Bush,
by Yoshi Sodeoka, 2004
An ASCII-based filter-
ing technique was used
to create a new version
of the State of the
Union addresses given
by former presidents
George W. and George H.
W. Bush. Sodeoka said
that he wanted to make
something "from the
debris of our culture
by recycling these
dreadful and pain-
fully long presidential
orations."

NUMERICAL TRANSFORM

When an image or object is represented in digital form, it must first be described in numerical terms. This description allows for countless new types of transformations. While geometric transformations (discussed above) require that objects be described using coordinates, image-based transformations are described using the numerical terms of pixel values. We can apply mathematical formulas to the values of each pixel, such as color, brightness, and transparency. This process weakens the connection between the object being acted upon and the transformed version of it. For instance, scaling will only make an image smaller or larger, but applying a mathematical function to the pixel values may create something that looks little to nothing like the original. For example, in 1966, computer engineers Kenneth C. Knowlton and Leon Harmon exploited this feature of digital images to create Mural, an image of a woman composed entirely of engineering symbols. Each section of the image was analyzed for its relative darkness and then replaced with a symbol having an equivalent tone. A similar technique is often seen in so-called ASCII transformations in which pixels are replaced with alphanumeric characters to form an image.

Among the most useful mathematical transformations are image filters. By looking just at the numerical values of pixels, filters can perform a surprising number of useful operations, such as blurring, sharpening, edge finding, and color conversion, to name just a few. Two common families of filters are called high-pass and low-pass filters. Low-pass filters dampen abrupt changes in value so as to produce a smoother, blurred image, and they are often used to reduce noise in digital images. High-pass filters do just the opposite; they preserve values with sharp transitions and are useful for sharpening features in images and enhancing the edges of elements.

In On Growth and Form, first published in 1917, mathematical biologist D'Arcy Wentworth Thompson described a way to

apply mathematical formulas to study the development of form in living creatures. This science, which he termed morphology, used a numerical description of form (similar to the one discussed in this chapter) as a foundation. In Thompson's words:

> The mathematical definition of a 'form' has a quality of precision which was quite lacking in our earlier stage of mere description....We discover homologies or identities which were not obvious before, and which our descriptions obscured rather than revealed.[2]

By describing form in mathematical terms, Thompson was able, through the use of transformations, to find continuity in the evolution of species. His work, however, took a slightly different approach. Rather than consider the transformation as acting upon the form, he characterized it in terms of the coordinate system in which the form was described. For example, consider an image printed on a piece of rubber; by poking and stretching the rubber sheet, endless variations of the original image can be produced, but the connections between each of them remain obvious. Thompson would manipulate and transform images by plotting them on new coordinate systems. These included scaled and sheared grids, systems based on logarithms, and polar planes. Thompson was able to describe (in mathematical detail) changes in the shapes of bones from one species to the next, and even make predictions about intermediate species in evolutionary history.

[2] D'Arcy Wentworth Thompson, On Growth and Form: The Complete Revised Edition (Mineola, NY: Dover Publications, 1992), 1027.

TRANSFORM

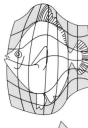

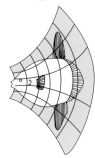

On Growth and Form, by D'Arcy Wentworth Thompson, 1917 In this book, Thompson demonstrated how a series of geometric and topological transformations could explain, even predict, morphological changes in animal species.

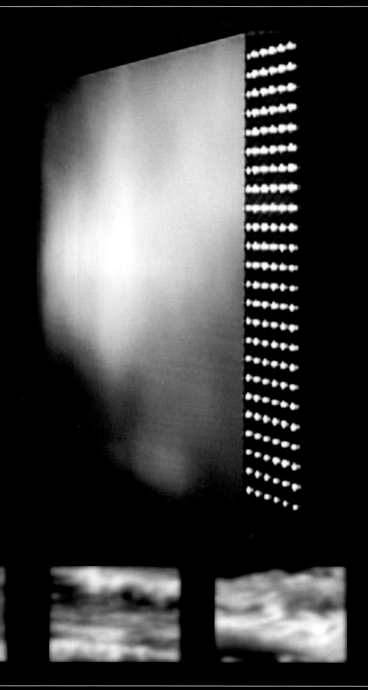

Wave Modulation,
by Jim Campbell, 2003
As a part of the
Ambiguous Icons
series, this work
reduces a video image

so that it can be
displayed on a coarse
matrix of LEDs. A
treated Plexiglas
panel placed in front
of the LEDs diffuses

the individual points
of light into a
ghostly image of ocean
waves. Over a period
of ten minutes, the
waves change from

undulating in real
time, to slowing down,
to a still image, and
back to their original
speed.

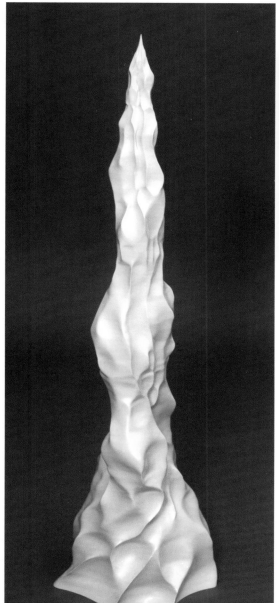

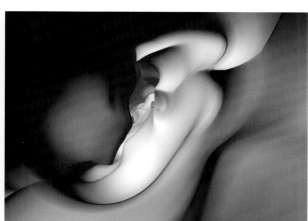

TRANSFORM

Tuboid,
by Erwin Driessens
and Maria Verstappen,
1999-2000
For this sculpture,
the artists combined
a series of 2-D cross-
sections to create a
3-D form. Starting from
a single point at the
top, it grows downward
in steps. The shape
of each cross-section
is controlled using a
genetic algorithm to
change the lengths and
rotations of spokes
within each otherwise
circular section.
In essence, it uses
a transformation of
polar coordinates to
create a unique form.
An interactive software
version of Tuboid makes
is possible to navigate
and travel through the
form.

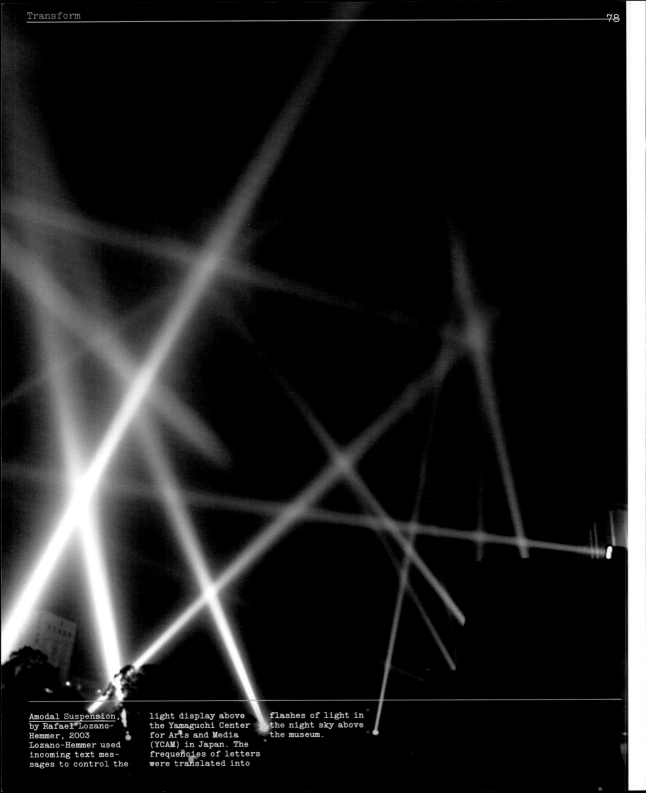

Amodal Suspension,
by Rafael Lozano-
Hemmer, 2003
Lozano-Hemmer used
incoming text mes-
sages to control the

light display above
the Yamaguchi Center
for Arts and Media
(YCAM) in Japan. The
frequencies of letters
were translated into

flashes of light in
the night sky above
the museum.

TRANSCODING

One direct consequence of describing information numerically is transcoding or the conversion of one type of digital information into another, for instance, converting a file from a JPEG to a PNG format. Transcoding can also be used to create completely new forms by interfering with how the computer handles a set of data. For example, it can allow the bits of an audio file to be read by a program that normally operates on the bits representing an image. Transcoding uses the file data as raw material for computation. A good example is a simple substitution cipher, where each letter is replaced with a number corresponding to its position in the alphabet. This cipher turns the name Ben into the numbers 2, 5, and 14. Once the conversion is made, the numbers can be used in a variety of ways to create new values. These values can, in turn, be used to create new images or artworks. For example, the number can be added together to get 21, which, in turn, can be used to set the red value of a pixel in an image. (But since the word "at" also has a value of 21, this will only create a very loose connection between the original word and the color of the pixel.) Because the letters have been converted to numbers, they can be transformed in atypical ways.

Rafael Lozano-Hemmer's 2003 installation Amodal Suspension transforms text messages into light beams, from spotlights projected into the sky above the Yamaguchi Center for Arts and Media (YCAM) in Japan. The transformation scheme used by Lozano-Hemmer produced a particularly striking display. The letters contained in each text message were analyzed based on the frequency with which they appeared. The frequency values were used to control the intensity of the spotlight: the letter A would push the light to full brightness, while Z would appear as a dim glow. In this way, our everyday language is transformed into something akin to the flashes of fireflies.

The continuity provided by the numerical representation of information is exploited to its fullest in the programming environment Max. Inspired by the patch cables of analog synthesizers, a Max program is composed of input and output patches that control the flow of data. When used with Jitter (a program extension that adds video features), Max can connect the frames of a video to a sound generator, run them through a filter, and reconnect the results back to a video generator. In the same way that the flow of electricity can be used to power any electronic device, the flow of binary data can be applied to any number of Max's software patches.

Transformation provides a way to express continuity between forms, data, and ideas. When a work utilizes techniques of transformation, it retains a connection between its original and transformed versions, and such radical transformations can reveal entirely new relationships.

TRANSFORM

Data Diaries, by Cory Arcangel, 2003 Arcangel tricked his computer into reading its memory as if it were a QuickTime movie. No complicated substitutions or interpretations were necessary, and no predetermined conversions were set up, such that a certain value from the memory file would cause a specific result. This was a direct translation, similar to reciting driving directions aloud like poetry.

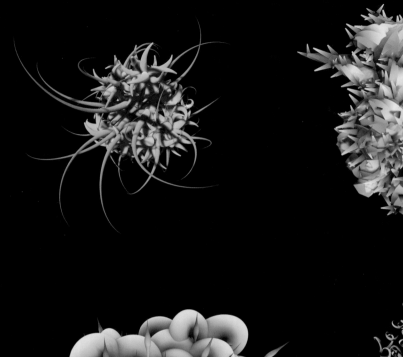

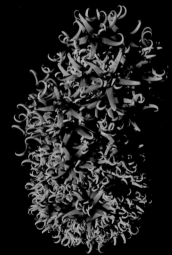

Malwarez,
by Alex Dragulescu,
2007
This project converts
the source code of
computer worms,
viruses, trojans and
spyware into visual
images. Dragulescu's
software analyzes
subroutines and memory
addresses stored in
the spyware to create
3-D forms exhibiting
patterns found in the
code.

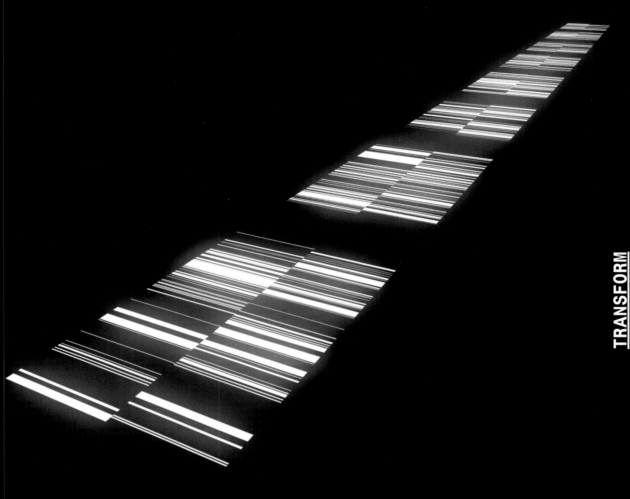

TRANSFORM

test pattern [nº1],
by Ryoji Ikeda, 2008
In this audiovisual
installation, the
sound from the loud
speakers is converted

in real-time to a
sequence of barcode
patterns displayed
on the monitors.
Ikeda explains:
"The velocity of

the moving images
is ultrafast, some
hundreds of frames
per second at certain
points, providing
a performance test

for the devices
and a response
test for visitors'
perceptions."

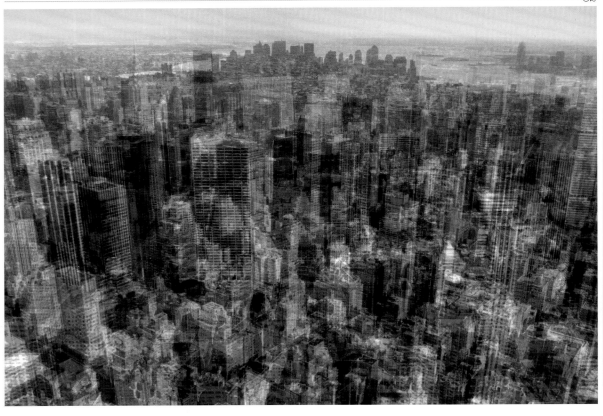

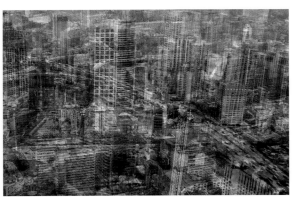

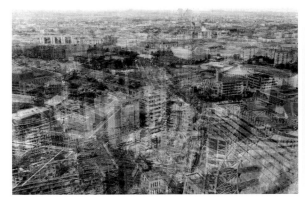

netropolis,
by Michael Najjar, 2004
The netropolis series
combines multiple per-
spectives of the same
city into images of

an imagined networked
future; shown clockwise
from the top: New York,
Berlin, and Shanghai.

TRANSFORMATION TECHNIQUE
<u>IMAGE</u> <u>AVERAGING</u>

The most compelling transfor-mations of images often involve repetition. Image averaging, for example, is one technique for calculating the median color or brightness value for pixels contained in an image. It then reassembles those values into a composite.

By repeatedly combining related images, one can expose behavioral norms, reveal expectations, and find new connections that were less obvious when the images were viewed as a series sepa-rated in space.

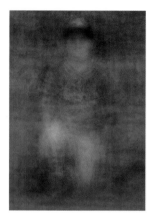

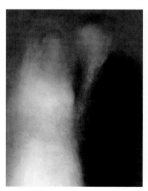

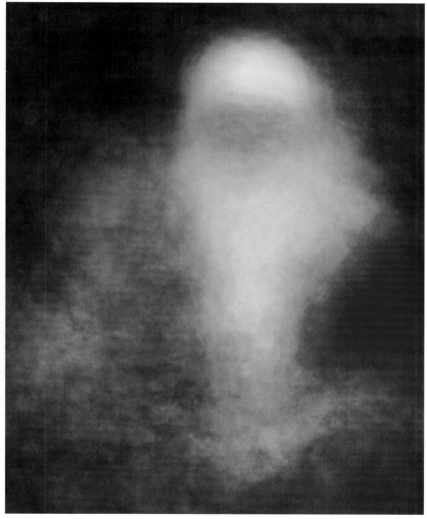

TRANSFORM

<u>100 Special Moments</u>, by Jason Salavon, 2004 Salavon applies an image-averaging algo-rithm to sets of com-memorative photographs, such as wedding pictures or children with Santa Claus, to show the similarities between these otherwise unique moments.

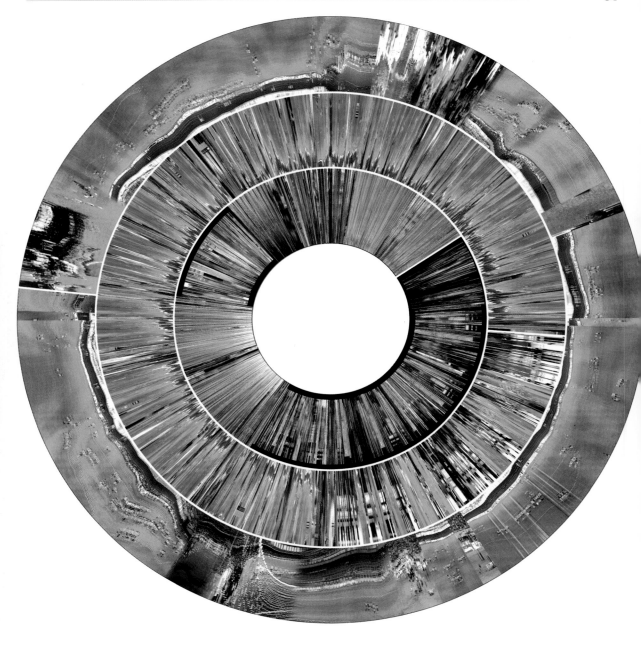

Last Clock,
by Ross Cooper and
Jussi Ängeslevä, 2004
This project reinvents
the clock to display
the passage of time

as an image capturing
the history of video
feeds in durations of
seconds, minutes, and
hours.

TRANSFORMATION TECHNIQUE
SLIT-SCANNING

Slit-scanning is a technique that transforms the frames of a video into an image to convey the passage of time or movement through space. Although there are a number of different ways to create a slit-scan image, they all involve one basic concept. For each frame of a video, capture a single column of pixels (or a slit) to make a very narrow camera. Then recombine the columns to create a single image. Slit scanning can also be used to create animations that emphasize movement. Perhaps the most well-known example of slit-scanning was executed by Douglas Trumbull for Stanley Kubrick's film 2001: A Space Odyssey.

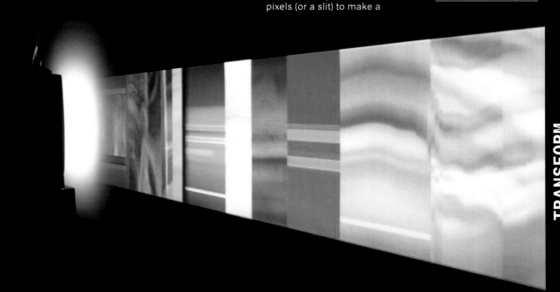

TRANSFORM

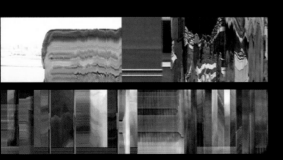

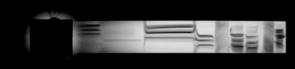

We interrupt your regularly scheduled program..., by Osman Khan and Daniel Sauter, 2003

This project uses slit-scanning to explore the vivid and manic imagery of broadcast television.

The artists used custom software to collapse each frame into a single column of pixels, which they

projected onto a wall as a steady stream of color.

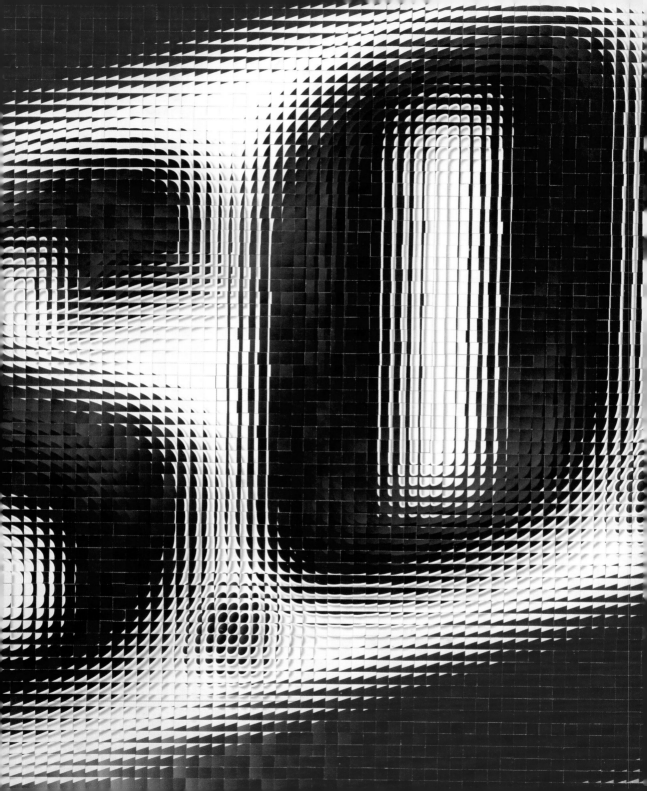

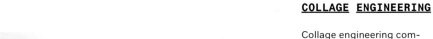

Collage engineering combines a number of different techniques for collecting, modifying, and compositing images and text. Some rely on the digital representation of texts and images and their widespread availability on the Internet. Others focus on classic collage techniques, such as cut-ups, décollage (in which an image or object is cut or torn away to create a new composition), and assemblages.

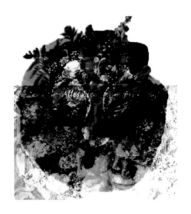

TRANSFORM

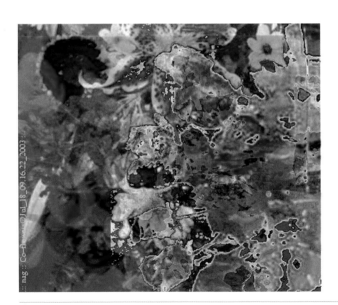

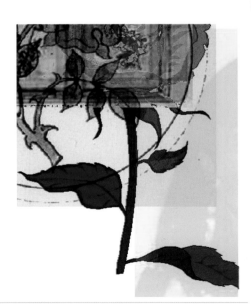

Untitled,
by Tom Friedman, 2004
Applying physical construction techniques, Friedman used an algorithm to disassemble and recombine thirty-six identical S.O.S. laundry detergent boxes into a single, larger box. It transforms them into something familiar, yet quite different.

net.art generator Series 'Flowers,'
by Cornelia Sollfrank, 2003
The net.art generator (net.art-generator.com) asks viewers to enter a search term for their soon-to-be-realized creation. It uses a series of algorithms to collect and combine images to create a completely unique web page from many online sources.

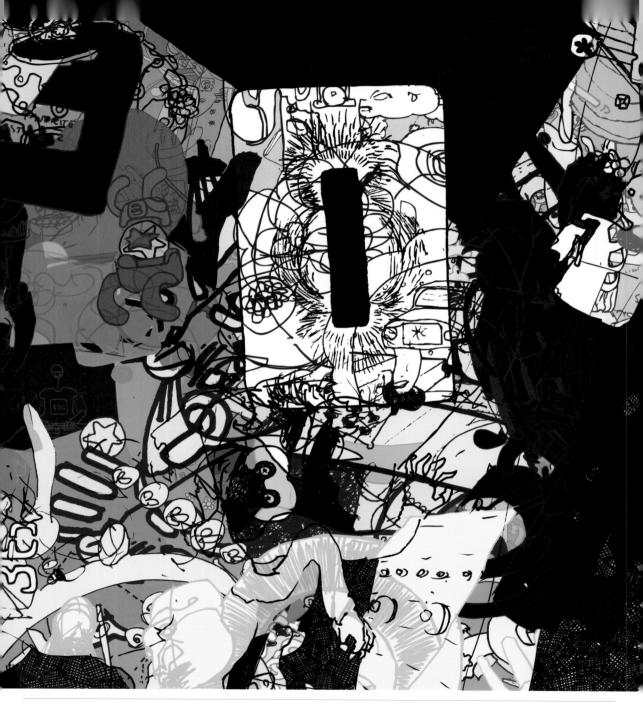

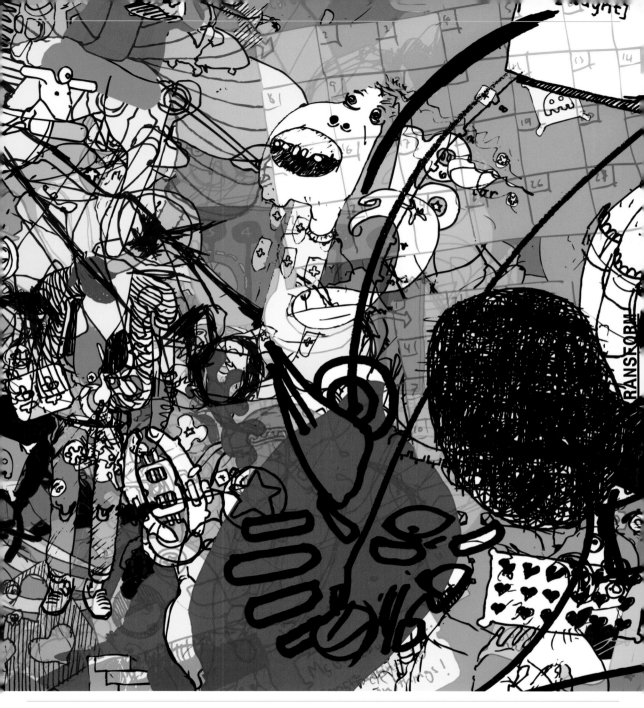

Untitled V,
by James Paterson, 2005
Paterson's Objectivity
Engine software uses
random values to define
the color, position,

and rotation of his
small drawings to make
a larger collage. Each
time the software
is run, a different
composition emerges

within the space of the
parameterized limits.

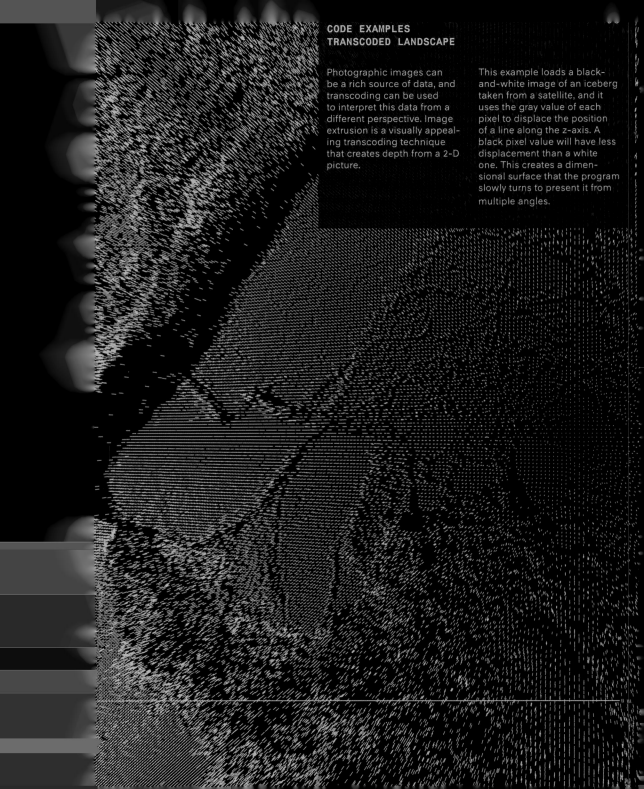

Photographic images can be a rich source of data, and transcoding can be used to interpret this data from a different perspective. Image extrusion is a visually appealing transcoding technique that creates depth from a 2-D picture.

This example loads a black-and-white image of an iceberg taken from a satellite, and it uses the gray value of each pixel to displace the position of a line along the z-axis. A black pixel value will have less displacement than a white one. This creates a dimensional surface that the program slowly turns to present it from multiple angles.

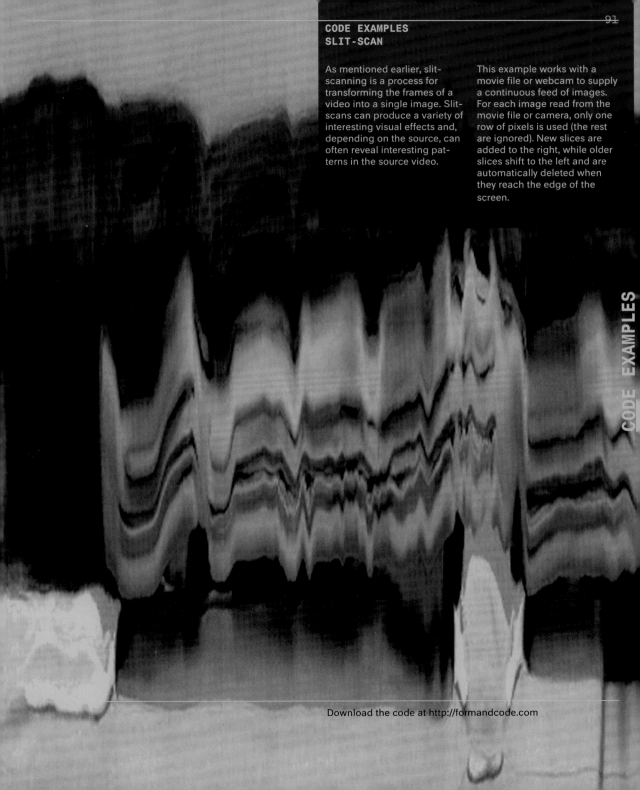

CODE EXAMPLES
SLIT-SCAN

As mentioned earlier, slit-scanning is a process for transforming the frames of a video into a single image. Slit-scans can produce a variety of interesting visual effects and, depending on the source, can often reveal interesting patterns in the source video.

This example works with a movie file or webcam to supply a continuous feed of images. For each image read from the movie file or camera, only one row of pixels is used (the rest are ignored). New slices are added to the right, while older slices shift to the left and are automatically deleted when they reach the edge of the screen.

CODE EXAMPLES

Download the code at http://formandcode.com

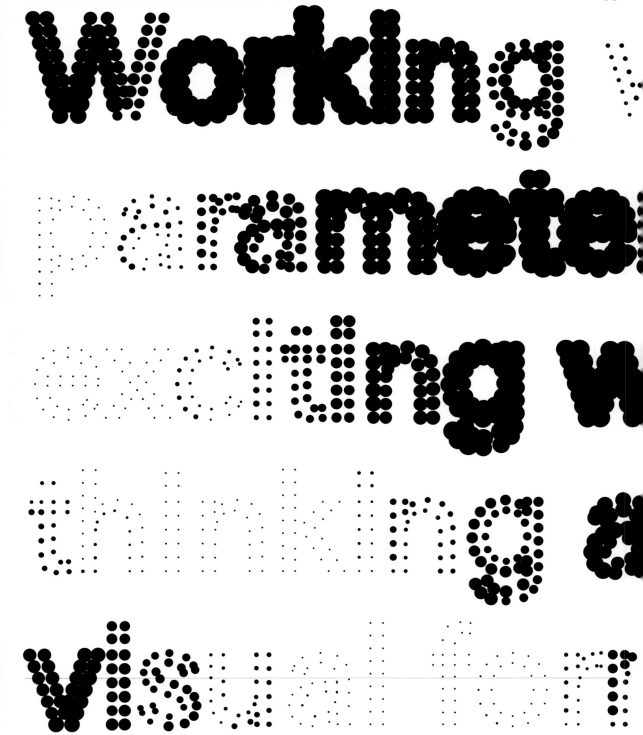

Working parameters exciting thinking a visual text

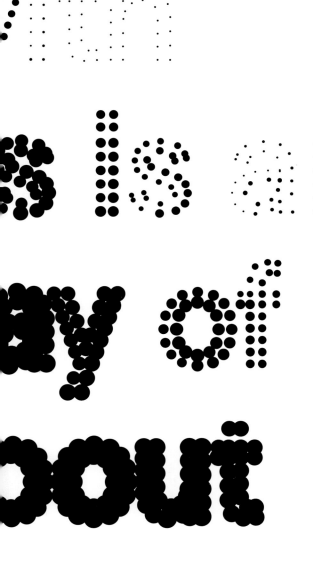

In this capacity, the designer is no longer making choices about a single, final object but creating a matrix encompassing an entire population of possible designs. This is a move from thinking about an object to thinking about a field of infinite options. This involves searching for and exploring a population of designs that meet certain requirements, behave in particular ways, or fit the desires of the designer.

PARAMETERIZE

These letters use parameters to determine the size of each circle. Working point by point, the program draws one circle at a time, with the radius cycling between small and large. Because the frequency of oscillation and circle size are both parameters, this permutation is only one of an infinite number of possible results.

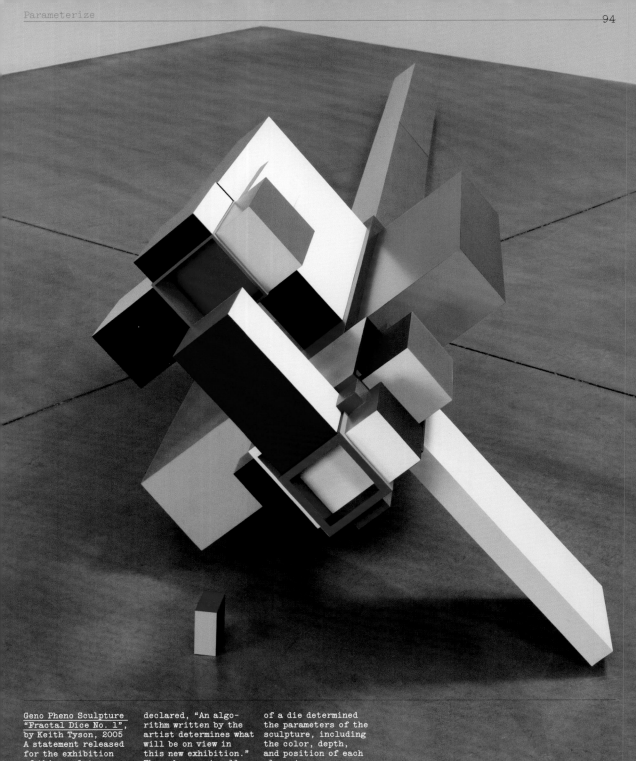

<u>Geno Pheno Sculpture</u>
<u>"Fractal Dice No. 1"</u>,
by Keith Tyson, 2005
A statement released
for the exhibition
of this sculpture
declared, "An algo-
rithm written by the
artist determines what
will be on view in
this new exhibition."
The subsequent rolls
of a die determined
the parameters of the
sculpture, including
the color, depth,
and position of each
element.

Defined broadly, a parameter is a value that has an effect on the output of a process. This could be something as straightforward as the amount of sugar in a recipe, or as complex as the activation threshold of a neuron in the brain. In the context of architecture and design, parameters describe, encode, and quantify the options and constraints at play in a system. A common constraint might be the budget available for a project, while a configuration option might control color, size, density, or material.

Identifying and describing the variable elements in a process—be it a section of code or the rules of a Dadaist poem—is called parameterization. This multistep process requires that the designer decide both what can change and the range of possible values for each parameter. For example, a designer can explore the effects of different color palettes on a logo design. In this case, the colors of the elements within the logo are the parameters, and the list of possible palettes defines the value range. Parameterization creates connections between the intention of the designer and the system he or she is describing.

As a greater number of parameters are identified and incorporated into a process, the number of possible outcomes also increases. Imagine each parameter as defining an axis on a graph, and a parameterized system as defining a space populated by potential design states (resulting from a combination of specific values being assigned to each parameter). As a simple example, consider a rack of T-shirts. Each shirt on the rack is a different size and color, and we can say that the "large, green shirt" is the design state when the size parameter is large, and the color parameter is green. But it is just as easy to imagine a "large, red shirt," as being exactly the same as a "large, green shirt," just in a different color.

Thinking about parameters provides a bridge between repetition and transformation, as well as visualization and simulation. While transformation describes a parameter's effect on form, repetition offers a way to explore a field of possible designs for favorable variations. Both visualization and simulation require the use of parameters to define the system, and they describe how data or other inputs will influence the behaviors of that system.

PARAMETERIZE

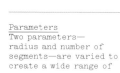

Parameters
Two parameters—radius and number of segments—are varied to create a wide range of different forms. This is a minimal system, but it shows the power of parameters for exploring form.

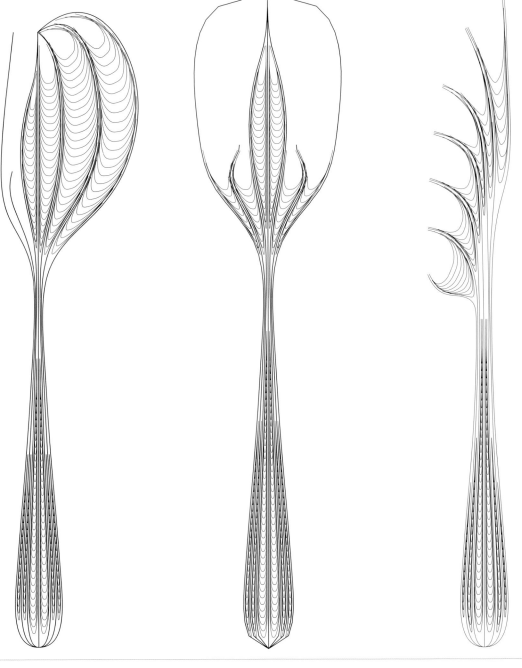

Flatware,
by Greg Lynn,
2005-present
This fifty-two-piece
flatware set was
designed by mutating,
blending, and evolving
a base form: a bundle
of tines and a webbed
handle. These special-
ized utensils, includ-
ing obscure pieces such
as a mustard spoon and
bon bon server, belong
to a larger family of
forms, with each being
a variation of the
others.

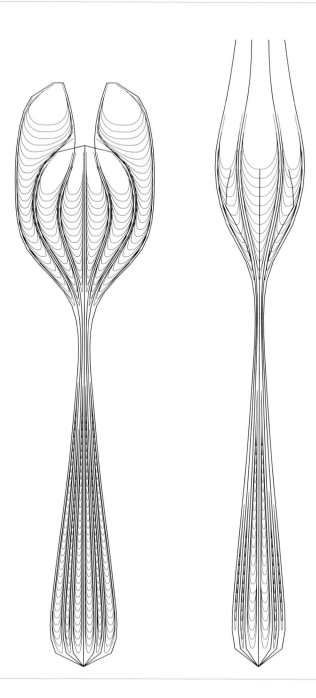

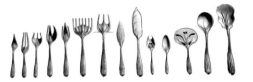

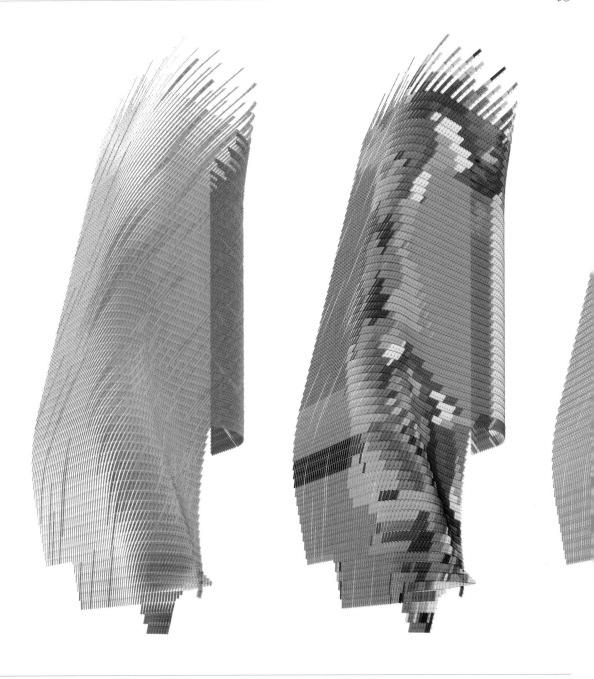

Phare Tower,
by Morphosis, 2008
The Phare Tower
is a design for a
sixty-eight-story
skyscraper in Paris.

Software developed by
Satoru Sugihara was
used to iteratively
develop, test, and
refine the structure
to address multiple

parameters essential
to the design. These
images show how the
software was used to
design the following
systems; shown from

left: optimization for
solar performance,
panel-dimension optimi-
zation, and panel-angle
analysis.

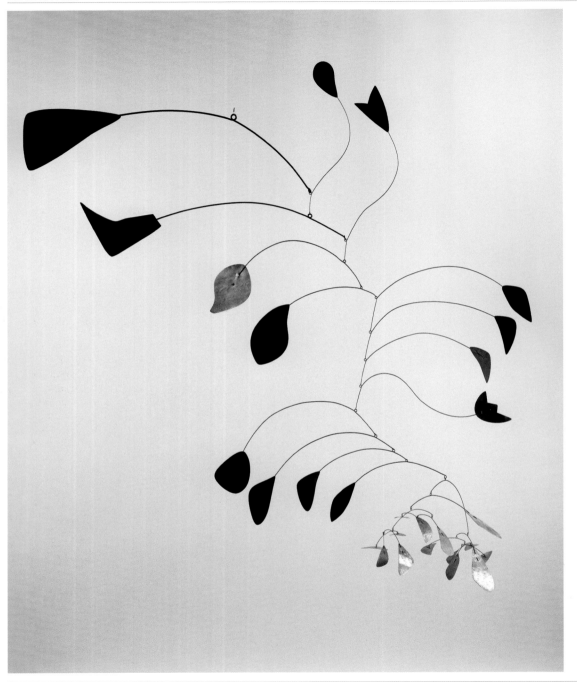

Arc of Petals,
by Alexander Calder,
1941
This mobile is composed
of a well-balanced
set of relationships

between shapes. Some
of these relationships
are constant; others
change in response to
air currents.

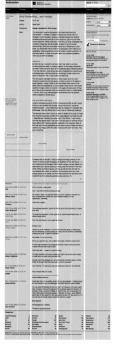

The desire to construct a system for composing images, rather than making a single image, has a long history in modern art. Marcel Duchamp's 3 Standard Stoppages from 1913–14 is an early and fascinating example. To create this series of objects, he dropped a string, measuring 1 meter, from a height of 1 meter to define a curve. Defined by gravity, this ephemeral curve and the twisting of the string as it fell was then cut out of wood and used as a template for other images. For example, the curves were used within his Large Glass to define the shapes of the bachelor figures. A contemporary of Duchamp, Jean Arp, produced collage works, such as Untitled (Collage with Squares Arranged According to the Laws of Chance), by scattering the elements onto a page. Perhaps the clearest, most iconic presoftware examples are the mobiles of Alexander Calder. In these sculptures, shapes relate to one another through fixed connections, under the weight of gravity, but they are so well balanced that the wind can move the elements to shift their positions. Umberto Eco wrote of these objects:

> Each of his works is a 'work in movement' whose movement combines with that of the viewer. Theoretically, work and viewer should never be able to confront each other twice in precisely the same way. Here there is no suggestion of movement: the movement is real, and the work of art is a field of open possibilities.[1]

Experimental writers Tristan Tzara and William S. Burroughs introduced innovative, unpredictable operations as methods of writing, and John Cage used randomness as a fundamental technique for musical compositions.

While it's clear that these early compositional systems relied heavily on chance, these artworks are important within the context of parameters in that each of their creators defined a set rules where some elements were selected by themselves and

others resulted from events outside of their control. They invented systems from which an infinite number of unique works could (and did) emerge. This way of working is summarized well by Sol LeWitt's statement: "The idea becomes a machine that makes the art."[2]

More carefully determined systems include grids for composing pages in books, magazines, websites, and for posters. They allow each page to be unique, while still relating to every other page. For example, the Unigrid System, designed for the U.S. National Parks Service (NPS) in 1968 allows each park (Yellowstone, Yosemite, etc.) to have a unique brochure suited to its needs while also allowing the NPS to maintain a strong organizational identity. The Unigrid System is a flexible, open framework that allows individual designers to make their own decisions about layout while working within a larger system. Subtraction.com, which is the website and blog of Khoi Vinh (the art director of NYTimes.com) is a more contemporary example. A grid system applied to a website allows for hundreds, even thousands of pages to be generated based on a single structure. Vinh cites Josef Müller-Brockmann and Massimo Vignelli as influences, and he makes direct links between the history of the grid within print design and how it transfers to the web. Speaking about grids in an interview, he said:

> A grid system is not just a set of rules to follow...but it's also a set of rules to play off of—to break, even. Given the right grid—the right system of constraints—very good designers can create solutions that are both orderly and unexpected.[3]

[1] Umberto Eco, The Open Work (Cambridge, MA: Harvard University Press, 1989), 86.

[2] Alexander Alberro and Blake Stimson, eds., Conceptual Art: A Critical Anthology (Cambridge, MA: MIT Press, 2000), 14.

[3] Interview with Khoi Vinh: http://www.thegridsystem.org/2009/articles/interview-with-khoi-vinh/.

Subtraction.com, by Khoi Vinh, 2000–09 There are many different layouts on this website, but Vinh uses an eight-column grid to give the same structure to each variation.

Variation Example, by Emil Ruder, 1967 Emil Ruder's book Typographie shows how a highly constrained set of elements can be used to generate a wide range of compositions. Using only one line and one dot, he diagrams thirty-six unique compositions. He makes a point to write that his variations are "only a fraction of the almost unlimited possibilities."

PARAMETERIZE

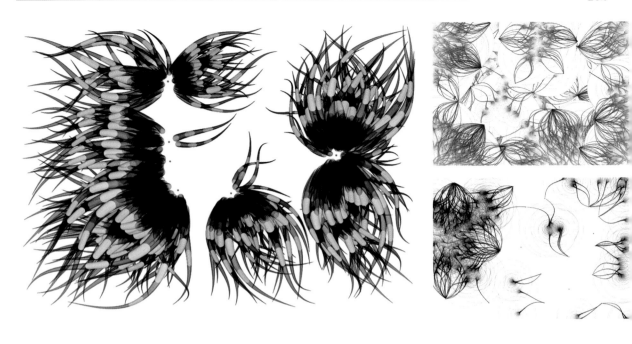

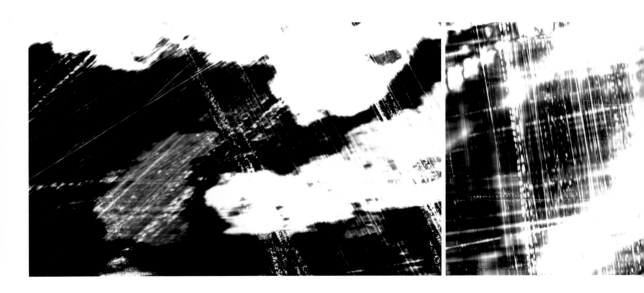

proximityOfNeeds,
by Lia, 2008
Lia provides controls
at the bottom of the
screen, so viewers can
change the parameters
of her software and
therefore change how the
forms grow. She controls
these parameters live
in her audiovisual
performances.

Mortals Electric,
by Telcosystems, 2008
This sophisticated,
live audiovisual
performance has more
parameters than can be
manually controlled.
It balances direct
control with an auto-
mated context-aware
system to produce a
stream of sonic and
visual events that move
beyond the expectations
of its creators.

VARIABLES

In any system or set of rules, there exists the potential for variation. Though the primary variation of form present in a Calder mobile comes from the unpredictable interaction of natural forces, it is still possible to get an even wider field of possibilities by changing other parameters in the system. These include the lengths of the rods, weights of the objects, and positions of the connections. A compositional system built out of 1-foot (0.3-meter) rods will look and behave very differently than a system made of 1-meter (3.3-feet) rods.

When the value of a parameter can change, we call this a variable. Variables can be distinguished from constants, whose values cannot change, such as the force of gravity; or constraints, which are fixed in response to the requirements of the project, such as cost or available materials, and provide boundaries that define the edges of a design space. The creation of a mobile, for example, may be constrained by the size of the room it will hang in and the need for it to be light and strong enough to hang from the ceiling. Though all three of these parameter types will effect the range of possible forms, the variables can be considered as the primary axes of variation. The artist changes the variables, either by hand or with code, in search of interesting outcomes.

Sometimes the variable's value will only makes sense within a certain range. Consider the tuning knob on a radio; only frequencies within the range shown on the dial are valid. It is conceivable that a radio could use values outside of this range, but the results will be unexpected, and certainly won't sound like radio. Defining the range of values is one way that designers can assert their aesthetic sensibilities in a parameterized system. Perhaps not all values will look good or create interesting results. Much like the dial on the radio, the range can be refined to produce a narrower, but more pleasing field of variations.

As with the compositional systems in use prior to the invention of the personal computer, randomness is a useful tool for finding interesting variations in a parameterized system. Random values can be used to emulate unpredictable qualities of our physical reality and to generate unexpected compositions. Though not as random as a toss of the dice, code provides a more flexible way to create random values. Sequences of random numbers can be generated in such a way that each number in the sequence differs only slightly from the last; this technique aids in the simulation of natural effects like wind, waves, and rock formations.[4] Although using random numbers to find interesting variations is not an efficient way to discover every possible form, it does provide a way to explore an exhaustively large parameter space in order to get an idea of possible outcomes. Even in a small system that uses only three parameters, each of which has a value from zero to 100, there are a million possibilities—far more than one can explore methodically.

[4] Ken Perlin greatly impacted the computer graphics world with his invention of Perlin Noise in 1985. This method for generating textures is widely used in computer graphics to create visual effects like smoke, fire, clouds, and organic motion.

PARAMETERIZE

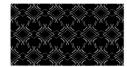

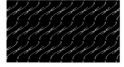

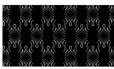

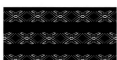

Two Space, by Larry Cuba, 1979 Cuba combined a set of nine tiles with twelve symmetrical pattern arrangements to create a mesmerizing animation. The white-on-black scheme creates optical illusions, figure-ground reversals, and after-image effects. The parametric organization of the software allows for any of the tiles to be combined with any of the patterning schemes.

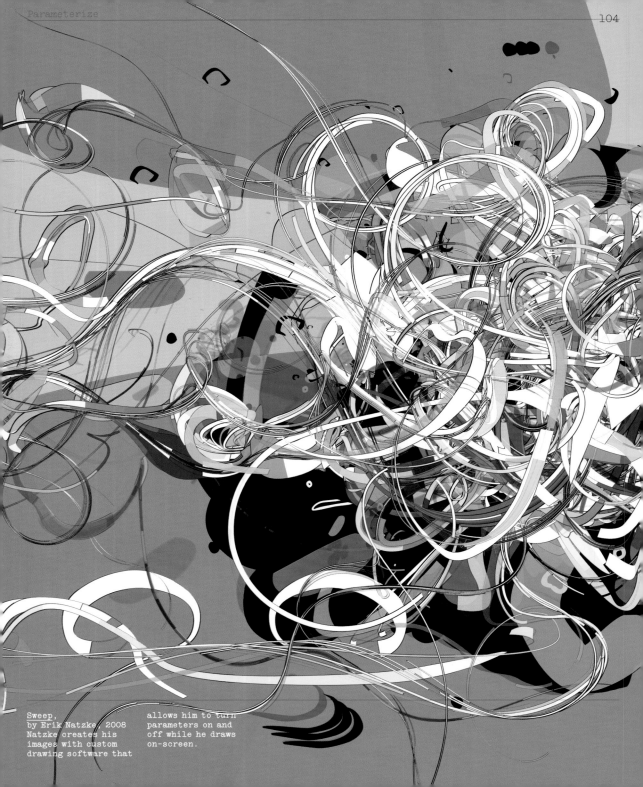

Sweep,
by Erik Natzke, 2008
Natzke creates his
images with custom
drawing software that
allows him to turn
parameters on and
off while he draws
on-screen.

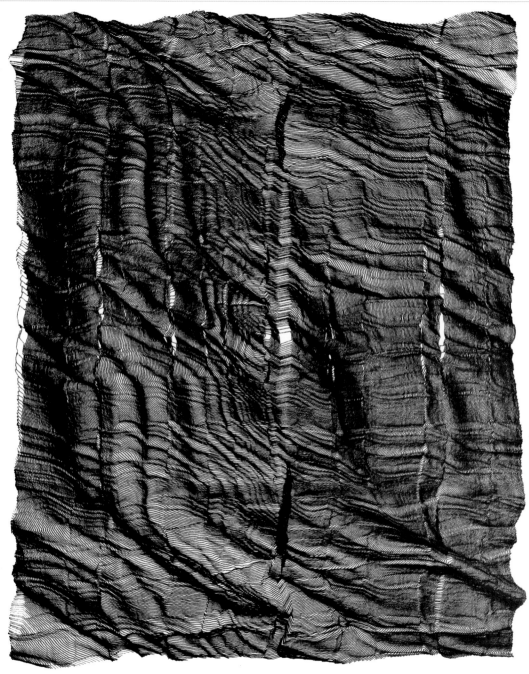

PARAMETERIZE

fractured landscape,
by Jean-Pierre Hébert,
2004
The shape of the lines
in this image were
generated entirely from
code, and drawn onto
paper by a mechanical
plotter. The physical
quality of this dense
drawing is impossible
to reproduce in a book.
The rich lines of the
pen's marks and the
high-quality paper
have an essence that
cannot be duplicated
using modern printing
processes.

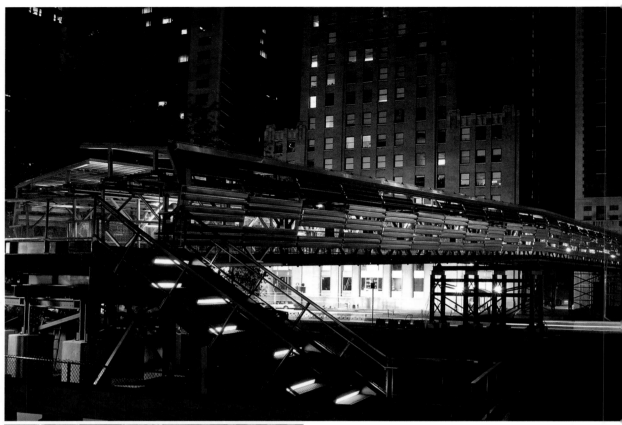

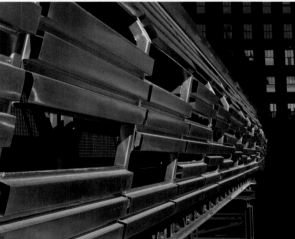

Rector Street Bridge
#1, by SHoP Architects,
2002
SHoP Architects was
asked to design and
construct a bridge in the shortest pos-
sible time. They used
parametric techniques
to meet these require-
ments and to create an
interesting system for augmenting a prefabri-
cated structure.

CONTROL

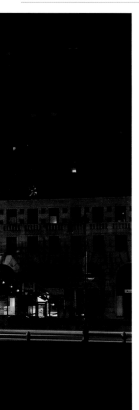

Parameters are often used to create a system that generates optimal variation within a given set of constraints. These constraints can be semifixed, meaning that they provide a boundary for the field of variations, but the constraints themselves can be changed when necessary. The most common example of this type of constraint is the cost of producing a variation. For example, a CNC-milling machine is a cost-effective digital fabrication technique, but most machines are not capable of producing shapes with undercut areas. The CNC bit sits on a computer-controlled arm that descends onto the material, so it can only remove the material on top. A parametric design system might take this into consideration by eliminating any design model that requires this type of cut. The constraint is semifixed, because it is always possible to use a different, more costly fabrication technology if necessary, or if the budget allows.

When the architecture firm SHoP Architects was commissioned by the Federal Emergency Management Agency (FEMA) to design a bridge in Lower Manhattan to restore a vital pedestrian connection that was lost after September 11, they used a combination of readymade structures and parametric design techniques to quickly create an interesting, cost-effective form. The architects wanted the exterior cladding of the bridge to let light in during the day and allow it to shine through at night, but also to discourage sightseers from stopping on the walkway. These programmatic constraints were combined with time and budgetary concerns, as well as the fixed geometry of the readymade bridge structure. Taking all of these elements into consideration, they were able to create a pattern using only a small number of unique pieces that gave the feel of a much more complex system.

In contrast to using random numbers to explore a field of possible designs, parametric systems can be controlled to determine the final form and to meet specific needs. In something akin to turning the knobs of an old television set to tune the picture, in this model, the designer first creates the system and defines the parameters, then inputs and adjusts specific settings to control and optimize the final output. Taking this one step further, it is possible to quantify and encode the designer's preferences or certain outcomes into the system. Less strict than a constraint, this allows flexibility in the range of possible variations, while encouraging the system to generate solutions that the designer likes.

Though parametric control is often understood in terms of numbers and variables, complex and unpredictable forms can be achieved by linking the parameters of multiple elements together. For example, an architect designing a staircase might want to connect the height of the staircase to the height of the ceiling, so that if the ceiling height changes, the staircase will adapt to the new values. The space of possible staircases is coupled to the properties of a single variation of the ceiling. This type of controlled coupling allows the designer to experiment and explore a field of possibilities, while simultaneously controlling related forms. In this way, parameters can be used to control things like proportion and scale without giving up the freedom to try different permutations.

PARAMETERIZE

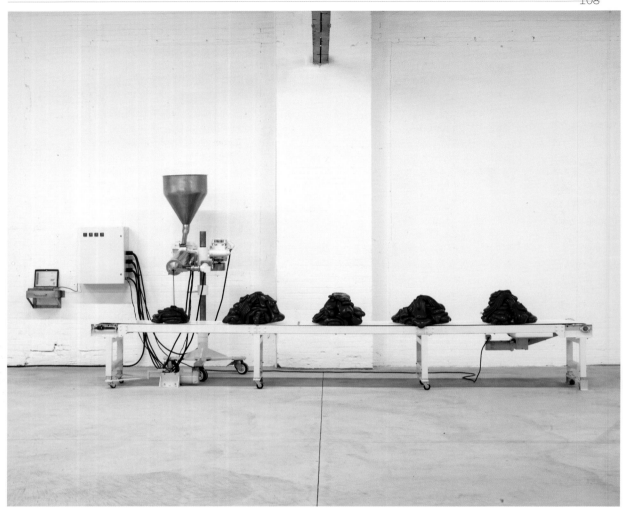

SCUMAK no. 2,
by Roxy Paine, 2001
Paine's machine resem-
bles industrial produc-
tion equipment, but it
produces idiosyncratic

blobs of polyethylene,
rather than mass-market
consumables. A software
program controls the
process: folding lay-
ers of material to

subvert the idea of mass
production and produce
a series of unique,
appealing objects.

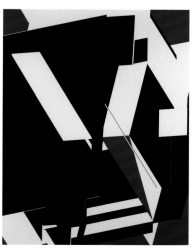

PARAMETER TECHNIQUE
ONE-OF-ONE

Using parameterized algorithms to generate form involves an exploratory process of searching through a field of designs to find interesting variations. As a result of this process, each variation is likely to appear related to but different from other possible versions. Depending on the number of parameters and the range of possible values, these resemblances can be subtle or extreme. When used in conjunction with repetition, these techniques allow artists and designers to straddle the boundary between creating serial editions and one-of-a-kind pieces. By presenting multiple versions, one-of-one works operate as singular pieces, but at the same time provide a window into the complexity of the system used in their creation.

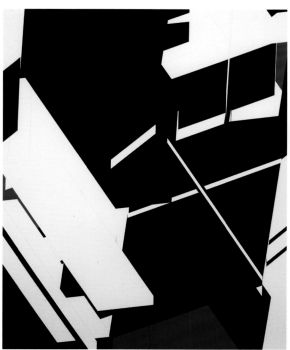

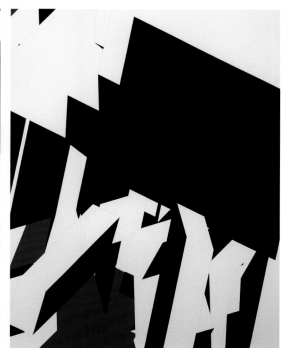

P1011-F1, P1011-H1, P1011-I1, by Manfred Mohr, 2004 Mohr explains that his software "selects a subset of cubes from a repertoire of 42,240 cubes inherent to the 11-d hyper-cube." Each image offers a view of the geometry through a window, as the structure rotates in eleven dimensions.

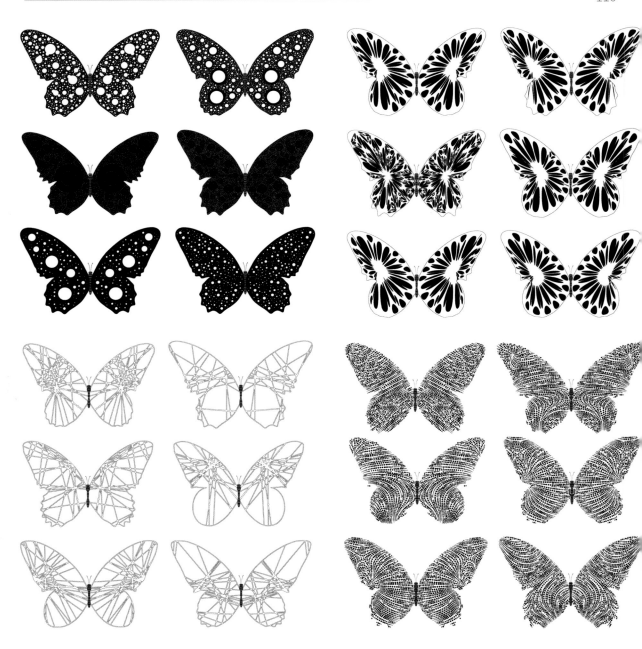

Biomimetic Butterflies, by The Barbarian Group, 2007
These wing patterns were created using custom algorithms, each parameterized to generate variety while preserving family resemblances.

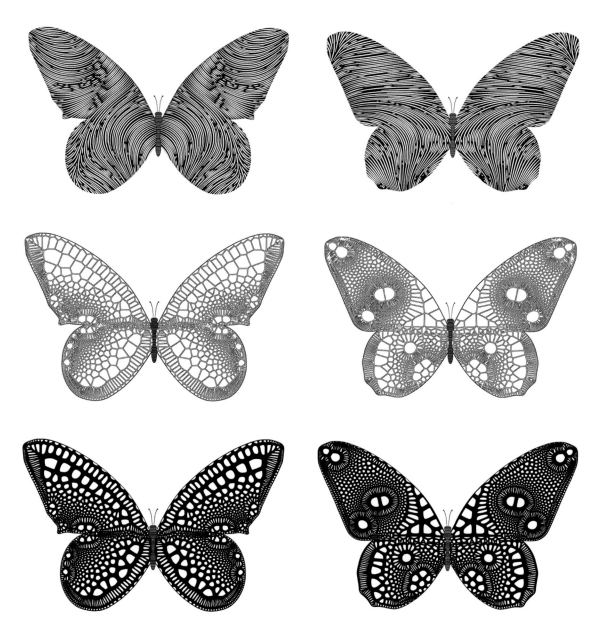

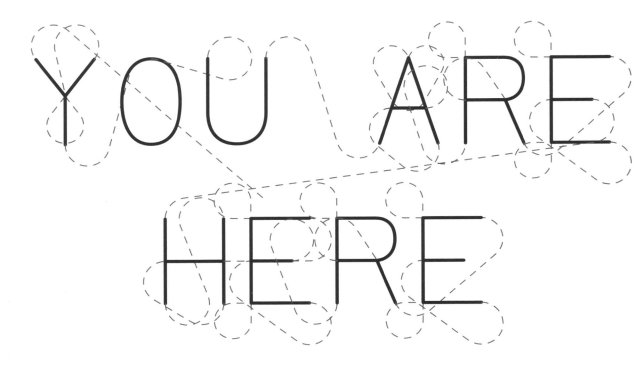

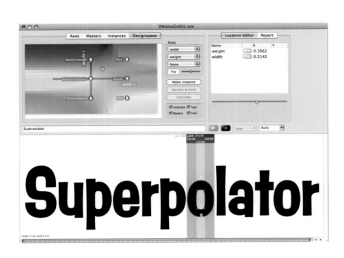

Scriptographer,
by Jürg Lehni,
2001-present
This plug-in is used
to write scripts for
Adobe Illustrator.
In this example, the

Scriptographer program
was used to calculate
the motion paths (shown
in red) for Hektor, a
computer-controlled
spray-paint device.

Superpolator,
by LettError, 2007
This software inter-
polates typographic
glyphs between multiple
axes. For example,
a simple font could

be generated using
weight and width axes.
A more intricate setup
could have an axis for
x-height, ascenders,
descenders, weight, and
contrast. Superpolator

provides an interface
for easily navigating
these axes and for view-
ing the changes through
animation.

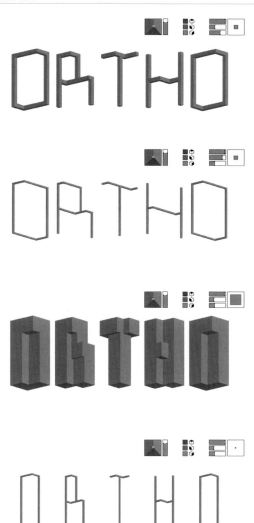

Since their invention, systems of writing have always been implicitly parameterized; the introduction of software has increased these possibilities. In ancient cuneiform writing, each symbol was made from a pattern of wedges impressed in clay. Changing the parameters, such as the quantity or size of the spaces between wedges, defined which character was written. This parameterization persisted to some degree in contemporary typefaces, but the Univers type family designed by Adrian Frutiger in 1954 was a landmark in this respect. Univers is a system of twenty-one related fonts, designed around the parameters of width, weight, and slant. The fonts range from Univers 39 Thin Ultra Condensed to Univers 83 Heavy Extended, with Univers 55 Roman as the base font.

Programming legend Donald E. Knuth's Metafont language from 1979 is a logical extension of Frutiger's plan. As the first fully parameterized software typeface, Metafont was capable of generating letters of every width and weight, because each was defined by a geometric equation. This idea was further commercialized by Adobe, with their Multiple Master (MM) technology. Like Metafont, an MM font such as Myriad or Minion could generate any width or weight according to the parameters set up by their designers. It remains an open question as to whether this kind of typographic flexibility is needed or even feasible, given that Adobe stopped producing MM faces in favor of the OpenType format. Nevertheless, this typographic quest was continued by LettError's Superpolator.

PARAMETERIZE

Ortho-Type, by Enrico Bravi, Mikkel Crone Koser, and Paolo Palma, 2004 This orthographic-projection typeface system provides control over the 3-D view, height, width, depth, thickness, and color.

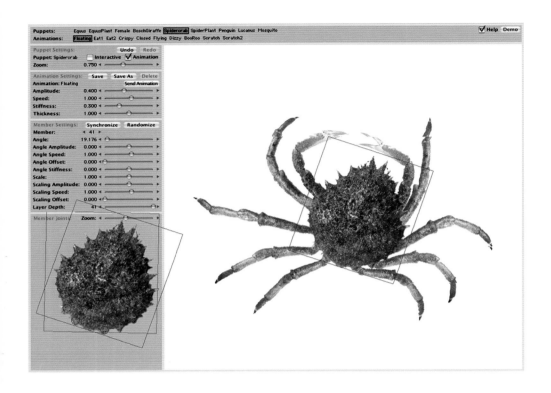

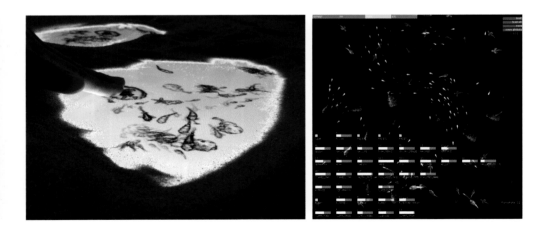

PuppetTool,
by LeCielEstBleu, 2002
The console on the left
of this software tool
controls a menagerie of
screen-based puppets.

It offers the abiity
to reconfigure and
distort the motion and
connections between
the limbs.

Oasis,
by Yunsil Heo and
Hyunwoo Bang, 2008
The behaviors of the
aquatic creatures in
Oasis have over thirty

parameters that can be
tuned to change their
behaviors. As part of
the design process,
this console allows
users to modify the

procedural animation
while it runs.

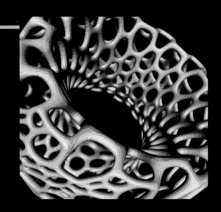

A console is a set of controls for electronic or mechanical equipment, such as cars, airplanes, radios, and milling machines. The structure of the console has migrated to software interfaces. For example, many computer games have a dense set of controls at the bottom of the screen, allowing players to monitor and control the status of the game. The values controlled through a software console are linked to variables within the program; they allow the state of the program to change without rewriting the code. Users can manipulate the program, even if they don't know how to program; and programmers can view changes immediately without stopping the program, changing variables in the code, and restarting. Consoles are used as interfaces for a wide range of tasks, including for designing buildings, flying a simulated airplane, or building avatars for online communities.

CONTROLS -
VIEW CONTROLS -
☐ 3D VIEW
☐ 2D UNROLLED VIEW
☐ SMOOTH PREVIEW
MESH STRUCTURE -
22 X DIVISIONS
8 Y DIVISIONS OUTSIDE
10 Y DIVISIONS INSIDE
 TWIST AMOUNT
 CLICK TO REGENERATE
MESH MODIFIERS -
15 HEIGHT
22.91 RADIUS
2.55 MAX THICKNESS
1.00 MIN THICKNESS
1.48 ROUNDNESS
EDGE CONTROLS -
 AMPLITUDE1
 2 FREQ1
PHASE1

 AMPLITUDE2
 2 FREQ2
PHASE2

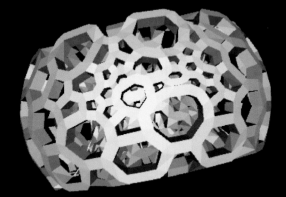

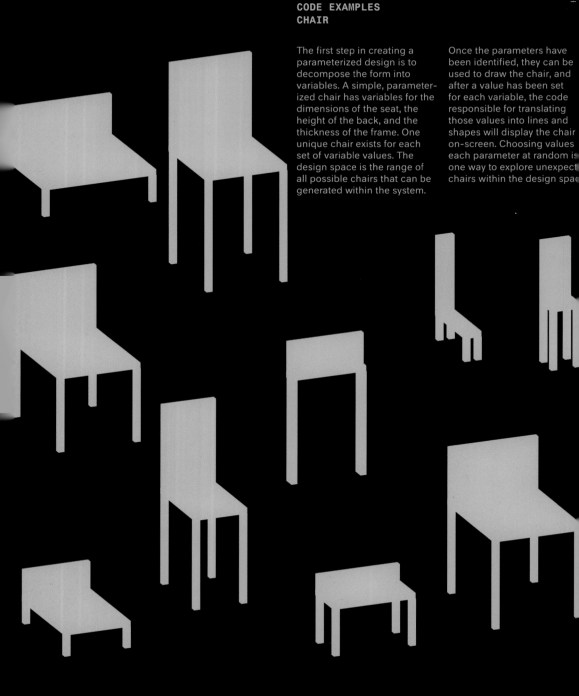

The first step in creating a parameterized design is to decompose the form into variables. A simple, parameterized chair has variables for the dimensions of the seat, the height of the back, and the thickness of the frame. One unique chair exists for each set of variable values. The design space is the range of all possible chairs that can be generated within the system.

Once the parameters have been identified, they can be used to draw the chair, and after a value has been set for each variable, the code responsible for translating those values into lines and shapes will display the chair on-screen. Choosing values each parameter at random is one way to explore unexpect chairs within the design spac

Parameters are powerful tools for controlling a series of objects. The behavior or form of each object can be connected to the value of one or more variables. The designer can think about more than just the individual objects—in this case a rectangle—and instead consider how a population of those objects could combine to create a larger form. Here, the rotation of each rectangle is linked to the rotations of its neighbors. This type of parameterization lends itself to the creation of complex patterns.

The pattern begins with a row of rectangles, each slightly rotated to a random angle. The rotation of each row is determined by the rotation of the rectangle above it. At first, the rotations proceed clockwise, but to prevent overlap, the direction reverses if the new rotation value is too large or small.

Visualizatio

derstanding

communica

it's a way o

ing someth

ten or other

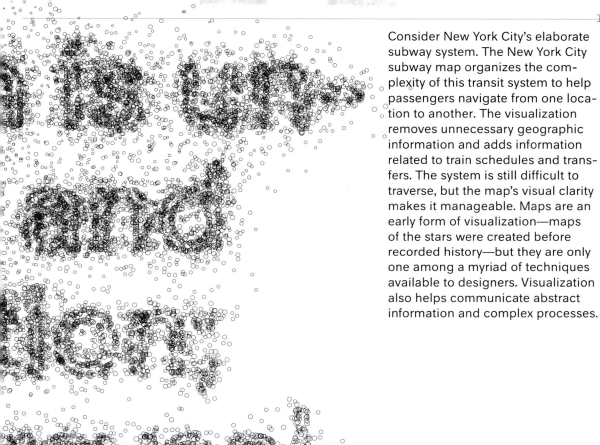

Consider New York City's elaborate subway system. The New York City subway map organizes the complexity of this transit system to help passengers navigate from one location to another. The visualization removes unnecessary geographic information and adds information related to train schedules and transfers. The system is still difficult to traverse, but the map's visual clarity makes it manageable. Maps are an early form of visualization—maps of the stars were created before recorded history—but they are only one among a myriad of techniques available to designers. Visualization also helps communicate abstract information and complex processes.

VISUALIZE

These letters were created using a particle system. The particles are attracted to a unique position within a set of interrelated points and, over time, they move toward a single point. This software demonstrates the potential for data visualization to bring clarity to an otherwise chaotic system.

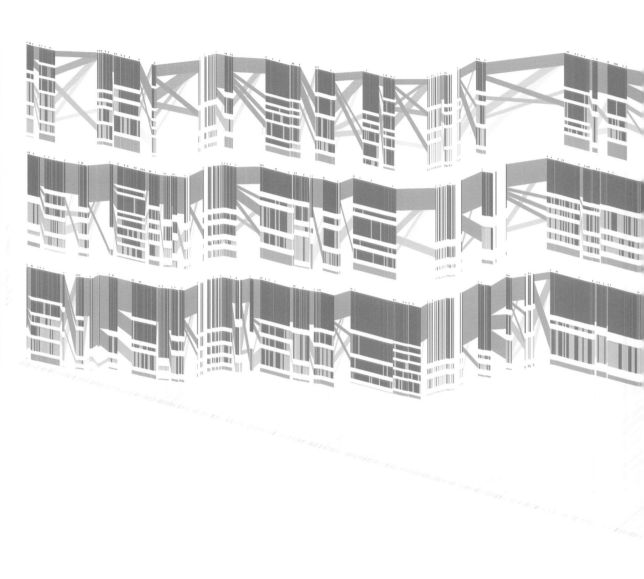

isometricblocks,
by Ben Fry, 2003
Fry worked closely with
researchers at the
Broad Institute of MIT
and Harvard to create

this visualization of
human genome data. It
visualizes single let-
ter changes (SNPs) of
the genome data for
approximately 100

people. It transitions
fluidly between com-
mon representations for
viewing the same data,
therefore revealing the

relationship between
each technique.

DATA INTO FORM

People have a remarkable ability to understand data when it's presented as an image. As researcher Stuart K. Card says, "To understand something is called 'seeing' it. We try to make our ideas 'clear,' to bring them into 'focus,' to 'arrange' our thoughts."[1] Like written words, visual language is composed to construct meaning. Our brains are wired to make sense of visual images. In contrast, it can take years of education to develop the ability to read even the simplest article in a newspaper. The fundamentals of visual understanding, originally pursued by Gestalt psychologists in the early twentieth century, are now researched at a deeper level within the field of cognitive psychology. The findings of this research have been communicated within the visual arts by educators including György Kepes, Donis A. Dondis, and Rudolf Arnheim, as well as through the work of visualization pioneers such as William Playfair, John Tukey, and Jacques Bertin. Data presentation techniques that combine our innate knowledge with learned skills make data easier to understand. In The Visual Display of Quantitative Information, Edward Tufte presents a data set and representation that supports this claim. Compare the tabular data to the scatterplot representation to see how the patterns become immediately clear when presented in the second format.

[1] Stuart K. Card, Jock Mackinlay, and Ben Shneiderman, Readings in Information Visualization: Using Vision to Think (San Francisco: Morgan Kaufmann, 1999), 1.

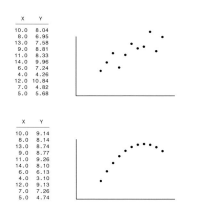

X	Y
10.0	8.04
8.0	6.95
13.0	7.58
9.0	8.81
11.0	8.33
14.0	9.96
6.0	7.24
4.0	4.26
12.0	10.84
7.0	4.82
5.0	5.68

X	Y
10.0	9.14
8.0	8.14
13.0	8.74
9.0	8.77
11.0	9.26
14.0	8.10
6.0	6.13
4.0	3.10
12.0	9.13
7.0	7.26
5.0	4.74

[2] Edward R. Tufte, Visual Explanations: Images and Quantities, Evidence and Narrative (Cheshire, CT: Graphics Press, 1997), 45.

In his book Semiology of Graphics: Diagrams, Networks, Maps, Bertin presents another clear example of the communicative power of visual representation.

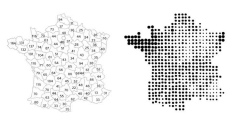

The maps of France on the left and right both present the same sociographic data, divided by canton (a French territorial subdivision). The representation on the right replaces each number with a circle sized to correspond to the numerical value. We can spend time analyzing the left map to see where there are concentrations of larger numbers, but on the right map we instantly comprehend the increased density in the upper left.

In the same book, Bertin introduces a series of variables that can be used to visually distinguish data elements: size, value, texture, color, orientation, and shape. For example, a bar chart distinguishes data through the height of each bar, and different train routes on a transit map are typically distinguished with color. For visualizations using only one variable, each element can be used in isolation. For multivariate visualizations (containing more than one variable) elements are combined.

When applying form to data, there are always questions about goodness of fit, meaning how well the representation fits the data. Visualizations can mislead as well as enlighten. As Tufte warns in Visual Explanations: Images and Quantities, Evidence and Narrative, "There are right ways and wrong ways to show data; there are displays that reveal the truth and displays that do not."[2] In Bertin's maps of France, the goodness of fit of the

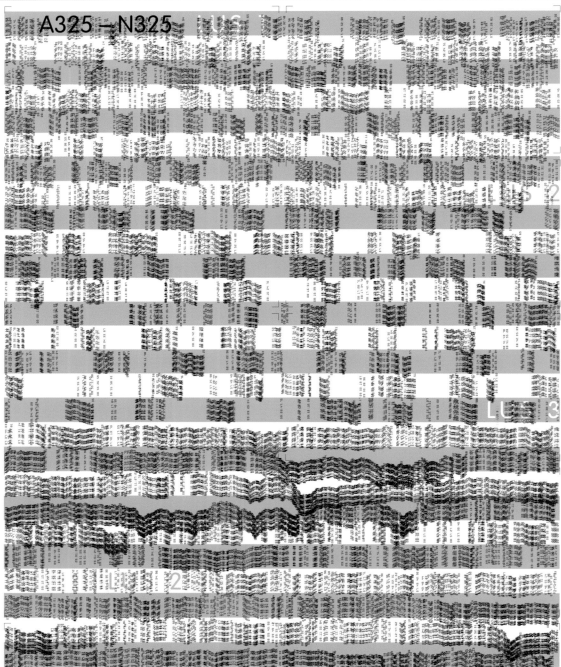

A325 – N325

Vinec,
by Catalogtree, 2005
This graphic shows data
for 10,000 cars cross-
ing a bridge between
the cities of Arnhem
and Nijmegen in the
Netherlands between
07:36 and 09:13 am.
The horizontal axis
for each unit shows the
distance between the
vehicles and the ver-
tical axis shows the
difference between the
measured speed and the
speed limit.

FD-6

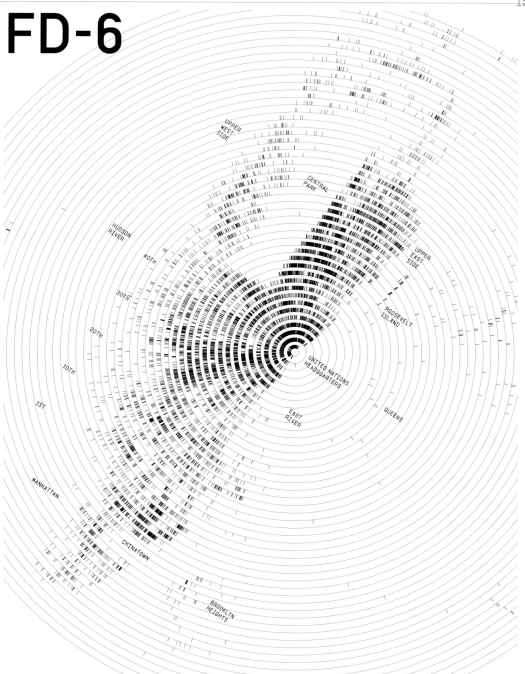

VISUALIZE

Flocking Diplomats,
by Catalogtree, 2008
Between 1998 and 2005,
diplomats in New York
City were responsible
for 143,703 parking
violations.

This visualization
shows each violation
at its location within
the city, with the
United Nations at the
epicenter.

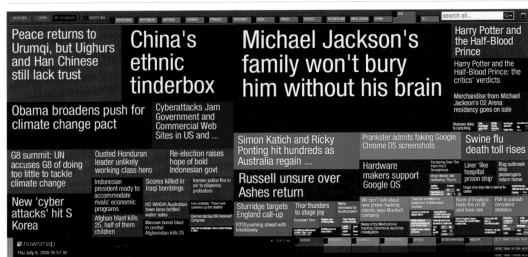

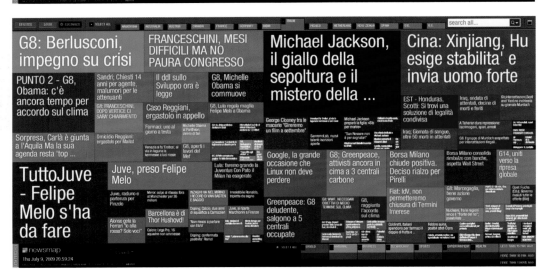

Newsmap,
by Marcos Weskamp,
2004-9
The Newsmap visual-
izes the changing
landscape of the Google
News aggregator. The
interface allows
users to view the news from
one or more of eleven
countries and to view
articles from seven
categories.

3 Ben Shneiderman and Catherine Plaisant, "Treemaps for space-constrained visualization of hierarchies," http://www.cs.umd.edu/hcil/treemap-history/.

representations reveals information hidden within the data. Because each piece of data derives from a particular canton, associating that data with its location on a map allows us to see regional patterns. Presenting the data in a table that is organized alphabetically would not reveal this pattern. By applying the same visualization technique to a different map—a map of Europe, for example—would also not work as well. The Bertin map works because each canton is roughly the same size, but the size differences among European countries would dilute the visual patterns needed for interpretation. In this case, the data is tightly linked to a source (geography), but in other instances data can be more abstract, such as when revealing patterns in language. The visualization techniques that follow in the next section present other options for revealing patterns in data.

There are hundreds of distinct visualization techniques that can be organized into categories, including tables, charts, diagrams, graphs, and maps. When creating a new visualization, one technique is selected instead of another based on the organization of the data and what the visualization is meant to convey. Data representations that commonly appear in newspapers, such as bar charts, pie charts, and line graphs, were all developed before people relied on software; in fact, most commonly used data representation techniques are only useful for representing simple data (1- and 2-D data sets). These techniques are automated within frequently used software tools such as Microsoft Excel, Adobe Illustrator, and related programs. Visualizing information, once a specialized activity, is becoming a part of mass culture.

Writing new software is one approach to move beyond common data representations. New visualization techniques emerge as researchers and designers write software to fulfill their growing needs. The treemap technique is a good example to demonstrate the origins and evolution of a new visualization. It also shows how techniques often arise within a research group and are visually

refined as designers use them in diverse contexts.

A treemap is a visualization that utilizes nested rectangles to show the relations between one or more data elements. They are effective because they allow for easy 2-D size comparisons. The story of the first treemaps, from their origin to the present, is documented by the technique's originator, Ben Shneiderman, a professor at the University of Maryland.[3] The first treemaps were developed in 1991 as a way to show the memory usage on a computer hard drive. After subsequent applications and further development, the public at-large was introduced to treemaps by Map of the Market, an Internet application created by smartmoney.com in 1998. This application introduced the innovation of making the tiles close to square, rather than using the thin tiles of previous treemaps, to increase legibility. The circular treemap technique explored by interface designer Kai Wetzel in 2003 pushed the form of treemaps even further. Wetzel worked on this representation as one of many ideas for a Linux operating system interface. He recognized that the approach wastes space and the algorithm is slower, but the aspect ratio of each node is the same. The 2004 Newsmap application by Marcos Weskamp applied treemaps to the headlines of news articles compiled from the Google News aggregator. The treemap representation makes is easy to see how many articles are published within each news category. For example, the visualization makes clear that, in England, the highest volume of published articles is world news rather than national stories, while in Italy, the reverse is true. By 2007, through the refinement of these and other initiatives, the treemap technique had become so ubiquitous that it was used in the New York Times with the expectation that a general audience can understand it.

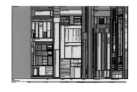

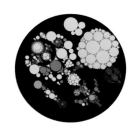

VISUALIZE

Treemaps,
by Ben Shneiderman and Brian Johnson, 1991
This visualization depicts the file contents of a networked

computer's hard drive that is shared by fourteen people. It shows who was using the most space and which large files (represented

by large rectangles) could be deleted to make space.

Circular Treemaps,
by Kai Wetzel, 2003
Like the original Treemaps, this visualization also depicts file space on a hard drive. In this

variation, the age of the file is shown with color. Red is applied to new files and the oldest files are a soft yellow.

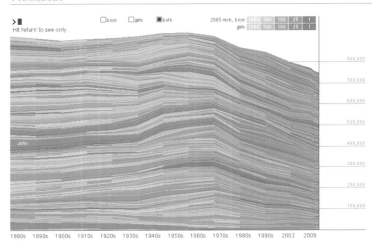

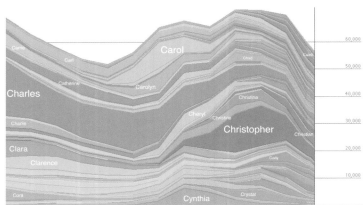

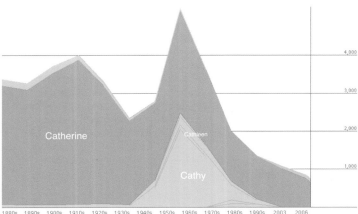

NameVoyager,
by Laura and Martin
Wattenberg, 2005
The NameVoyager shows
the popularity of baby
names in the United

States from the 1880s
to the present. The
thickness of each
name's color band
shows how many babies
were given that name

each year. Names are
selected by clicking on
its band or by typing.
Type a single letter
to refine the search to
only names beginning

with that letter. Type
an additional letter
to further narrow the
search.

DYNAMIC FILTERS

The era of modern data analysis began with the 1890 U.S. Census. The Census Bureau realized that the population was growing so quickly that, using their existing analysis method, the newly collected data would be out of date by the time it was evaluated. Herman Hollerith was commissioned to build a machine to automate the process. He succeeded by developing punch cards to store data and a machine to read them. Since that time, computing machines have enabled an unprecedented ability to acquire data. Today, it's no longer possible to rely solely on static, paper representations. The deluge of data created by the information age has made new forms of software analysis necessary.

When there is more data than can be viewed at one time, it's necessary to limit the amount that is displayed. This process is called filtering or querying. An internet search is an act of filtering. The internet is such a large data source that to get value from it, search terms are used to limit what is seen at any given time. A tool for filtering can provide different levels of control, often corresponding to its use at a basic or expert level. For instance, when searching the web, it's possible to make a simple search where only keywords are input, but it's also possible to select a broad range of criteria such as file type and date to further refine the results. A real estate database is a good example of a large data set that becomes more useful with a filter. It doesn't make sense to look for all available listings for apartments, houses, and condominiums if you're only looking for one of the options. A tool like this becomes even more useful to search by a specific price, size, or neighborhood. In fact, a 1992 research project called the Dynamic Home Finder, developed by Christopher Williamson at the University of Maryland, was an early prototype for such a system.

Another example is the NameVoyager by Laura and Martin Wattenberg. It's a clear example of a continuous visualization that is accessed through a dynamic filter. The project presents a simple way to discover the popularity of nearly 5,000 baby names used in the United States from the 1880s to the present. For example, by typing the name Deanna, we see this name originated in the 1920s, reached its peak in the late 1960s, and has since become less common. The interface begins with a stacked-graph representation of all names in the data set. When a letter is typed, the search narrows to reveal only those names that begin with the specified letter. For example, typing the letter C reveals the historic popularity of Christopher and Charles. Further inputting an A and T reveals that Catherine is the most popular name that begins with Cat and also shows the relative obscurity of Catalina and Catina, among others.

A group of photographs is also a database that may be filtered and navigated. The proliferation of online digital photographs has created a fascinating data set to be explored through image searching. Jonathan Harris's The Whale Hunt is an elegant example of navigating a large series of images. He travelled to Alaska to participate in a whaling expedition with a family of Inupiat Eskimos. He took 3,214 photos from the time he left New York City to returning home nine days later. By default, the images are presented sequentially, but he also allows viewers to navigate in other ways. It's possible to jump to any image in the timeline, pause, and change the pace. But more interestingly, it's possible to select a subset of images based on categories. By using a fluid and clear interface, images can be filtered according to a concept (e.g. blood, boats, buildings), context (e.g. New York City, Alaska, the Patkotak family house), or a member of the cast (e.g. Abe, Ahmakak, Andrew). After one or more selections are made, the image sequence is automatically edited and the story told through the images is changed to reflect the filters.

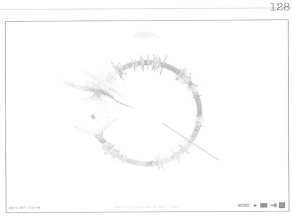

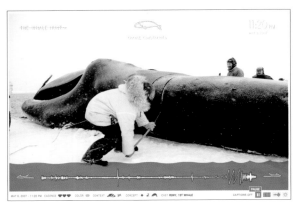

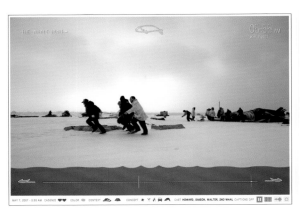

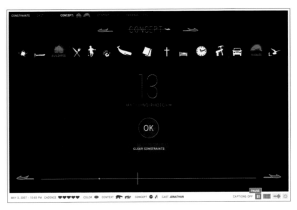

The Whale Hunt,
by Jonathan Harris,
2007
The Whale Hunt is an
experimental inter-
face for storytelling.

Viewers may rearrange
the photographic ele-
ments of a story to
extract multiple sub-
stories focused around
different people,

places, topics, and
other variables.

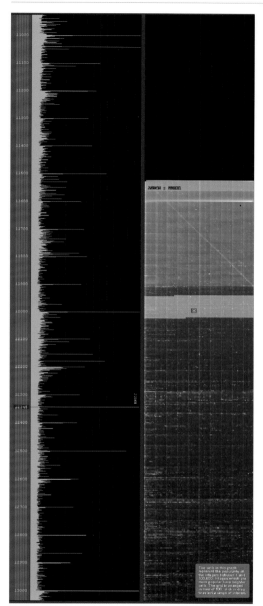

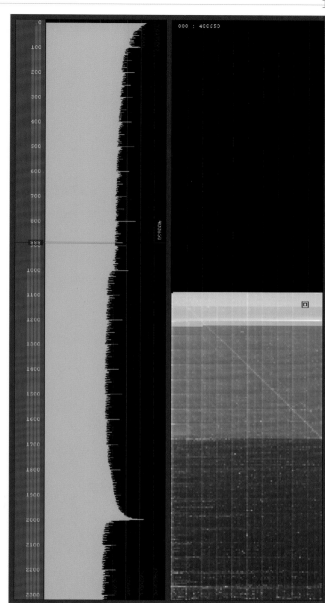

The Secret Lives of Numbers, by Golan Levin with Martin Wattenberg, Jonathan Feinberg, Shelly Wynecoop, David Elashoff, and David Becker, 2002 This web-based project reveals the relative popularity of every integer between zero and one million according to their frequency on web pages. The interface allows for exploration of this massive data set and provides a novel lens for viewing social patterns. Levin states, "Certain numbers, such as 212, 486, 911, 1040, 1492, 1776, 68040, or 90210, occur more frequently than their neighbors because they are used to denominate the phone numbers, tax forms, computer chips, famous dates, or television programs that figure prominently in our culture."

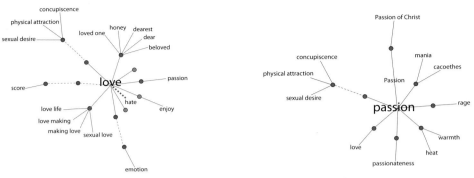

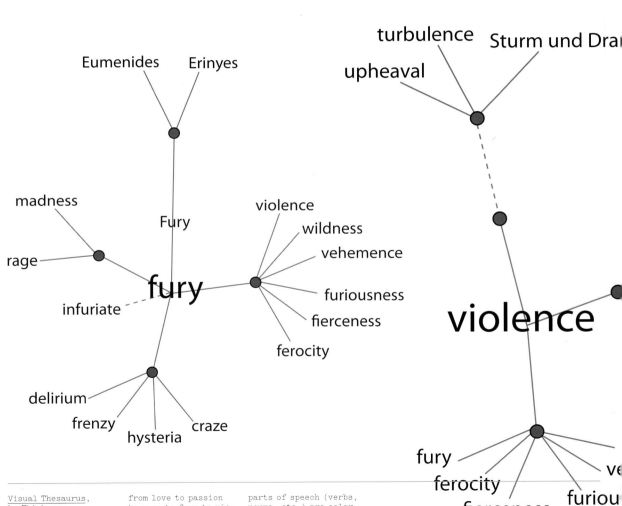

Visual Thesaurus,
by Thinkmap,
1998-present
When a word is select-
ed, a new set of related
words emerges. In these
images, follow the path from love to passion
to rage to fury to vio-
lence. Related words
are connected with gray
lines and antonyms are
connected with red-
dashed lines. Different parts of speech (verbs,
nouns, etc.) are color-
coded. Try it at
www.visualthesaurus.
com.

NAVIGATION

Some early forms of data navigation might have included flipping through clay tablets, moving through a room painted with hieroglyphs, and rolling and unrolling a scroll. Early books improved upon scrolls because they allowed the reader to move quickly between sections in the text and could be smaller and therefore easier to carry. Book conventions such as the index, page numbers, and table of contents developed slowly. Despite thousands of years of refine·ment and the widespread proliferation of the Internet, we're still scrolling and viewing data on pages. The unique tool for looking at and navigating pages on the web is the hyperlink, a link from one page to another. Ted Nelson coined the phrase hypertext in the 1960s to describe this concept. Since that time, designers and researchers have pushed forward this and other innovative navigation concepts by writing software.

As an example, imagine the data inside a thesaurus. There's a list of thousands of words in addition to all of the relations from each word to others. To explore this data, you look up one word, which you may then follow to another, and so on. Even the small amount of time needed to hunt for the next word can break the flow. The Visual Thesaurus software, written by Thinkmap, makes navigating language relations a more fluid experience. The software shows a network of words related to the currently selected word. Clicking on one of the outlying words makes it the center, and new words appear that relate to it, while the former relations disappear. The interface allows the user to see the context around the current selection, but avoids overwhelming the senses with additional layers of nonrelevant information.

Spatial navigation is an emerging technique for exploring data, but it has roots that are thousands of years old. The ancient memorization technique Method of Loci, sometimes called a Memory Palace, places information inside imagined rooms within the mind to enhance recall by associating data with a mentally navigable space.

The sci-fi novels of William Gibson introduced intriguing concepts for spatial data navigation. In Neuromancer, published in 1984, he wrote about "rich fields of data" and described a vision of cyberspace: "A graphic representation of data abstracted from the banks of every computer in the human system."[4] Although Gibson's world was fictional, a related real-world concept was developed by designer Lisa Strausfeld in 1995. She describes her software, Financial Viewpoints, as follows:

> Imagine yourself without size or weight. You are in a zero-gravity space and you see an object in the distance. As you fly towards it, you are able to recognize the object as a financial portfolio. From this distance the form of the object conveys that the portfolio is doing well. You move closer. As you near the object, you pass through an atmosphere of information about net assets and overall return statistics. You continue moving closer. Suddenly you stop and look around. The financial portfolio is no longer an object, but a space that you now inhabit. Information surrounds you.[5]

At that time, Strausfeld was a research assistant in the Visible Language Workshop (VLW) at the MIT Media Lab. The research group was directed by Muriel Cooper, who set out to discover what graphic design could mean in the new era of communications, through the use of software applications. David Small, another researcher in the group, used software to present large bodies of text within a single navigable environment. His Virtual Shakespeare presents the entire works of William Shakespeare within one continuously navigable space. From the long view, only the names of individual plays, such as Hamlet and Henry V, are visible, but as you zoom closer, the acts come into view as rectangular textures, and finally it's possible to read the dialog and stage directions.

[4] William Gibson, Neuromancer (New York: Ace, 1984), 51.

[5] Lisa Strausfeld, "Financial Viewpoints: Using point-of-view to enable understanding of information," http://sigchi.org/chi95/Electronic/documnts/shortppr/lss_bdy.htm.

force

ss
ice

VISUALIZE

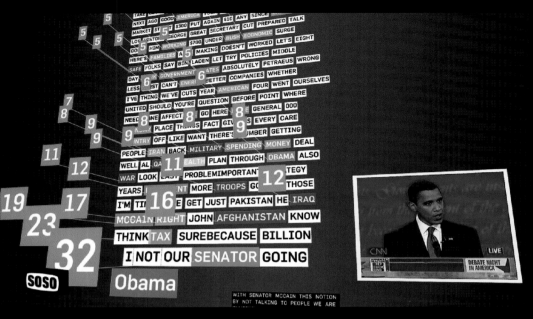

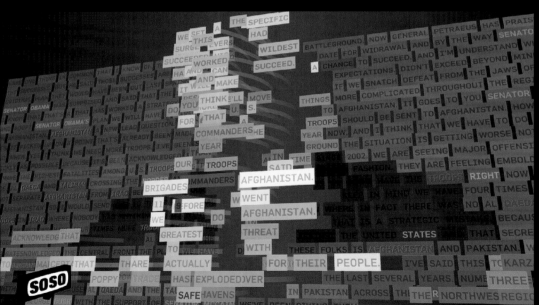

ReConstitution,
by Sosolimited (Eric
Gunther, Justin Manor,
and John Rothenberg),
2008

This software was
written for use with
live performances dur-
ing three presidential
debates between Barack

Obama and John McCain.
Algorithms were
applied to the live
images and closed cap-
tions to dynamically

visualize the way lan-
guage was used during
the debates.

...ng out a young man's revenue.

0HIPPOLYTA
Four days will quickly steep themselves in night,
Four nights will quickly dream away the time;
And then the moon, like to a silver bow
New bent in heaven, shall behold the night
Of our solemnities.

THESEUS
Go, Philostrate,
20 Stir up the Athenian youth to merriments.
Awake the pert and nimble spirit of mirth.
Turn melancholy forth to funerals
The pale companion is not for our pomp.

[[Exit Philostrate]]
Hippolyta, I wooed thee with my sword,
And won thy love doing thee injuries.
But I will wed thee in another key
With pomp, with triumph, and with revelling.

30[Enter Egeus and his daughter Hermia, and Lysander and Demetrius]

EGEUS
Happy be Theseus, our renowned Duke.

THESEUS
Thanks, good Egeus. What's the news with thee?

EGEUS
Full of vexation come I, with complaint
40 Against my child, my daughter Hermia.
Stand forth Demetrius. My noble lord,
This man hath my consent to marry her.
Stand forth Lysander. And, my gracious Duke,

A short comic drama, or any short entertainment, originally performed between more serious dramatic pieces. The interlude originated in medieval times, to provide light entertainment between morality or mystery plays.

Is all our company here?

...vold Bottom the weaver, and Flute the bellows-mender, and Snout the tinker.

BOTTOM
You were best to call them generally, man by man, according to the scrip.

QUINCE
10 Here is the scroll of every man's name which is thought fit through all Athens to play in our interlude before the Duke and the Duchess on his wedding-day at night.

BOTTOM
First, good Peter Quince, say what the play treats on; then read the names of the actors; and so grow to a point.

20QUINCE
Marry, our play is
[The Most Lamentable Comedy]
and Most Cruel Death of Pyramus and Thisbe.

BOTTOM
A very good piece of work, I assure you, and a merry. Now, good Peter Quince, call forth your actors by the scroll. Masters, spread yourselves.

30QUINCE
Answer as I call you. Nick Bottom, the weaver?

BOTTOM
Ready. Name what part I am for, and proceed.

QUINCE
You, Nick Bottom, are set down for Pyramus.

BOTTOM
40 What is Pyramus? A lover or a tyrant?

QUINCE
A lover, that kills himself most gallant for love.

BOTTOM
...in the true performing

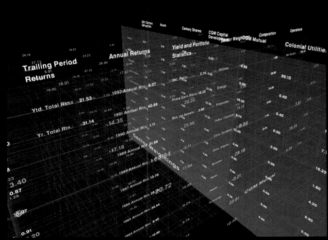
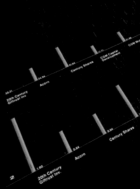

Virtual Shakespeare, by David Small, 1994 Utilizing software's ability to dynamically scale typography, Small presents all of Shakespeare's plays within a navigable environment. From far away, each play looks like a column of lines. As you navigate closer, each character's dialog is revealed.

Financial Viewpoints, by Lisa Strausfeld, 1995 Strausfeld defines her project as "an experimental interactive 3-D information space that spatially and volumetrically represents a portfolio of seven mutual funds. A 3-D point of view is used to represent context, and context shifts in the information to allow users to view multiple representations of the information in a continuous environment."

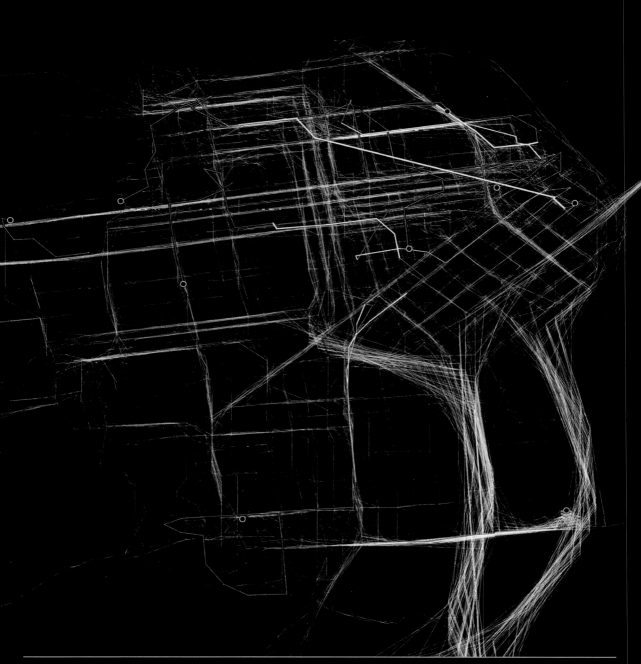

<u>Cabspotting,</u>
by Stamen design with
Scott Snibbe, Amy
Balkin, Gabriel Dunne
and Ryan Alexander,
2006–8

To track the move-
ment of taxis around
the San Francisco
Bay Area, Global
Positioning System
(GPS) devices were

attached to the vehi-
cles. Lines are drawn
to connect the GPS
data points, show-
ing the taxis' paths
as they navigate the

city. The city grid
and circulation pat-
terns are revealed
through line density.

VISUALIZATION TECHNIQUE
TIME SERIES

A time-series visualization shows data collected over a long period within a single image. It compresses many moments into a single frame. A time-series image can be a single, static image or it can be an animated image that combines data through motion. By using time as the ordering principle, changes become clearer.

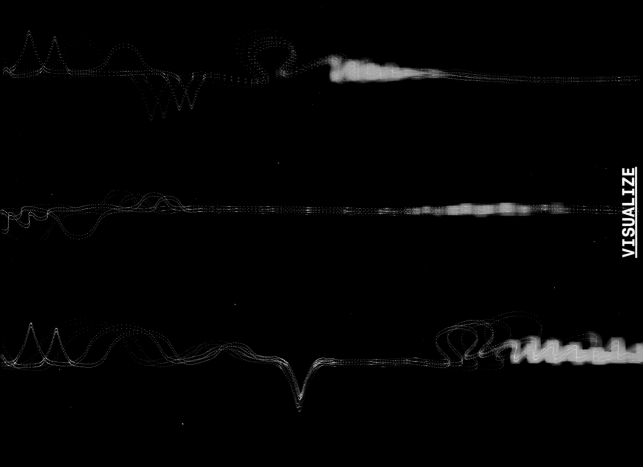

Takeluma,
by Peter Cho, 2005
Takeluma is an innovative alphabet that displays the rhythms and emphases of human

speech. Each letter relates to the visual quality of a consonant or vowel sound. The characters are different from any known

alphabet, but each glyph has an analog within the English alphabet. Language flows into a single expressive line.

This image represents part of the Neil Armstrong quote, "That's one small step for man, one giant leap for mankind."

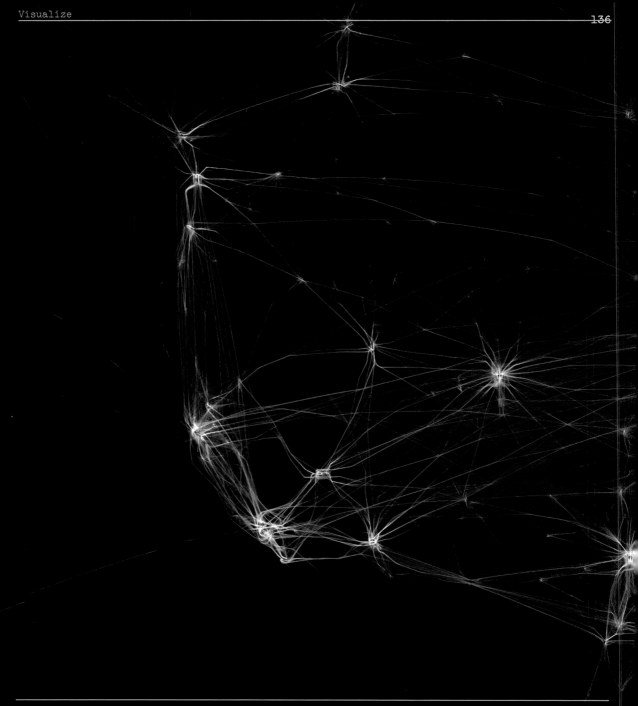

Flight Patterns,
by Aaron Koblin, 2005–9
The animated path of
each plane is shown as
a line delineating where

the plane is and where it
was, therefore implying
its destination. This
gives insight into the
nature of the invisible

high-ways far above
the ground. Population
clusters are visible
through the densities
of patterns.

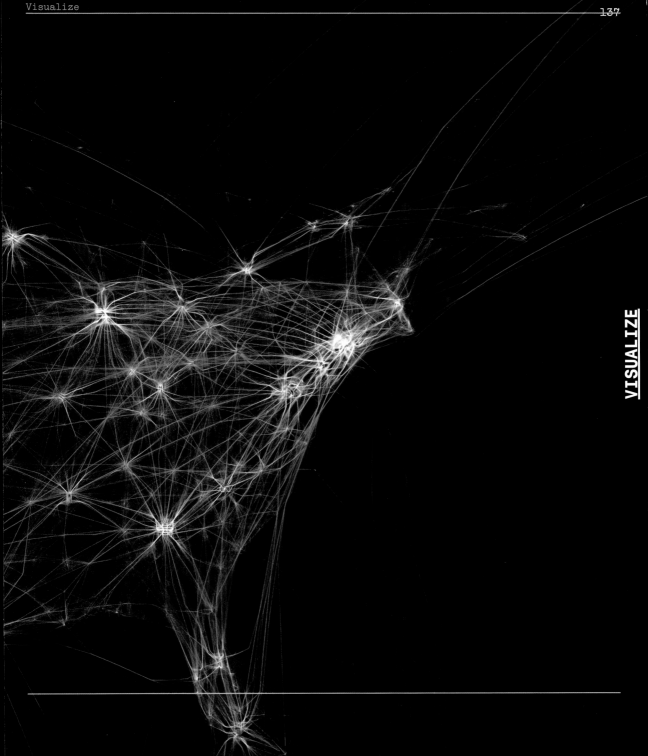

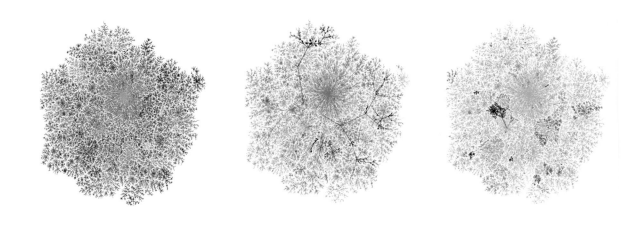

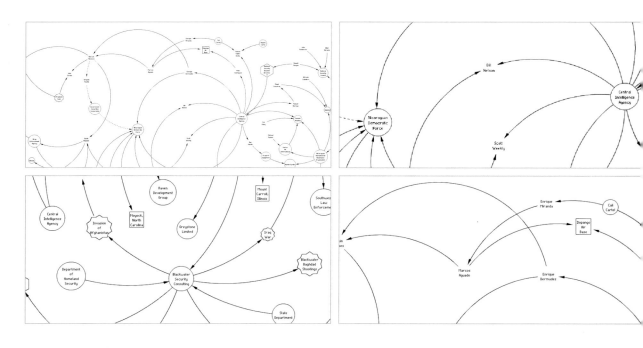

The Internet Mapping Project, by Bill Cheswick and Hal Burch, 1998 These images were the first attempts to assign an appropriate visual form to the Internet. They captured the public's imagination; from left: color is applied in relation to the distance from the test host, as a function of the network address, colored by the top-level domain (the black areas are .mil sites) and by the Internet service provider.

Power Structures, by Aaron Siegel, 2008 These drawings build on the work of Mark Lombardi, an artist who depicted crime and conspiracy information as visual networks. It is a relational database and mapping tool that allows users to contribute data and draw relationships.

VISUALIZATION TECHNIQUE
NETWORKS

As social, political, and technical networks become denser and more complex, widespread interest in visualization is growing. Provocative visualizations help us to better understand the sometimes invisible relationships that affect our world. Network diagrams frequently include two types of elements: nodes and connections. A node is an individual element (a person, country, or computer) and connections show relationships between the nodes. Visualizations help us to see different types of networks: centralized (star), decentralized (hybrid), and distributed (grid or mesh). These different organizations were elegantly diagramed in 1962 by Paul Baran, one of the conceptual architects of the Internet.

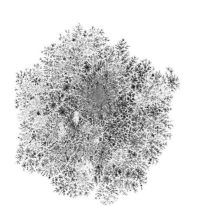

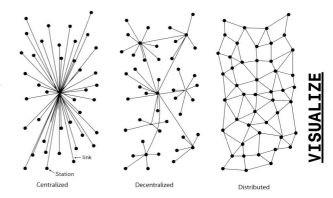

Centralized Decentralized Distributed

VISUALIZE

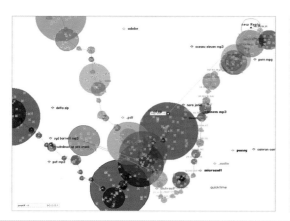

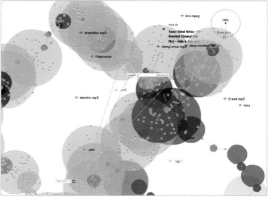

Minitasking,
by Schoenerwissen/
OfCD, 2002
With the rise of
Internet file sharing,
the duo of Anne Pascual
and Marcus Hauer built

Minitasking to reveal
the ad hoc networks
created through the
Gnutella network, a
peer-to-peer proto-
col for sharing files.
Data fed into the

visualization as the
transactions occurred,
revealing the struc-
ture, filenames, and
rhythm.

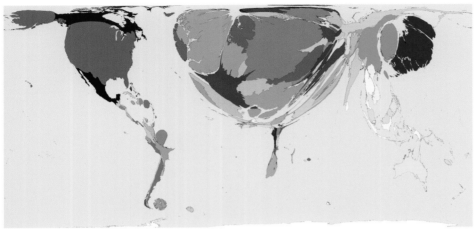

Tourism expenditure

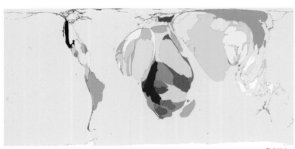

Child labor

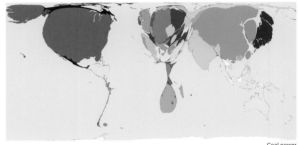

Coal power

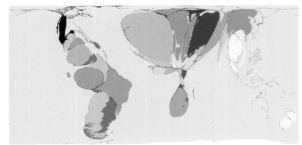

Fruit export

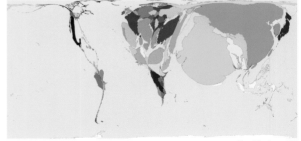

Population in year 1 CE

Worldmapper.org, 2006
In these cartograms, information is communicated through deformations in the size of each territory represented in the data being mapped. For example, in the map representing Coal Power, the territory size shows the proportion of worldwide electricity generated from the coal produced there. Because the United States produces a high amount of energy from coal, its size is proportionally larger than countries that produce a smaller amount. This type of map helps the viewer see differences immediately; clockwise from top, the maps show: tourist expenditure, coal power, population in the year 1 CE, fruit exports, and child labor.

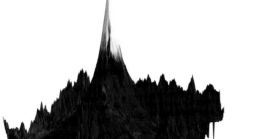

Most maps show many layers of information within a single surface. For example, a single map might show the locations of roads, landmarks, topography, and political borders. Because the sophisticated language and representation of maps are so familiar, they provide a good foundation for additional layers of information. Adding changes in time and geometric distortion are effective ways to push the conventions further.

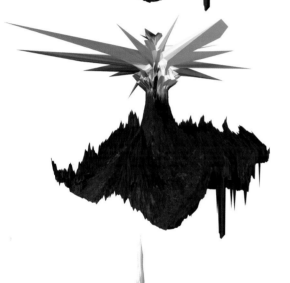

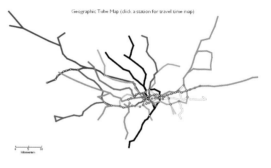

Geographic Tube Map (click a station for travel time map)

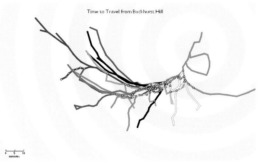

Time to Travel from Buckhurst Hill

VISUALIZE

Impressing Velocity, by Masaki Fujihata, 1994
A 3-D map of Mount Fuji was distorted by the GPS data gathered from Fujihata's ascent

(middle) and descent (bottom) from the mountain. The decreased climbing speed near the summit is reflected in extreme distortion at the peak.

Travel Time Tube Map, by Tom Carden, 2005
This map reimagines the draftsman Henry Beck's classic Underground Map as a malleable space. It warps to show the

time between stations, rather than simply their order. When a station is selected, it becomes the center of the diagram and all of the other stations

are organized into concentric rings showing travel times from that place.

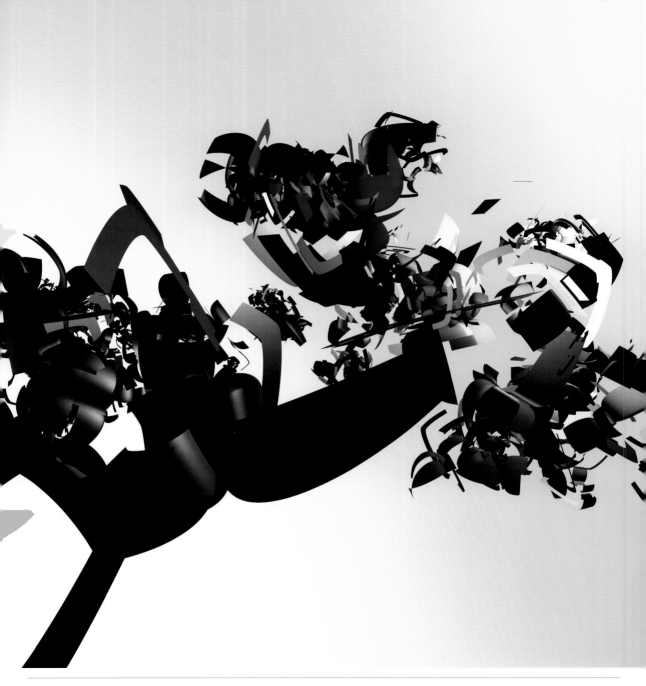

Superformula,
by David Dessens, 2008
Dessens has been using
the superformula since
2006 as a basis for
his dynamic visual
compositions and ani-
mations. The graphic
forms depicted in this
image were generated
using that equation.

VISUALIZATION TECHNIQUE
MATHEMATICS VISUALIZATION

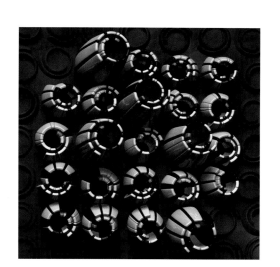

Images were created to think about mathematics long before computers were invented to calculate and visualize. For instance, Euclid (circa 300 BCE) constructed diagrams to show relationships between geometric elements and physical models. A paper model of a Möbius strip and a glass model of a Klein bottle can make these intriguing surfaces approachable to a wider audience, beyond those who understand the equations behind them. Before the era of the personal computer, the Mathematica exhibition, created by the Eames Office in 1961, presented diagrams, objects, and machines to demystify basic mathematical principles. Mathematica is also the name of a powerful program used within the sciences for calculations and visualizations. This program, along with other software development projects, cleared the path to new categories of mathematics visualization, including the popular fractal images of the Mandelbrot set. Mathematicians, artists, and architects are actively mining the structures of numbers and equations to produce visual images for pleasure and insight.

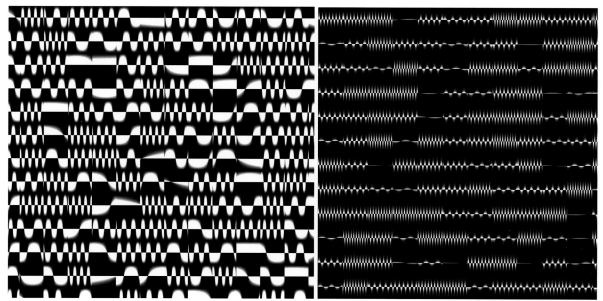

EPF:2003:V:A:997141, by Kenneth A. Huff, 2003
Using the properties of prime numbers to determine the base structure, Huff adds the dimensions of depth, texture, and lighting to create fantastic forms. A different prime number determines the length of each unique segment.

Algorithmic Visualizations, by George Legrady, 2002-5
These images are created from mathematical equations that have their origins in image-processing algorithms. Legrady "shapes" and "massages" the equations to affect their visual expression.

the and i
of to my a
that me but had
you which it his as
this from her have be wh
your him an so they one all cou
or are we who no more these now should yet some before myself what man
them am upon our into its only did do life father than every then first might own
shall eyes said may time being towards how even saw can night those most elizabeth such found
mind any again there heart day felt whom death after where feelings very other thought dear soon friend
up made never many still while passed during also thus miserable has must place like same heard became few
sometimes us love clerval over little human appeared indeed often country misery words friends justine about nature
although until several among cottage feel ever whose see old away hope well great return happiness know despair felix long through world
cannot voice another days happy sun poor horror much years men alone scene ice light joy creature came fear affection house far power part nothing out

CODE EXAMPLES
LOADING AND DISPLAYING DATA

This example loads, parses, and visualizes text files from Project Gutenberg, a massive online collection of electronic books. The images on this page show the program's analysis of two books side by side: Mary Shelley's Frankenstein and Bram Stoker's Dracula. The size of each word correlates to the number of times it is used in the book. In some language analysis programs, the words most frequently used in English, the articles and pronouns, are not included in the visualization because they are too common.

The program loads a book one line at a time and splits each line into individual words. For each word, it checks if it is new or if it has already been used in the text. If the word is new, the program adds it to a growing list. If it is already in the list, the program adds to the tally of how many times it has been used. After the entire book is read, the program sorts the list by the number of times each word was used.

the and i
to of a he in
that it was as we for
is his me not you with my
all be so at but on her have
had him she when there which if this
from are said were then by could one no do them
what us or they will up must some would out shall may
our now know see been time can more has am come over van
came your helsing went an like into only who go did any before very
here back down well again even seemed about room lucy way such good man took
mina much how though think saw their dear night than where too through hand after
face door should tell made poor dr sleep jonathan old away own eyes looked friend great
once things other get just look little make day got might yet professor found count thought off god
take let work long say life something men asked told oh last heart place without fear arthur till first its
myself two house ever done knew never himself still window began nothing quite harker find coming same these blood
want diary white mind head put many mr hands round

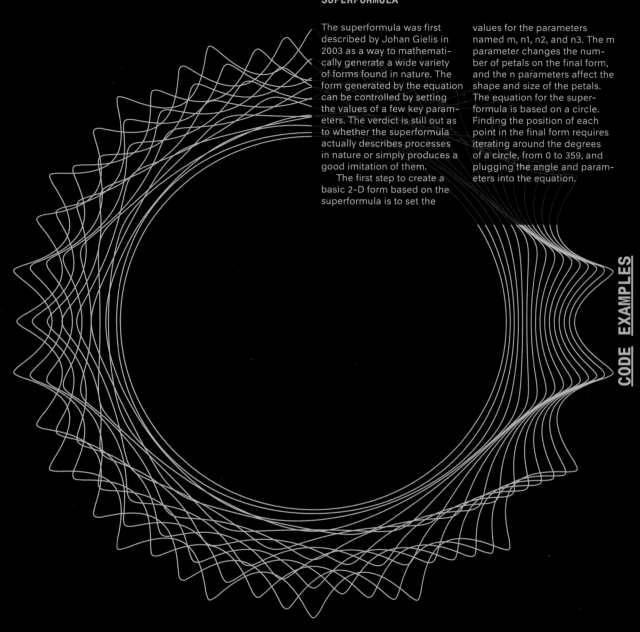

CODE EXAMPLES
SUPERFORMULA

The superformula was first described by Johan Gielis in 2003 as a way to mathematically generate a wide variety of forms found in nature. The form generated by the equation can be controlled by setting the values of a few key parameters. The verdict is still out as to whether the superformula actually describes processes in nature or simply produces a good imitation of them.

The first step to create a basic 2-D form based on the superformula is to set the values for the parameters named m, n1, n2, and n3. The m parameter changes the number of petals on the final form, and the n parameters affect the shape and size of the petals. The equation for the superformula is based on a circle. Finding the position of each point in the final form requires iterating around the degrees of a circle, from 0 to 359, and plugging the angle and parameters into the equation.

CODE EXAMPLES

A simulat
imitates t
appearan
character
somethin

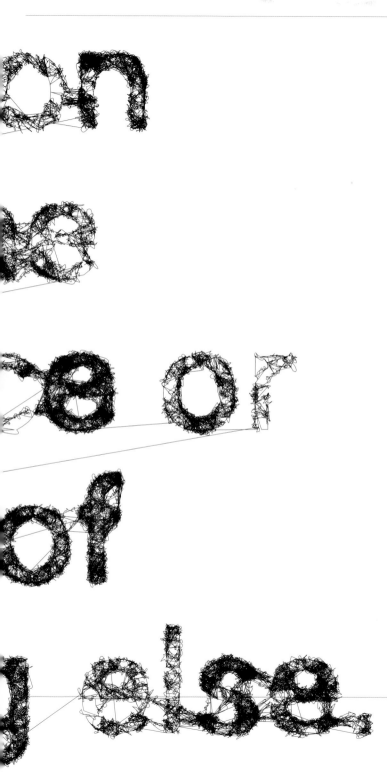

From watching Hollywood movies, we all know that software's ability to simulate the real world is improving. The clothes worn by simulated characters flow like the real thing, the hair on cartoon animals is fluffy and bouncy, and the quality of light in fully rendered scenes is atmospheric and natural. These technical achievements present an interesting aesthetic question. Is modeling the natural world with precision the ultimate goal of software simulation? In some situations, the answer is a definite yes; for example, scientific weather and traffic simulations are only useful when they are realistic. Within other domains, such as design, architecture, and art, high fidelity is less important than the final experience. Bending the rules can create something unexpected and sublime. Simulation can be a precise tool, but also a foundation for something beyond.

SIMULATE

These letters simulate an idiosyncratic human hand. They were created by drawing curves, from a given point to one of its nearest neighboring points, rather than directly to the next logical point. This demonstrates the computer's ability to use ordered and systematic processes to produce the opposite result.

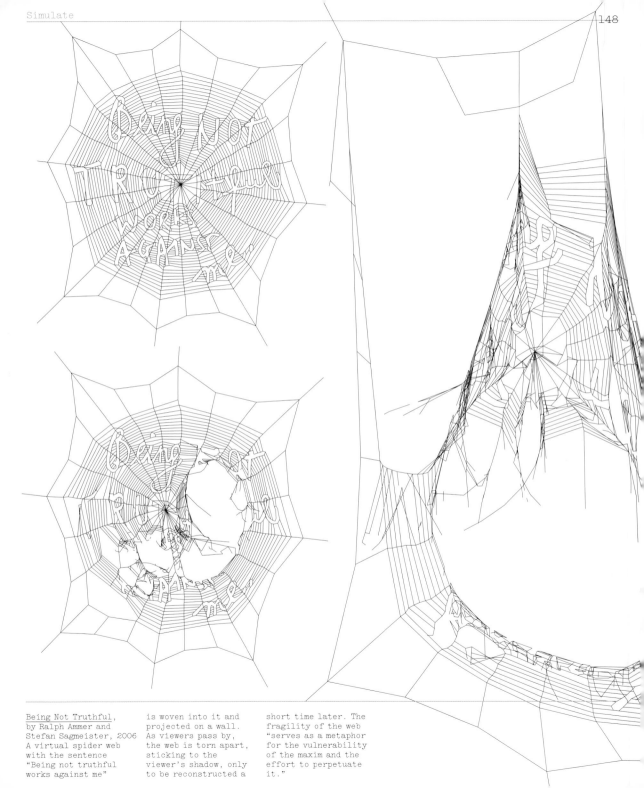

Being Not Truthful,
by Ralph Ammer and
Stefan Sagmeister, 2006
A virtual spider web
with the sentence
"Being not truthful
works against me"
is woven into it and
projected on a wall.
As viewers pass by,
the web is torn apart,
sticking to the
viewer's shadow, only
to be reconstructed a
short time later. The
fragility of the web
"serves as a metaphor
for the vulnerability
of the maxim and the
effort to perpetuate
it."

Every simulation has three parts: variables, a system, and a state. A variable is a value that represents a component of the simulation. A system is a description of how the variables interact. The state of the system is the values of the variables at any given time. This becomes clearer through an example: a simulation of a spinning toy top. The first step is to realize there are an infinite number of variables for simulating anything. Beyond the most significant aspects of any object or system, there is an infinite amount of miniscule details that may have profound effects. For example, no two tops are totally identical. How do we measure the affect of a small dent that changes the rotation ever so slightly? How do we measure the difference in behavior when the top is new, rather than old and worn? To make a software simulation, it's necessary to select a finite number of variables from an infinite number of options. For a simple top simulation, perhaps the revolutions per minute (RPM), the angle, the diameter, and the height are sufficient. (For simplicity, let's ignore the fact that a person needs to give the top its initial energy.) All software simulations run as a series of time steps. The simulation starts at the first step, then the values are recalculated for the second step, and so on. In the simulation of the top, the state is composed of the values of the four variables at a specific step. The RPM and angle change constantly until the top comes to a stop, but the diameter and height are constant.

As friction on the bottom of the top causes it to slow down, the angle changes so it tilts closer and closer to the ground. Eventually, at a certain ratio of speed to angle, the top falls over.

This simulation becomes more interesting and complicated when we add another system: a simulation of a world. What happens when the top hits a wall while spinning? Does it fall over? What happens when it moves from a smooth to a rough surface? Does it slow down? You can start to imagine how complicated a software simulation can become.

Though simulations often make use of parameterization, these two techniques have some important differences. Whereas parameterization allows for precise, top-down control of form; simulation involves bottom-up mechanisms that make it very difficult to predict how a particular system will behave. Each iteration will have differing results, which may not be obvious from the description of the system. Simulation is the creation of the possibility of form. Whether designed to reproduce the natural world or to generate novel and unexpected forms, it is this very open-ended quality that makes simulation such a powerful technique.

SIMULATE

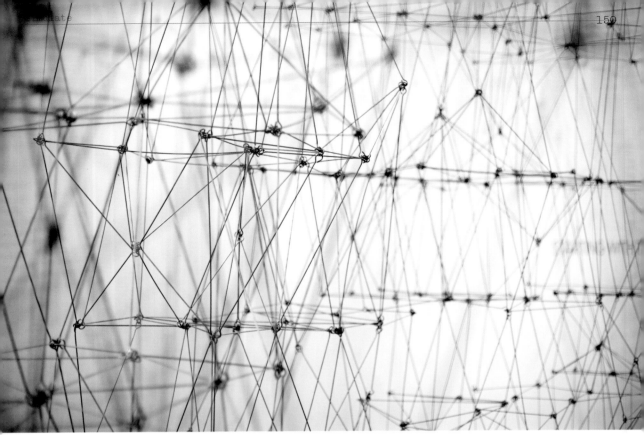

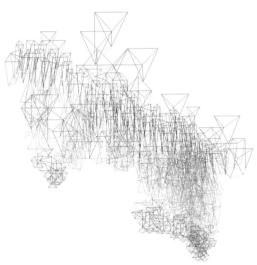

<u>Transformation of a
Necklace Dome</u>,
by MOS Architects, 2008
Created for the
Buckminster Fuller:
Starting with the
Universe retrospective at the Whitney Museum
of American Art, this
piece represents a
dialog with Fuller's
necklace dome. The
piece was generated in
a simulated physical environment to create a
structure whose "con-
nections are flexible
locally, but within
an overly redundant
network of forces they
perform as a rigid structure." It is hung
from the ceiling and
constructed from over
5,000 aluminum rods
whose lengths dimin-
ish as they reach the
ground, creating a structure that "is more
rigid at the bottom and
more flexible at the
top."

To gain a deeper understanding of the world around us often requires rigorous experimentation and testing. In the sciences, the theory-to-experiment cycle can take years or decades. Often, the system we want to test is too large, too complex, too distant, or the time scales are too large to effectively test a hypothesis. Computers and code have offered a new way to explore these and other systems, and to test our current knowledge. For example, the first computer-generated film simulated a satellite orbiting the Earth. It demonstrated that a satellite can be stabilized so that one side will always face Earth. The film, titled A Two-Gyro Gravity-Gradient Altitude Control System, was made by Edward Zajac at Bell Labs in 1961.

Much closer to home, simulations in the field of physics that focus on gravity and the interactions between objects have become a part of everyday life. Many of the most successful video games feature the realism of the worlds they portray. With such accurate worlds, it is possible to create games with truly lifelike environments, which, in turn, allow game developers to loosen some restrictions on what the character can do. Rather than restrict how the player can get from point A to point B, these games give the player the freedom to find other routes and use objects in the environment in new ways to achieve the goal at hand.

The ability to simulate physics has had a substantial impact on architecture and engineering. These tools allow engineers to simulate how forces and loads move through virtual structures. Based on the outcome, the model is modified and the simulation is run again until an optimal combination of structure and material is found. The CCTV Tower in Beijing, designed by Rem Koolhaas's firm Office for Metropolitan Architecture (OMA) and built by the engineering firm Arup, went through years of detailed simulation to ensure that the building could stand and survive an earthquake while maintaining its unique shape. The simulations, created by Arup, tested how every part of the building would react in the event of a large earthquake so that adjustments could be made to materials or design. The building was constructed in two parts, and Arup was able to calculate the time of year (late autumn) and time of day (five o'clock in the morning) when conditions would be ideal for connecting the two halves.[1]

Simulations can also become a laboratory for testing new ideas. For example, a Japanese supercomputer built in 2002 called Earth Simulator was designed to imitate weather systems. The Earth Simulator allowed researchers to enter real-time climate data, then speed up the clock and see the cumulative effects hundreds of years in the future. These complex simulations work to expand our understanding by providing a sandbox for testing the effects of different actions on the system. Building such a simulation requires a meticulous description of how things work and interrelate. If there is an error in the assumptions, the simulation will look strange or behave incorrectly, which in turn requires more testing and experimentation.

Will Wright's SimCity is one of the most popular games of all time. The objective of the game is to create and manage a successful city. To do so, the player can control zoning and taxes, construct buildings, roads, and railways, and respond to natural disasters. Constructing a large city takes time, and players often work on the same city for years. SimCity lets the player experiment with a staggeringly complex system, going so far as to offer scenarios based on real-world cities in times of crisis. Playing a game as complex as SimCity requires the player to become intimately familiar with the assumptions underlying the simulation. To be successful, he or she must put aside all preconceived ideas about public policy and learn what actions are rewarded in the game. Some have argued that SimCity encodes certain biases toward policies like rail transportation and environmentalism. In the context of a game purporting to be

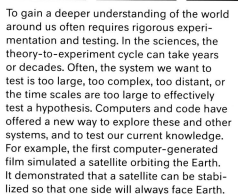

[1] David Owen, "The Anti-Gravity Men," The New Yorker, June 25, 2007.

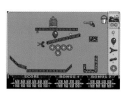

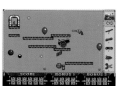

SIMULATE

A Two-Gyro Gravity-Gradient Altitude Control System, by Edward Zajac, 1961 Zajac created this computer-generated film at Bell Labs to explore options for stabilizing a communications satellite so that one side always faces Earth.

The Incredible Machine, by Sierra, 1992 The Incredible Machine is a video game based on Rube Goldberg contraptions. The player must arrange a set of odd objects—such as mice in cages, cannons, or conveyor belts—to create a machine capable of achieving a goal such as lighting a candle. The game uses a simple physics-based engine to simulate interactions between the machine's parts, as well as with environmental effects like air pressure and gravity.

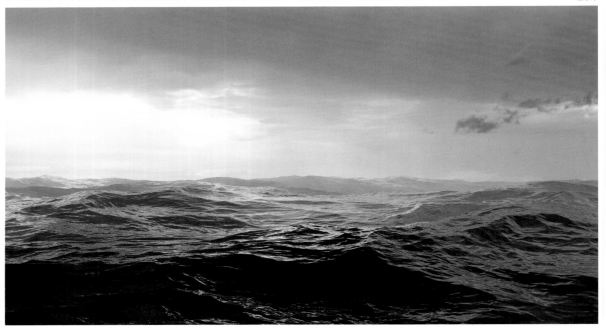

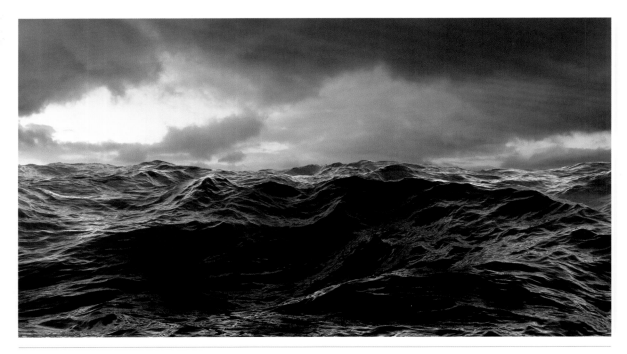

<u>Persönliches Wagnis</u>
(top), <u>Unabweisbare</u>
<u>Gefahr Nr. 6</u> (bottom),
by Gerhard Mantz, 2009
Mantz began making
digital 3-D models

as prototypes of his
sculptures, but he
pushed further into
creating software-based
landscapes as metaphors
for psychological

states. Simulated
light, atmosphere,
and water are used to
express emotions.

an accurate simulation of the real world, such biases, intentional or not, can have a powerful effect on the beliefs and habits of the players.

The complex processes behind many fascinating natural phenomenon have been described in equations and procedures, making them ideal for exploration in code. Fractals are a perfect example of a naturally occurring phenomenon that has been explored in depth using computers. In 1978, while working for Boeing, computer graphics researcher Loren Carpenter first started using fractal geometry to create complex and realistic artificial landscapes from simple and elegant processes. First, a rough landscape is created out of large triangles, then each triangle is broken into smaller triangles, and each smaller triangle is broken down again, and the process repeats recursively until a realistic terrain emerges. Carpenter went on to use these techniques to create a fully computer-generated sequence of an alien planet for the 1982 film Star Trek II: The Wrath of Khan.

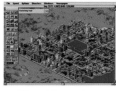

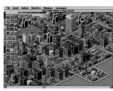

One of the most fascinating biological phenomena to be discovered and described in mathematical terms is the reaction-diffusion system. In 1952 Alan Turing, one of the pioneers of computer science, turned his attention to the problem of morphogenesis: how a fertilized egg turns into a fully formed animal. Turing's novel approach described the problem in terms more familiar to physics than biology. He described the problem as one of symmetry breaking, and eventually developed equations for some of the problem's simpler aspects. He was, however, limited to mathematical expressions that would be computable using only a pencil and paper, and he speculated that perhaps one day a computer would be capable of solving the problem using more complex mathematics. Twenty years later, scientists Hans Meinhardt and Alfred Gierer fulfilled this prophecy and used the computer to continue and expand on Turing's work. Reaction-diffusion systems are incredible

in their ability to create a wide variety of patterns, from butterfly wings to zebra spots. The relative simplicity of the system, in which one chemical compound activates another, which in turn inhibits the first, adds to this allure.

SimCity 2000, by Maxis, 1993 Players design, build, and manage cities by determining every detail of planning and urban development. SimCity, released in 1989, was the first in a long line of simulation games leading up to the release of The Sims in 2000, which simulated the day-to-day life of suburbanites. Will Wright later released Spore in 2008, in which the player controls the development of a species, from a microorganism to a space traveler.

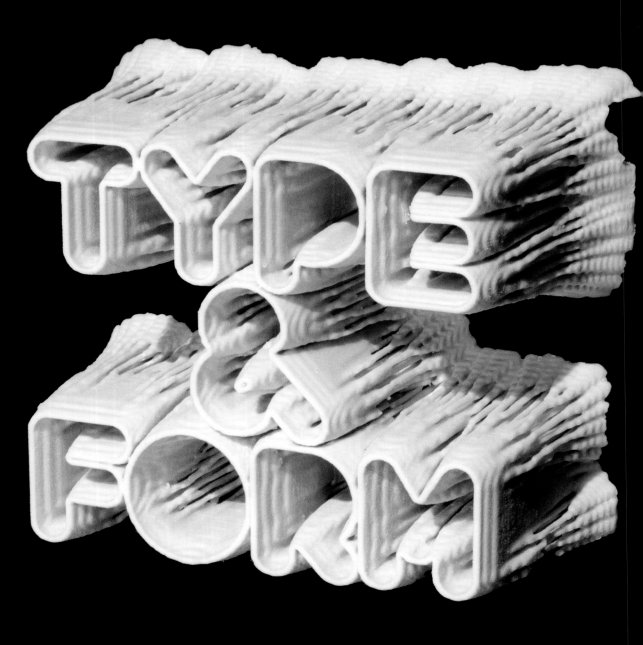

Print magazine cover, the August 2008 issue
by Karsten Schmidt of of Print magazine.
PostSpectacular, 2008 A 3-D form was made
A reaction-diffusion using code; it was
system was used to then fabricated using
create the cover for a 3-D printer.

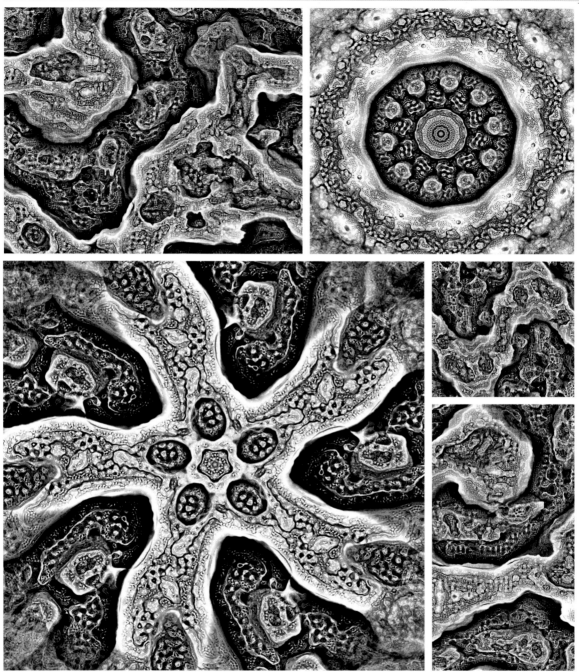

MSRSTP (Multi-Scale
Radially Symmetric
Turing Patterns),
by Jonathan McCabe,
2009

McCabe created imag-
ery reminiscent of
biological structures
by employing several
reaction-diffusion
systems.

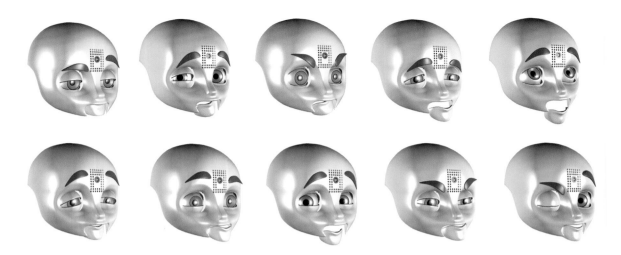

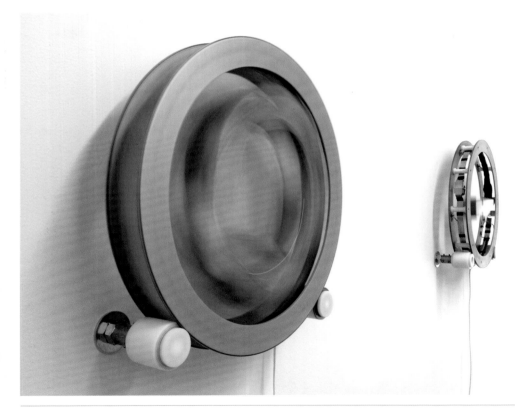

Nexi,
by the Personal Robotics Group at MIT Media Lab, UMASS Amherst, and Xitome Design, 2007
This MDS (Mobile/ Dexterous/Social) robot is equipped with a face capable of expressing a wide range of emotions that reveal its inner state.

Micro.Adam and Micro. Eva, by Julius Popp, 2002
A pair of wall-mounted robots try to learn how to rotate by moving their inner actuators and changing their centers of gravity. Popp's aim is "to find self-adapting algorithms that feel and learn the robot's body behavior. The two robots are 'born' with the same 'empty' programs, which then must form themselves according to the specific body characteristics of each robot."

ARTIFICIAL INTELLIGENCE

[2] Hubert L. Dreyfus and Stuart E. Dreyfus with Tom Athanasiou, Mind Over Machine: The Power of Human Intuition and Expertise in the Era of the Computer (New York: Free Press, 1986), 78.

[3] Rodney Brooks, "Cog Project Overview," 2000, http://www. ai.mit.edu/projects/humanoid-robotics-group/cog/overview. html.

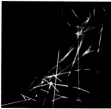

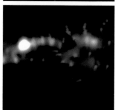

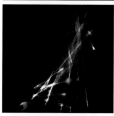

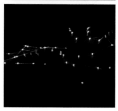

The history of artificial intelligence (AI) is a tortured one. The mid-1950s saw an explosion of research and speculation on the possibility of creating artificially intelligent machines. The development of the computer was a central catalyst, pushing AI research forward at a breakneck pace. At first, problems were being tackled so quickly that AI pioneer Marvin Minsky was quoted as saying, "Within a generation...the problem of creating 'artificial intelligence' will substantially be solved."[2] By the 1970s, however, progress in AI had slowed and funding for large, expensive projects was getting scarce. Nevertheless, progress has continued, and AI software is common in fields as diverse as banking and medicine.

The goals of AI are varied. Some researchers imagine fully sentient beings capable of anything we might term intelligent, while others are concerned with specific activities such as game playing, planning, pattern finding, and social interaction. Robotics researcher Rodney Brooks broke new ground in the 1980s by focusing on behavior-based systems, what he calls Cambrian intelligence. Brooks's robots are constructed of multiple layers of behavior-driven processes, with higher-level layers having some control over inputs on the lower layers and vice versa. Brooks calls this subsumption architecture, and it has had a large impact on robotics and AI in general. For example, one layer might be concerned with avoiding obstacles, on top of that could be a layer that directs the robot toward a goal, and on top of that might be a layer that is interested in faces. When the highest level finds a face, it tells the lower layer where it wants to go, which in turns is responsible for the actual moving, all the while the lowest layer is actively looking out for obstacles in the robot's path.

All discussions of AI pose problems of embodiment. These problems concern philosophical questions like the existence of a mind-body split, to more practical ones of how a computer or robot can sense the world around it. When Brooks developed the robot Cog, he designed it to be somewhat human in appearance, with video-camera eyes and a face. Looking at the problem of embodiment face on, he argues, "If we are to build a robot with humanlike intelligence then it must have a humanlike body in order to be able to develop similar sorts of representations."[3] The current work of researcher Cynthia Breazeal and the Personal Robots Group at the MIT Media Lab has taken this research in new directions with the development of the Nexi Mobile/Dexterous/Social (MDS) robot. MDS robots are designed to learn about and engage in human social interaction. Nexi has a small body, which allows it to move freely and pick up objects, but perhaps its most interesting feature is its expressive head and face, which are capable of a wide range of emotions, including sadness, anger, confusion, excitement, and even boredom.

Video games are another significant area of exploration in AI. Even simple games like tic-tac-toe may be used to test novel approaches to creating intelligent behavior. The defeat of chess grandmaster Garry Kasparov to IBM's Deep Blue supercomputer in 1997 received widespread media attention, however, chess is not the only or even the central interest for game-playing AI. Video games designed for consoles and computers are one of the most visible and active areas of AI development. Though the goals are often more restricted than in academic research, games offer an environment to test many key problems: planning, reacting to events in the real world, and interacting with and moving through an environment. For example, AI game characters are expected to look and act like real players; they must execute complex attacking behaviors while protecting themselves from counterattacks and responding to input from the player in a believable way that also drives the narrative forward. The 2005 Monolith

SIMULATE

Loops,
by The OpenEnded Group, 2008
Loops is a real-time generative animation built with motion-capture data from the performances of dance choreographer Merce Cunningham. The software uses a complex action-selection mechanism to interpret the motion data to create stunning visual imagery. Each point chooses how to interact with nearby points, how to move, and how to draw itself. The creators explain, "Our basic idea was to make the points that construct the hands of Loops 'autonomous'—so that these points are, to a limited degree, live 'creatures.'"

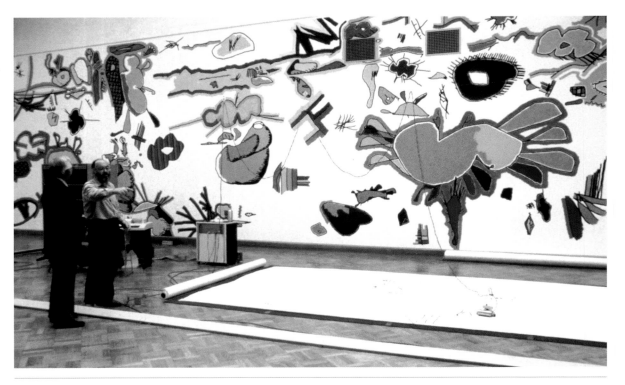

AARON,
by Harold Cohen
1973-present
The AARON software
creates original draw-
ings based on the rules
encoded in it. Over the
last thirty years, the
software has advanced
from drawing basic geo-
metric forms to human
figures, from black-
and-white drawings to
color prints.

Productions game F.E.A.R. was notable for the sophisticated AI control of the game's characters. Opponents can spontaneously act as a team, providing cover fire for one another and moving around to flank the player. A different approach to game AI is found in Façade, created by Procedural Arts in 2005. In this game, the player is a guest invited to dinner by a married couple. As the evening progresses, tension in the couple's relationship forces the player to make choices that have a direct effect on the behaviors and lives of the characters. Unlike a simple branching structure, like a classic Choose Your Own Adventure book, the characters in the game change their behaviors based on the actions of the player, thus affecting the moment-to-moment flow of the narrative.

Since the first days of AI, researchers have searched for ways to imbue computers with the spark of creativity. In contrast to systems focused on reasoning and deduction, these projects explore strategies for creation. Programs such as Douglas Lenat's Automated Mathematician, written in 1977, tried to generate mathematical theorems from basic principles, while in 1983 William Chamberlain and Thomas Etter's Racter program was made famous when it was credited with writing the book The Policeman's Beard Is Half Constructed.

Perhaps the most famous piece of creative software is Harold Cohen's AARON. Cohen programmed AARON to create drawings, which have been displayed at numerous museums including the Tate Britain in London and the San Francisco Museum of Modern Art. He has worked on AARON since 1973, continually adding features and expanding its capabilities. The software has progressed from black-and-white outlined shapes to scenes of people posing and dancing surrounded by colorful vegetation. AARON is fully automatic and produces images with no human interaction. Cohen recently added reflectivity to AARON so that the program monitors the image as it's

created and alters how it applies its coloring rules based on what it finds. The consistent style seen in AARON's images suggests that the rules used to compose, choose colors, and evaluate its drawings are an increasingly accurate encoding of Cohen's own ideas about composition.

A different approach to the problem of artificial creativity is found in the work of the computer and cognitive scientist Douglas R. Hofstadter. In the late 1970s, Hofstadter set out to model the mechanisms of creativity in a computer. His Fluid Analogies Research Group created software to solve seemingly trivial problems, such as finding the rule for a number sequence and solving anagram puzzles. In contrast to traditional computational or AI techniques, Hofstadter's team tried to mimic their own mental processes of solving these puzzles; the software was designed to repeat the mental back-and-forth of coming up with ideas and trying them out until the solution is found. One program, Copycat, tried to find novel analogies between sequences of letters, and use those analogies to generate new sequences. This work eventually led to the project Letter Spirit. Hofstadter explains:

The Letter Spirit project is an attempt to model central aspects of human creativity on a computer. It is based on the belief that creativity is an automatic outcome of the existence of sufficiently flexible and context-sensitive concepts....The specific locus of Letter Spirit is the creative act of artistic letter-design. The aim is to model how the 26 lowercase letters of the roman alphabet can be rendered in many different but internally coherent styles. Starting with one or more seed letters representing the beginnings of a style, the program will attempt to create the rest of the alphabet in such a way that all 26 letters share that same style, or spirit.[4]

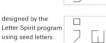

seed "g" designed by hand and given to the program

designed by the Letter Spirit program using seed letters "b,c,e,f,g"

designed by hand by Douglas Hofstadter to be in the same style as the "g"

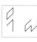

[4] Douglas R. Hofstadter, Fluid Concepts & Creative Analogies: Computer Models of the Fundamental Mechanisms of Thought (New York: Basic Books, 1996), 407.

Letter Spirit, by Gary McGraw and John Rehling with Douglas R. Hofstadter, 1996 Letter Spirit used a two-by-seven grid of lines to create letters. Given a few seed letters, the program attempts to generate the entire alphabet in the same style as the seeds.

SIMULATE

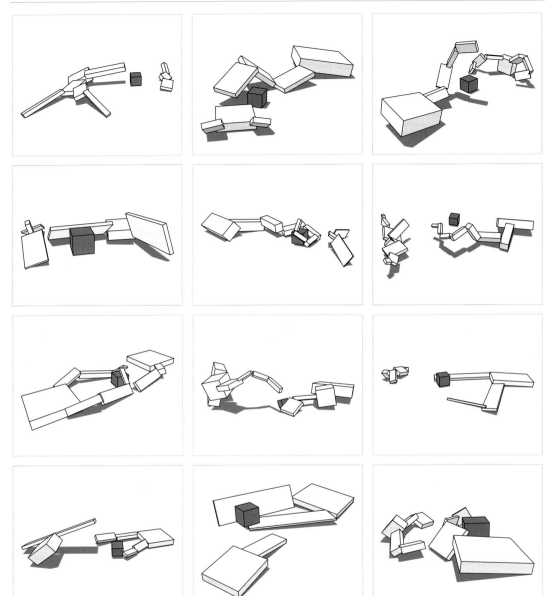

<u>Evolved Virtual</u>
<u>Creatures</u>, by Karl
Sims, 1994
Evolved virtual crea-
tures compete for the
possession of a cube
within this simulated
world. The winner of
each round of the com-
petition receives a
higher score, giving it
the ability to survive
and reproduce.

ARTIFICIAL LIFE AND GENETIC ALGORITHMS

Artificial life (a-life) has different goals from artificial intelligence. While AI focuses on higher-level cognitive functions, a-life imitates biological phenomena to simulate reflexes, behaviors, and evolution. The goals of a-life are to simulate life as it exists and to explore new categories of life. In his book Artificial Life: The Quest for a New Creation, Steven Levy describes the context:

> Artificial life…is devoted to the creation and study of lifelike organisms and systems built by humans. The stuff of this life is nonorganic matter, and its essence is information: computers are the kilns from which these new organisms emerge. Just as medical scientists have managed to tinker with life in vitro, the biologists and computer scientists of a-life hope to create life in silico.[5]

Since its origins in the early 1980s, a-life researchers have developed simulations based on many kinds of flora and fauna, ranging from cells to trees to insects to mammals. Within the visual arts, these simulations are the foundation for new ways to generate form. Instead of creating form directly through drawing or sculpting, it can be grown or evolved using a-life techniques.

Related to a-life research, a genetic algorithm (GA) is a software process that simulates evolution by creating and changing an artificial genome. As in real genetics, an artificial genome is modified through crossbreeding and mutation. Crossbreeding (or sexual reproduction) uses a combination of genes from two parents to form a unique child. Parts of the genome of each parent are used to create a new child with a mix of both. Mutation affects a gene in a single creature, and this change is transmitted to the next generation. In nature, mutation can result from a copying error or radiation, among other events. In a-life, mutation is simulated by changing one or more characters of the simulated genome. The primary advantage of evolution within a software environment

is the ability to go through thousands of generations (or more) within seconds rather than thousands of years.

The potential of genetic algorithms to evolve visual form was pioneered by the evolutionary biologist Richard Dawkins, through software he wrote for his book The Blind Watchmaker: Why the Evidence of Evolution Reveals a Universe without Design, published in 1996. He created the software to demonstrate his belief that the diversity of life on Earth is the result of a process of evolution involving the gradual accumulation of small changes. His software experiment produced results that far exceeded his expectations. He wrote, "Nothing in my biologist's intuition, nothing in my 20 years' experience of programming computers, and nothing in my wildest dreams, prepared me for what actually emerged on the screen."[6] Using only mutation and a simple genome of nine genes (or parameters), Dawkins generated shapes, one step at a time, that emerged to look remarkably like complex organisms (trees, insects, amphibians, mammals) from the starting point of a single pixel. In the words of author and Wired magazine cofounder Kevin Kelly, he demonstrated visually that, "While random selection and aimless wandering would never produce a coherent design, cumulative selection (the Method) could."[7] Dawkins called the software's design space Biomorph Land. He acknowledges that every biomorph form in this land already exists mathematically as a sequence of variables within a finite set, but he insists that the experience of evolving form within the software is a creative act, because the space is so large and the search must be directed rather than random. Although biomorphs are visually simple, the project opened the door for other researchers, including William Latham and Karl Sims, to create more fully realized visual projects.

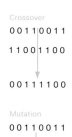

Crossover
0 0 1 1 | 0 0 1 1
1 1 0 0 | 1 1 0 0

0 0 1 1 1 1 0 0

Mutation
0 0 1 1 0 0 1 1

0 0 1 1 0 1 1 1

[5] Steven Levy, Artificial Life: The Quest for a New Creation (New York: Pantheon Books, 1992), 5.

[6] Richard Dawkins, The Blind Watchmaker: Why the Evidence of Evolution Reveals a Universe without Design (New York: Norton, 1986), 59.

[7] Kevin Kelly, Out of Control: The New Biology of Machines, Social Systems & the Economic World (Reading, MA: Addison-Wesley, 1994), 266.

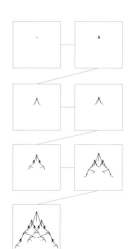

Crossover and mutation
Crossover uses part of the genome from each parent, and mutation is a random change to one

or more elements of the genome. Together, they simulate biological evolution.

Biomorph, by Richard Dawkins, 1986
Starting from a single pixel in the upper-

left, the form at the bottom evolved through many generations, each with only a single genetic mutation.

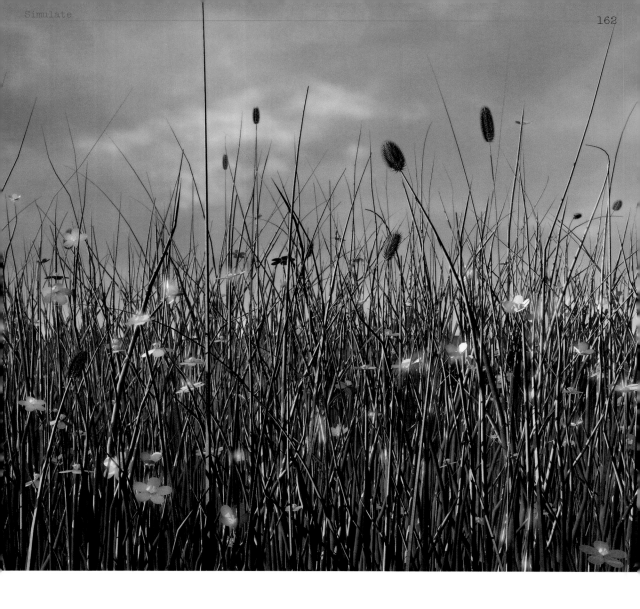

<u>Morphogenesis Series</u> development of plantlike to present a personal
<u># 4</u>, by Jon McCormack, structures, based on interpretation of
2002 native Australian nature's process.
Using an evolutionary species. Unlike natural
process, McCormack selection, McCormack
explored the growth and influenced the selection

Karl Sims' Evolved Virtual Creatures, which he created in 1994, was a breakthrough in a-life. The project is so convincing that it remains relevant over fifteen years later. Through software, Sims was able to simulate the evolution of creatures to perform different tasks, such as swimming, walking, jumping, and following. Eventually he added the ability for two creatures to compete against one another to control possession of a cube. He did this by simulating the basic physical properties of gravity, friction, and collision, and then building creatures that could evolve at amazingly fast rates through crossbreeding and mutation. The genotype of his creatures is a directed graph, and the phenotype is a hierarchy of 3-D parts.

[8] "NASA Evolvable Systems Group, Automated Antenna Design," http://ti.arc.nasa.gov/projects/esg/research/antenna.htm.

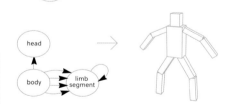

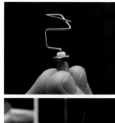

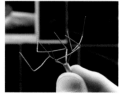

At each generation, some creatures were allowed to survive and reproduce based on their fitness, how well they performed the current task. For example, how well did they swim, walk, jump, or follow? To communicate the results, Sims produced an appealing series of short animations that featured the creatures in action. The most fascinating aspect of the project was the diversity of strategies the creatures developed to meet their goals. Despite the primitive geometry

and limited joints, they had the essence of living, self-motivated animals. GAs are an emerging technique for solving real-world design problems that are well suited to optimization. The X-band antenna developed by NASA in 2004 is a clear example. Designing an antenna by hand is time and labor intensive, and therefore expensive. In contrast, software can be used to design a better antenna in less time. NASA describes the process:

> Our approach has been to encode an antenna structure into a genome and use a GA to evolve an antenna that best meets the desired antenna performance as defined in a fitness function. Antenna evaluations are performed by first converting a genotype into an antenna structure, and then simulating this antenna using the Numerical Electromagnetic Code (NEC) antenna simulation software.[8]

NASA claims that generated designs have the potential to outperform those designed by expert engineers. Additionally, the generated antennae often have radically different forms compared to those designed by hand. In general, GAs have the potential to find unique forms that more traditional design approaches overlook.

GAs and evolutionary thinking have played an important role in contemporary architectural theory and practice. John Frazer's 1995 book An Evolutionary Architecture presents the genetic algorithm as a technique for creating novel forms that bridge the form-function divide. Theorist Karl Chu has explored the intersection of computer and genetic code as an avenue for exploring possible futures.

SIMULATE

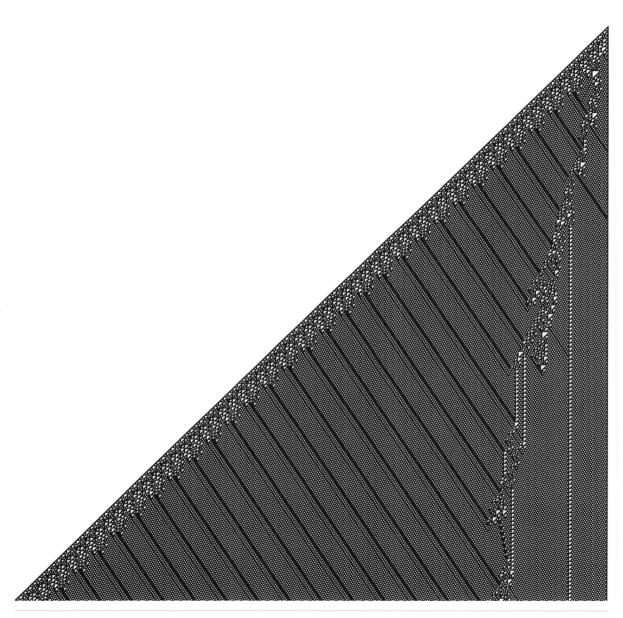

1D Cellular Automata, Rule 110, by Stephen Wolfram, 1983
This set of rules produces what Wolfram categorizes as "class IV behavior." This means that the pattern is neither completely random nor repetitive. Seen as a diagram, the rule for the current pattern is:

111	110	101	100	011	010	001	000	CURRENT PATTERN
↓	↓	↓	↓	↓	↓	↓	↓	
0	1	1	0	1	1	1	0	NEW STATE FOR CENTER CELL

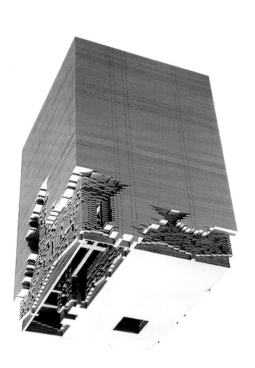

CELLULAR AUTOMATA

A cellular automata (CA) is a grid of cells, with the behavior of each cell defined by a set of rules. CAs are remarkable for their ability to demonstrate unexpectedly complex behavior based on a small group of simple rules. The simplest CAs are of the one-dimensional type invented by Stephen Wolfram in the early 1980s. Each cell is either white or black (also referred to as alive or dead). Over time, the cell becomes white or black by following a few rules. For example, if a cell is white but has one black adjacent cell, it changes to black. Each generation of cells is drawn below the previous generation so one sees the complete history of life and death within a single image. Remarkably, some of the patterns discovered by Wolfram have a striking resemblance to patterns found in nature. CAs have the astounding ability to emulate many properties of living systems within an incredibly constrained set of rules. The most famous CA is John Conway's Game of Life; this 2-D CA has inspired countless projects within the visual arts.

SIMULATE

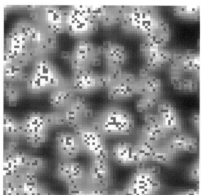

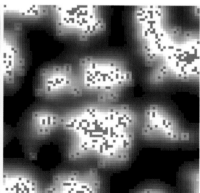

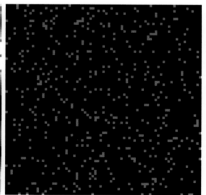

ZZ-IM4 Museum Model, by Mike Silver, 2004 This entry for a competition sponsored by San Jose State University's Museum of Art and Design was designed using AutomasonMP3, a custom software application that generates brick patterns linked to simple concrete structures. AutomasonMP3 also contains a voice synthesizer that enables masons to convey and receive audible block-stacking commands in the field.

StarLogo Slime Mold Aggregation Simulation This simulation mimics the behavior of slime-mold organisms as they follow pheromones to form groups. Each simulated organism is represented as a red dot, and their pheromones are shown in green.

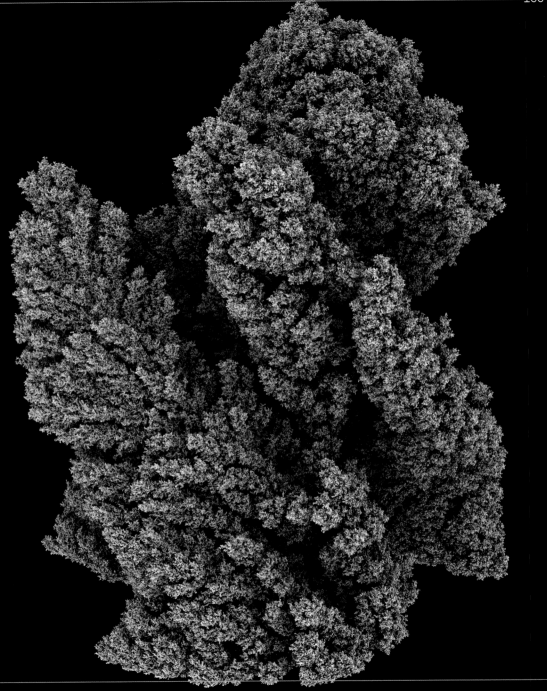

<u>Aggregation 4,</u>
by Andy Lomas, 2005
This form was built
from a gradual
accumulation of
particles on top of

an initial surface.
In the simulation,
millions of particles
flow freely until they
hit either the initial
seed surface or other

particles that have
been previously
deposited.

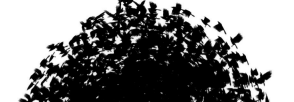

SIMULATION TECHNIQUE
SWARMS

We're all familiar with the surprising phenomenon of a school of fish zipping through the water, turning as a group in a fraction of a second. Software simulations for swarming, flocking, and crowd behavior introduce the ideas of agents to represent each bee, fish, or person. Each agent follows a set of rules that define its behavior in relation to its local environment. For example, in the Boids software, written by Craig Reynolds, each agent follows three clear rules: steer to avoid crowding local flockmates, steer toward the average heading of local flockmates, steer to move toward the average position of local flockmates. The complex swarming patterns seen in the images on this page emerge from these basic rules.

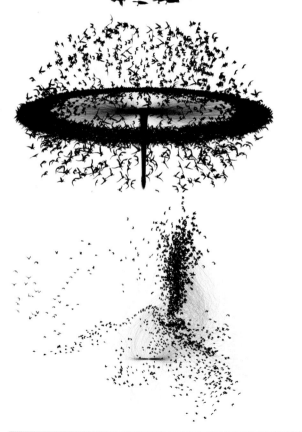

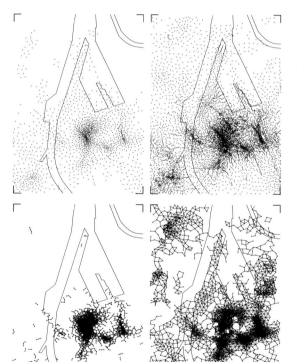

SIMULATE

Fox Horror,
by Robert Hodgin and Nando Costa, 2007
Using the Boids rules (created by Craig Reynolds) as a foundation, Hodgin wrote a parameterized performance tool for Costa, who then used the tool to choreograph animation and create composites with it using video footage.

Swarm Urbanism,
by Kokkugia, 2008
In an attempt to rethink urban planning, the firm Kokkugia applied the logic of swarms to develop a plan for the Melbourne Docklands. Using swarms in this way, they hope to create a more dynamic plan that is adaptable and better fits the needs of the inhabitants.

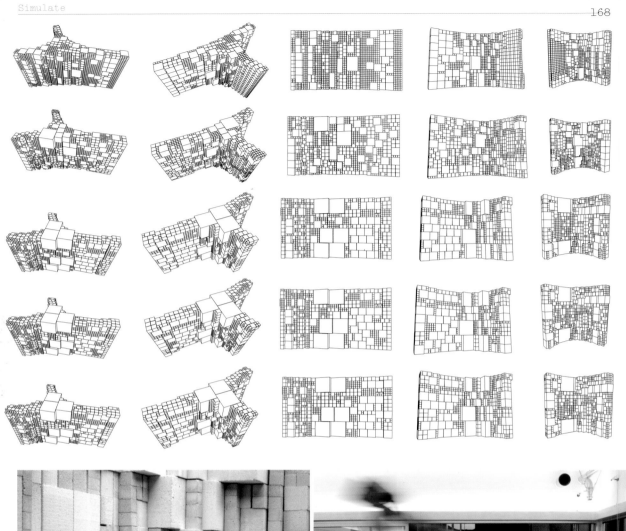

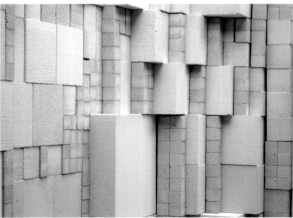

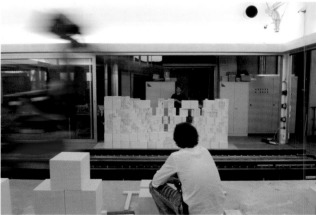

The Resolution Wall, by Gramazio & Kohler with the Architecture and Digital Fabrication department at ETH Zürich, 2007

Constructed by a robot, this wall is composed of aerated concrete blocks with a dimension ranging from 5 to 40 centimeters (1.9 to 15.7 inches). Smaller blocks allow for finer detail, but building with larger blocks is faster and therefore more cost effective.

In a student course, a genetic algorithm was developed to evolve a design with a good balance between aesthetic detail, construction time, and structural stability.

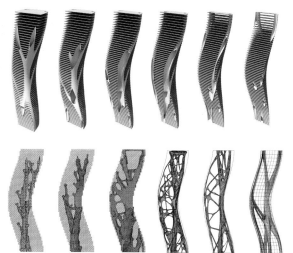

SIMULATION TECHNIQUE
UNNATURAL SELECTION

Just as a painter chooses which work to exhibit, or a novelist chooses which sentence to cut, systems that generate form often need some rubric by which to measure success. This can be either implicit (left to the whims of the designer) or explicit (part of the system). Cases where there are clear requirements for performance, structure, or fidelity lend themselves to encoding these requirements directly into the system. In this way, simulations can run autonomously, first generating, then testing, and so on, until an optimal candidate is reached. It is not always possible or desirable, however, to achieve this level of autonomy. Often the designer acts, as William Latham has described it as a "gardener," choosing favorite specimens and culling weeds to encourage the system to grow in a desired direction.

<div style="text-align: right">**SIMULATE**</div>

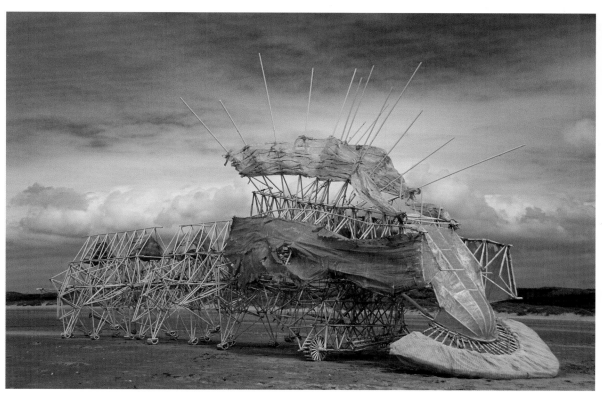

evolutionary computation, by moh architects, 2006 The design of this tower emerged from a process utilizing evolutionary and genetic computing to create a structurally sound form. This technique creates unity of form and structure, and it eliminates the need to post-optimize a design to meet structural demands.

Strandbeest, by Theo Jansen, 1990-present Jansen has worked for over a decade to create a population of artificial animals to survive unassisted on the beaches of the Netherlands. The skeletons of these creatures are completely constructed of plastic tubing, are powered by wind, and they can secure themselves to the ground in a storm. A genetic algorithm was written to optimize the lengths of the bones.

CODE EXAMPLES
PARTICLES

Particle systems are an essential technique for simulating nature. These systems can replicate the look and behavior of water, fire, smoke, explosions, clouds, fog, hair, fur, stars, and more. In a basic particle system, each element has a position and a velocity. In more advanced systems to simulate water or the movement of stars, each particle is influenced by virtual forces such as gravity and friction. A particle can be rendered on-screen as either a single pixel, a small image, or a 3-D object.

This basic particle system is created by making multiple copies of a simple particle. Each particle stores some information about itself: its position in space, velocity, and acceleration. At each step in the simulation, every particle calculates its next location using its current position, velocity, and acceleration. Finally, each particle is drawn to the screen and the process repeats.

CODE EXAMPLES
DIFFUSION-LIMITED AGGREGATION

Diffusion-limited aggregation (DLA) is a process for generating organic forms from a few simple rules. Particles moving through space, typically in a pattern called a random walk, stick together when they collide. The form is built up over time as more and more particles collide and clump together. The aggregate form often has a complex, branching structure.

The process begins with a fixed seed. Next, virtual particles are created and begin to move through the space. The motion of each particle is created by choosing a new random direction and moving a short distance at each step of the simulation. When the particle moves, it checks to see if it has collided with the seed or another fixed particle. If it collides with either, it stops moving and becomes part of the growing form.

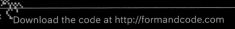

Download the code at http://formandcode.com

ACKNOWLEDGMENTS

The selection of designers, artists, and architects featured in this book is not comprehensive; the scope of the work makes this impossible. Individual projects often represent larger movements and bodies of work. Despite this, we feel that the selection is representative of many historical and current ideas within these fields. We are extremely grateful for the time and expertise of our advisory group, who generously assisted us with the curatorial process:

Noah Wardrip-Fruin, Ben Fry, Roland Snooks, Lucas van der Velden, and Marius Watz.

Abrams, Janet, and Peter Hall, eds. Else/Where: Mapping New Cartographies of Networks and Territories. Minneapolis, MN: University of Minnesota Design Institute, 2006.

Alberro, Alexander, and Blake Stimson. Conceptual Art: A Critical Anthology. Cambridge, MA: MIT Press, 2000.

Altena, Arie, and Lucas van der Velden. The Anthology of Computer Art–Sonic Acts XI. The Netherlands: Sonic Acts Press, 2006.

Aranda, Benjamin, and Chris Lasch. Tooling. Pamphlet Architecture. New York: Princeton Architectural Press, 2006.

Ashby, W. Ross. Design for a Brain: The Origin of Adaptive Behavior. 2nd ed. New York: Wiley, 1960.

Ball, Philip. The Self-Made Tapestry: Pattern Formation in Nature. Oxford: Oxford University Press, 1999.

Benthall, Jonathan. Science and Technology in Art Today. London: Thames & Hudson, 1972.

Bertin, Jacques. Semiology of Graphics: Diagrams, Networks, Maps. Translated by William Berg. Madison, WI: University of Wisconsin Press, 1984.

Bird, Jon, Alan Dorin, Annemarie Jonson, and Jon McCormack. Impossible Nature: The Art of Jon McCormack. Melbourne: Australian Centre for the Moving Image, 2004.

Bogost, Ian. Persuasive Games: The Expressive Power of Videogames. Cambridge, MA: MIT Press, 2007.

Brooks, Rodney. "Cog Project Overview," 2000. http://www.ai.mit.edu/projects/humanoid-robotics-group/cog/overview.html.

Brougher, Kerry, Jeremy Strick, Olivia Mattis, Ari Wiseman, Museum of Contemporary Art (Los Angeles, CA), Judith Zilczer, and Hirshhorn Museum and Sculpture Garden. Visual Music. London: Thames & Hudson, 2005.

Brown, Paul, Charlie Gere, Nicholas Lambert, and Catherine Mason, eds. White Heat Cold Logic: British Computer Art 1960-1980. Cambridge, MA: MIT Press, 2009.

Burnham, Jack. Software—Information Technology: Its New Meaning for Art. New York: The Jewish Museum, 1970.

Cache, Bernard. Earth Moves: The Furnishing of Territories. Cambridge, MA: The MIT Press, 1995.

Card, Stuart K., Jock Mackinlay, and Ben Shneiderman. Readings in Information Visualization: Using Vision to Think. 1st ed. San Francisco, CA: Morgan Kaufmann, 1999.

Carpenter, Edmund Snow, and Marshall McLuhan. Explorations in Communication: An Anthology. Boston, MA: Beacon Press, 1960.

Corne, David W., and Peter J. Bentley, eds. Creative Evolutionary Systems. San Francisco: Morgan Kaufmann, 2001.

Davis, Douglas. Art and the Future: A History/Prophecy of the Collaboration Between Science, Technology, and Art. New York: Praeger Publishers, Inc., 1973.

Dawkins, Richard. The Blind Watchmaker. Ontario: Penguin, 2006.

Eco, Umberto. The Open Work. Translated by Anna Cancogni. Cambridge, MA: Harvard University Press, 1989.

Fishwick, Paul A., ed. Aesthetic Computing (Leonardo Books). Cambridge, MA: MIT Press, 2006.

Flake, Gary William. The Computational Beauty of Nature: Computer Explorations of Fractals, Chaos, Complex Systems, and Adaptation. Cambridge, MA: MIT Press, 2000.

Fogg, B. J. Persuasive Technology. San Francisco: Morgan Kaufmann, 2003.

Franke, Herbert. Computer Graphics, Computer Art. London: Phaidon, 1971.

Frazer, John. An Evolutionary Architecture (Themes). London: Architectural Association, 1995.

Fry, Ben. Visualizing Data: Exploring and Explaining Data with the Processing Environment. Illustrated edition. Sebastopol, CA: O'Reilly Media, Inc., 2008.

Gerstner, Karl. Designing Programmes; Four Essays and an Introduction. Sulgen: A. Niggli, 1968.

Gibson, William. Neuromancer. New York: Ace Books, 1948.

Goodman, Cynthia. Digital Visions: Computers and Art. New York: H. N. Abrams, Everson Museum of Art, 1987.

Gramazio, Fabio, and Matthias Kohler. Digital Materiality in Architecture. Baden, Switzerland: Lars Müller Publishers, 2008.

Hays, K. Michael, and Dana Miller, eds. Buckminster Fuller: Starting with the Universe. New York: Whitney Museum of Art, 2008.

Hight, Christopher, and Chris Perry, eds. Collective Intelligence in Design (Architectural Design). London: Academy Press, 2006.

Hofstadter, Douglas R. Fluid Concepts and Creative Analogies: Computer Models of the Fundamental Mechanisms of Thought. New York: Basic Books, 1995.

Kelly, Kevin. Out of Control: The New Biology of Machines, Social Systems & the Economic World. Reading, MA: Addison-Wesley, 1994.

Kristine Stiles, and Peter Selz, eds. Theories and Documents of Contemporary Art: A Sourcebook of Artists' Writings (California Studies in the History of Art; 35). Berkeley: University of California Press, 1996.

Leavitt, Ruth, ed. Artist and Computer. New York: Harmony Books, 1976.

Levin, Golan, Meta, Lia, and Adrian Ward. 4x4 Generative Design—Beyond Photoshop: Life/Oblivion. Olton, UK: Friends of Ed, 2002.

Levy, Steven. Artificial Life: The Quest for a New Creation. New York: Pantheon Books, 1992.

Lippard, Lucy. Six Years: The Dematerialization of the Art Object from 1966 to 1972. Berkeley: University of California Press, 1997.

Lynn, Greg. Animate Form. New York: Princeton Architectural Press, 1999.

Maeda, John. Creative Code: Aesthetics + Computation. London: Thames & Hudson, 2004.

———. Design By Numbers. Cambridge, MA: MIT Press, 1999.

Mateas, Michael. "Procedural Literacy: Educating the New Media Practitioner." On The Horizon. Special Issue. Future of Games, Simulations and Interactive Media in Learning Contexts 13, no. 2 (2005).

Mihich, Vasa. Vasa. Los Angeles, CA: Vasa Studio Inc., 2007.

Mitchell, William John, and Malcolm McCullough. Digital Design Media: A Handbook for Architects and Design Professionals. New York: Van Nostrand Reinhold, 1991.

Montfort, Nick, and Ian Bogost. Racing the Beam: The Atari Video Computer System. Cambridge, MA: MIT Press, 2009.

Morgan, Robert C., and Victor Vasarely. Vasarely. New York: George Braziller, 2004.

NASA Evolvable Systems Group. "Automated Antenna Design." http://ti.arc.nasa.gov/projects/esg/research/antenna.htm.

Ono, Yoko. Grapefruit: A Book of Instructions and Drawings by Yoko Ono. New York: Simon & Schuster, 2000.

Orkin, Jeff. "Three States and a Plan: The A.I. of F.E.A.R." Game Developer's Conference Proceedings, 2006.

Owen, David. "The Anti-Gravity Men." The New Yorker, June 25, 2007.

Papert, Seymour. The Children's Machine: Rethinking School in the Age of the Computer. New York: Basic Books, 1993.

Paul, Christiane. Digital Art (World of Art). London: Thames & Hudson, 2003.

Pearce, Peter. Structure in Nature is a Strategy for Design. Cambridge, MA: MIT Press, 1978.

Peterson, Dale. Genesis II Creation and Recreation With Computers. Reston, VA: Reston Publishing Company, 1983.

Petzold, Charles. Code: The Hidden Language of Computer Hardware and Software. Redmond, WA: Microsoft Press, 2000.

Prueitt, Melvin L. Computer Graphics: 118 Computer-Generated Designs (Dover Pictorial Archive). Mineola, NY: Dover Publications, 1975.

Rahim, Ali. Contemporary Techniques in Architecture. London: Academy Press, 2002.

Rappolt, Mark, ed. Greg Lynn Form. New York: Rizzoli, 2008.

Reas, Casey, and Ben Fry. Processing: A Programming Handbook for Visual Designers and Artists. Cambridge, MA: MIT Press, 2007.

Reichardt, Jasia. Cybernetic Serendipity: The Computer and the Arts. New York: Praeger, 1969.

———. Cybernetics, art, and ideas. New York: New York Graphic Society, 1971.

———. The Computer in Art. New York: Van Nostrand Reinhold, 1971.

Resnick, Mitchel. Turtles, Termites, and Traffic Jams: Explorations in Massively Parallel Microworlds (Complex Adaptive Systems). Cambridge, MA: MIT Press, 1994.

Rinder, Lawrence, and Doug Harvey. Tim Hawkinson. New York: Whitney Museum, 2005.

Rose, Bernice, ed. Logical Conclusions: 40 Years of Rule-Based Art. New York: PaceWildenstein, 2005.

Ross, David A., and David Em. The Art of David Em: 100 Computer Paintings. New York: Harry N. Abrams, Inc., 1988.

Ruder, Emil. Typographie: A Manual of Design. Zurich: Niggli, 1967.

Russett, Robert and Cecile Starr. Experimental Animation: Origins of a New Art. Cambridge, MA: Da Capo Press, 1976.

Sakamoto, Tomoko, and Ferré Albert, eds. From Control to Design: Parametric/ Algorithmic Architecture. New York: Actar, 2008.

Schöpf, Christine, and Gerfried Stocker, eds. Ars Electronica 2003: Code:The Language of our Time. Linz: Hatje Cantz Publishers, 2003.

Simon Jr., John F. Mobility Agents. New York: Whitney Museum of American Art and Printed Matter, 2005.

Shanken, Edward A. Art and Electronic Media. London: Phaidon Press, 2009.

Shneiderman, Ben. "Treemaps for space-constrained visualization of hierarchies," December 26, 1998. http://www.cs.umd.edu/hcil/treemap-history/.

Silver, Mike. Programming Cultures: Architecture, Art and Science in the Age of Software Development (Architectural Design). London: Academy Press, 2006.

Skidmore, Owings & Merrill. Computer Capability. Chicago, IL: Skidmore, Owings & Merrill, 1980.

Sollfrank, Cornelia. Net.art Generator: Programmierte Verführung (Programmed Seduction). Edited by Institut für moderne Kunst Nürnberg. New York: Distributed Art Publishers, 2004.

Spalter, Anne Morgan. The Computer in the Visual Arts. Reading, MA: Addison-Wesley Longman, 1999.

Strausfeld, Lisa. "Financial Viewpoints: Using point-of-view to enable understanding of information." http://sigchi.org/chi95/Electronic/documnts/shortppr/lss_bdy.htm.

Thompson, D'Arcy Wentworth. On Growth and Form: The Complete Revised Edition. New York: Dover, 1992.

Todd, Stephen, and William Latham. Evolutionary Art and Computers. Orlando, FL: Academic Press, Inc., 1994.

Toy, Maggie, ed. Architecture After Geometry. London: Academy Editions, 1997.

Tufte, Edward R. The Visual Display of Quantitative Information. Cheshire, CT: Graphics Press, 1983.

Tufte, Edward R. Visual Explanations: Images and Quantities, Evidence and Narrative. 4th ed. Cheshire, CT: Graphics Press, 1997.

Volk, Gregory, Marti Mayo, and Roxy Paine. Roxy Paine: Second Nature. Houston, TX: Contemporary Arts Museum, Houston, 2002.

Wardrip-Fruin, Noah, and Nick Montfort, eds. The New Media Reader. Cambridge, MA: MIT Press, 2003.

Whitelaw, Mitchell. Metacreations: Art and Artificial Life. Cambridge, MA: MIT Press, 2004.

Whitney, John H. Digital Harmony. Peterborough, NH: Byte Books, 1980.

Wilson, Mark. Drawing With Computers. New York: Perigee Books, 1985.

Wood, Debora. Imaging by Numbers: A Historical View of the Computer Print. Chicago: Northwestern University Press, 2008.

Woodward, Christopher, and Jaki Howes. Computing in Architectural Practice. New York: E. & F. N. Spon, 1997.

Youngblood, Gene. Expanded Cinema. New York: E. P. Dutton, Inc., 1970.

Zelevansky, Lynn. Beyond Geometry: Experiments in Form, 1940s–1970s. Illustrated edition. Cambridge, MA: MIT Press, 2004.

BIBLIOGRPAHY

FORM
CODE

IN DESIGN,
ART, AND
ARCHITECTURE

Casey Reas, Chandler McWilliams, LUST

Princeton Architectural Press / New York

Published by
Princeton Architectural Press
37 East Seventh Street
New York, New York 10003

For a free catalog of books, call 1-800-722-6657.
Visit our website at www.papress.com.

© 2010 Princeton Architectural Press
All rights reserved
Printed and bound in China
13 12 4 3 First edition

Series editor: Ellen Lupton
Project editor: Laurie Manfra
Designer: LUST

Special thanks to: Nettie Aljian, Bree Anne Apperley,
Sara Bader, Nicola Bednarek, Janet Behning, Becca
Casbon, Carina Cha, Tom Cho, Penny (Yuen Pik) Chu,
Carolyn Deuschle, Russell Fernandez, Pete Fitzpatrick,
Wendy Fuller, Jan Haux, Linda Lee, John Myers,
Katharine Myers, Steve Royal, Dan Simon, Andrew
Stepanian, Jennifer Thompson, Paul Wagner, Joseph
Weston, and Deb Wood of Princeton Architectural
Press —Kevin C. Lippert, publisher